PAINTING
TECHNIQUES

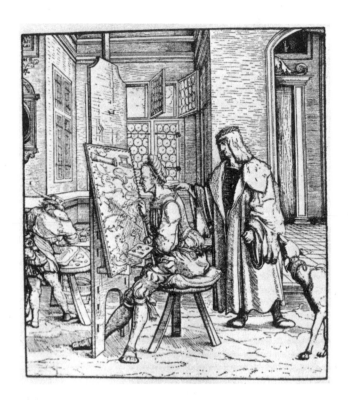

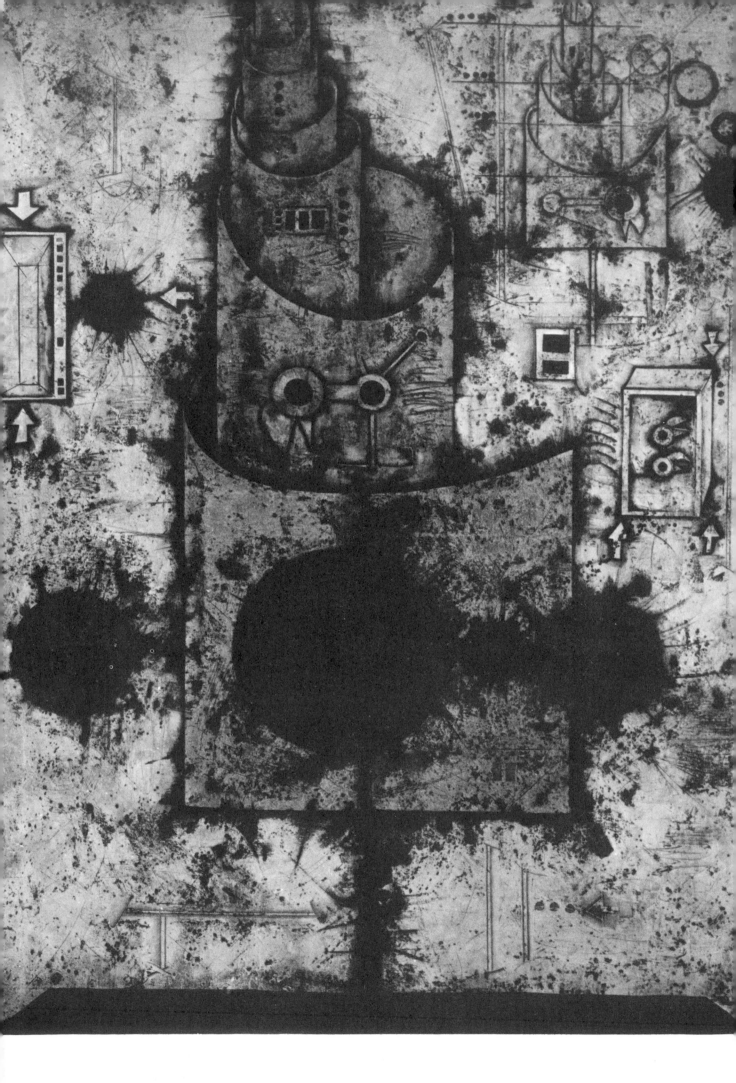

Ludvík Losos

PAINTING TECHNIQUES

1 ← ←
Hans Burgkmair (1473—1531)
A Visit to an Artist's Workshop
Wood engraving
In the foreground the artist holds a palette set with
colours; in the background his apprentice is preparing
the colours

2 ←
Mikuláš Medek (1929—1974)
The Table of a Tower Designer I
Combined technique, oil and synthetic enamel,
1620 × 1300 mm

Designed and produced by Artia
First published 1987 by
Octopus Books Limited,
59 Grosvenor Street, London W 1
© Copyright Artia, Prague 1987
Illustration No. 21 © A.C.L. Antwerp 1987
Illustration No. 69 © National Gallery, London 1987
Text by Ludvík Losos
Translated by Vladimír Feldman
Edited by Susanne Haines
Drawings by Yvetta Oulíková
Graphic design by Aleš Krejča
ISBN 0-7064-2816-1
Printed in Czechoslovakia
2/12/03/51-01

CONTENTS

3
Zdeněk Beran (1937)
The Positioning of the Torso of a Portrait
Gypsum on a masonite board, acrylic emulsion,
synthetic enamel, oil, 650 × 500 mm

4 →
Antonio Tàpies (1923)
A Red Mark on a Chestnut Ground
Impasto with a sand-filled colour layer, 1140 × 1620 mm

INTRODUCTION

... The example of the masters does not impose a style, composition, or any definite form on their followers. If one person achieves success in one way, another may achieve it in a different way. There is, however, one indispensable condition — that the entire work follows a chosen path ...

Hippolyte Taine

7

The Technique of Painting in History and Literature

The technique of painting, in relation to the entire creative process, is essentially the vehicle through which the artist conveys a message. But the degree of mastery of technique has a direct bearing on the quality of this message. The historical examples in this book provide proof of the great care attached by the old masters to the technical aspect of painting, illustrating their profound awareness of the need to achieve harmony between the technique and the creative process — a harmony that is vital for a successful result.

The creation of a picture, being the visual message of its author, involves the preparation and use of the appropriate materials with the help of certain technical means. The physical and, especially, chemical properties of these materials condition their method of application, so knowledge of them is essential. Drawing, colour, and the structure of materials give form, visual impact and tactile qualities to a work: a successful unity of these aspects will generate a perfect synthesis in the perception of a work of art.

Thus, for a painter, knowledge of the techniques and methods of painting is a tool of paramount importance for conveying his or her message, and the mastery of those techniques constantly opens up new prospects for creative experimentation.

The development and systematic accumulation of technical experience in all ancient cultures was brought about by the specialization of crafts. In a comparatively early period the specialized trades which produced luxurious items became separated from the other crafts and today may be designated as 'the arts'.

The evolution of the arts, as the most demanding branch of human activity in terms of technique and method, directly influenced the development of industries such as glass-making, enamel production, dyestuff manufacture, stone-working and pigment making.

The knowledge thus obtained represented a valued and cherished intellectual wealth, which was passed from generation to generation as one of the basic prerequisites of success. Those who possessed it were assured an exclusive and privileged social standing for themselves. In ancient times, most notably in the cultures of the Middle East, this knowledge was the prerogative of the priests. This fact accounted for the necessity to obscure its low origin, which is described by the alchemist Zosimos, who lived in the 3rd century A.D. In his work the origin of chemical science is ascribed to demons which were expelled from the Heaven. For many years afterwards the scripts dealing with technical information remained anonymous, being intentionally attributed by their authors to mythical characters such as Hermes and Zoroaster (according to the author's own background). Greek alchemists such as Synesius and Olympiodoros employed allusions, allegories, and intricate symbolism in order to hinder the understanding of texts. Throughout medieval times endeavours were made to protect professional secrets.

Thus, in Italy technical data on painting were long called *segreti;* in 14th-century France, apprentice Raymond Juillard had to vow never to give away the secrets of his master, the painter Jean Changenet. In the late 16th century, the writer Valentin Boltz, in a preface to his work on painting, defends himself, anticipating an outbust of anger on the part of the painters' community which felt threatened by the publication of the work.

However strict the precautions, manuscripts and compendia on the methods of painting and on the arts did appear, even in those dark times, as is demonstrated by the original foreword to the most significant Roman treatise of its kind — Vitruvius' *De Architectura.* A considerable number of the preserved manuscripts indicate the great popularity of recipe books; many so-called alchemic writings on allegedly 'secret' scientific subjects were actually ingeniously coded technical instructions. Furthermore, the personal diaries of alchemists from the 17th century reveal that their works were largely motivated by purely practical interests — in them we find recipes for the preparation of drying oils, acids, colours, and mordants. Apart from that, recipe books also contain evidence of the main technical traditions that prevailed at a certain period — in

Heraclius' work these are obviously of Roman origin, while an anonymous manuscript from Lucca, or the manuscript *Mappae Clavicula* from approximately the 12th century, point to Byzantine roots. The author of the Lucca document was most likely a mosaicist, judging from the particularly detailed manner in which he wrote the chapters on the preparation, painting, gilding, and polishing of materials for mosaic, including the making of putty. Apart from that, he offers recipes for dyeing hides and wood, a list of minerals employed in the goldsmith's and painter's trade; there are passages describing the preparation of parchment for the needs of scribes and illuminators with a view to the then popular embellishment of books with gold. The *Mappae Clavicula* was a manual of painting and making pigments, probably written for the need of scriptoria; it is very close in content to the Lucca document. Later additions to the work expanded its scope. However, a comparative study of the texts of these medieval sources clearly shows the fusion of west-European technical traditions with those of Byzantium, which in turn draw on the even older experiences of the Greek, Syrian, and Arabic schools. The treatise on the technique of painting which may be regarded as the oldest is by Pliny the Elder. This is the first comprehensive study on the subject compiled on the basis of excerpts from contemporary records. It is a valuable document shedding light on the technical knowledge of the ancients from the beginning of the Christian era. Apart from insignificant mentions of this work in later manuscripts, it was not referred to until Heraclius' treatise on 'Colours and Art of the Romans' which spans the period of the development of the art that elapsed since Pliny's times. It dates back to the end of the 12th and the beginning of the 13th century. The third volume was often transcribed in medieval times; it is documented in the Egerton manuscript (in the collection of the British Museum), which dates from the first half of the 13th century. A typical medieval digest of technical information is the treatise *Schedula diversarum artium* by Theophilus Presbyter. To this day, it remains practically one of the most significant accounts of the techniques of medieval painting and arts, apart from Cennini's work, *Il Libro dell'Arte* (1398), a valuable guide to painters' techniques in late medieval and early Renaissance times. The Middle Ages provide clear signs of attempts to disseminate the hitherto guarded know-how, as is demonstrated by a variety of manuals, issued in the 15th and 16th centuries, based on old sources. One of these is the Strasbourg manuscript, conceived as a handbook for painters, as was the Sloane manuscript (in the collection of the British Museum), which dates from the second half of the 15th century. At the same time a work under the title *Segreti per colori* (also known as the Venice manuscript) appeared in Italy. The traditions of the Byzantine school of painting are dealt with in great detail in the Mount Athos book, *Hermeneia,* which is written in Greek.

The Renaissance, a golden age of arts and learning, is marked by an intense interest in artistic methods. Leon Battista Alberti should probably be singled out as the foremost author of those times; his work *De pictura was* issued in 1435. Along with the usual compendia and recipe books, specialized works begin to appear at this time, devoted to such aspects as the illumination of books and perspective (notably Dürer's treatise). The publications of that period include Fioravanti's *Del compendio dei secreti rationali,* released in Venice in 1564.

The 17th century saw the publication in Europe of more significant works, such as the one by Caneparius on dyestuffs, *De Atramentia,* published in Venice in 1619, or the long manuscript by de Mayerne, who was a royal physician and a friend of many of the then prominent painters. The book remains to this day a source of knowledge of painting techniques of the period.

The first scientific venture into the properties of colours is a book by the famous Irish scientist Robert Boyle, entitled *Experiments and Considerations Touching Colours,* published in London in 1664.

The 18th century is marked by an abundance of practical manuals and, above all,

dictionaries, exemplified by Orlandi's *Abecedario pittorico* from 1753 and A. J. Pernety's *Dictionnaire Portatif de Peinture, Sculpture et Gravure,* published in Paris in 1757 and translated into German and English. An attempt at a critical revision of older works is J. M. Cröker's handbook *Der Wohlanführende Maler,* published in 1753.

An incentive to produce qualified and critical investigation in the historical techniques of painting came at the beginning of the 19th century when structured training in the arts was first introduced at art schools. The most systematic presentation of the accumulated experience was offered by the works of Sir Charles Eastlake and M. G. Merrifield, while the end of the 19th century brought whole editions of books on the history of painting techniques. However, the most valuable collection of old records is Berger's *Beiträge* and A. P. Laurie's works which exemplify a modern presentation of the facts. In the first decades of this century, just as before, art writers addressed themselves not only to the historical aspects of painting, but also to modern experiences, trying to sum them up in their works, as did Doerner, Mayer and Gettens and Stout. Studies on historical techniques are now also published in periodicals.

In comparison to the history of manuals and handbooks of painting techniques, the commercial production of painter's tools is relatively young. As recently as the 19th century, painters were advised to prepare colours, brushes, and other items for themselves. (However, it is interesting to note that as far back as the 17th century, specialized shops in Holland offered all that was necessary for painting.) Medieval records show that pharmacists and monasteries played a role in preparing and supplying colours, because only they had all the necessary facilities (such as small furnaces). The traditional methods of the preparation of colours outlived the other technical processes, for the commercial production of synthetic pigments did not challenge that of natural ones until the 19th century. Commercial paints prepared in tubes have had a good influence as they have enabled painters to work in *plein air,* using

demanding techniques. The manufacture of paints, apart from extending the range of the palette, helped, at last, to define and standardize certain hues, something that could not be done without the expertise of chemists. The production of paints by the 'artist's colourmen' began to encourage the manufacture of other painter's accessories such as brushes, easels, prepared canvases and palettes.

5
Title page of the painter's handbook
by J. M. Cröker (1736)

Principles of Colour

Colour is an optical phenomenon whose source is the visible segment of electromagnetic radiation. It is a property of a substance which is determined by our perception of it while looking at an object by reflected or transmitted light. The value of light radiation given by the light source is expressed in wavelength, which is expressed in millimicrons (abbreviated to mμ, in millionth parts of a millimetre). The visible segment of light radiation ranges from 397 to 687 mμ, with each wavelength corresponding to a specific colour. The shortest wavelength corresponds to violet, and, gradually, as the values grow, they correlate with blue, green, yellow, orange, and, finally, with red. Ultra-violet and ultra-red are situated beyond the ends of the visible spectrum. So, when we say that a substance is blue, this means that it reflects the waves whose length corresponds to the blue colour, absorbing the rest of the colours (the rest of the electromagnetic waves). Black absorbs the subtractive total of all the colours and is thus the 'warmest' of them.

To see the spectrum, it is enough to send a beam of light through a prism which will dissect the beam into its components and divert them according to their wavelengths to produce a 'multicolour fan' of about 150 shades, the maximum colour range of the palette.

A chromatic scale can be organized on a colour wheel to determine colours and their tints. Begin with the basic primary hues of the spectrum — red, yellow, and blue. By mixing, always in equal proportions, the neighbouring hues of the three, we obtain three new secondary hues — orange, green, and violet. Further mixtures of two adjoining hues, following the pattern of the chromatic scale (again in equal proportions), give a number of intermediate degrees — a subtle gradation of colours. All colours obtained in this way may be described as 'pure', to distinguish them from colours obtained by mixing any of the three basic colours or their shades, in different proportions.

Physics differentiates two methods of colour formation, additive and subtractive. The difference between the two is illustrated by the following experiment: if two beams of light are being simultaneously projected onto the same spot on a white screen, with one of them passing through a blue piece of glass and the other through yellow, the spot on the screen where both meet will be white, provided the intensity of both beams is adequately adjusted (additive mixing). On the other hand, if equal quantities of blue and yellow pigment are mixed together they will produce green (if viewed in white light). This subtractive mixing is of relevance to the artist when mixing coloured substances, such as pigments and glazes.

The additive mode of achieving a desired colour always produces less saturated shades, which shift towards the white end of the scale. Each colour of the spectrum has its opposite on the chromatic scale, called a complementary colour. If added, each pair of opposites, when mixed additively, should theoretically give a white colour. On the contrary, the subtractive mixing of pigments always produces a darker shade. A saturated shade can only be achieved by combining two saturated pigments, situated close to each other on the chromatic scale. The farther apart they are, the paler the resultant shade. If they are well matched they will produce a hue close to a neutral grey. The following complementary pairs have been experimentally established, although their resultant neutrals differ from neutral grey:

rose madder, dark	— medium green, permanent
cadmium purple	— chrome oxide
cadmium red, dark	— chrome oxide + blue-green oxide
cadmium red, light + orange	— cerulean blue
cadmium orange	— ultramarine blue + violet
cadmium yellow, dark	— ultramarine violet
permanent green, light	— cobalt violet, dark

Several systems have been designed to classify and define colours. Wilhelm Ostwald pioneered a system of numerical expression of

Colour: Pigments and Dyestuffs

shades. His *Colour Atlas* (1916) listed 2,500 colours, later abridged to 680, defined by three factors — hue-content, white-content and black-content. Albert Munsell's system is used in America. His *Book of Color* (1929) is an 'illustrated system defining all colours and their relations by measured scales of hue, value and chroma'. There is yet to be an internationally standardized system.

Pigments (colours in powder form) are coloured particles which are combined with, but remain insoluble in, binding mediums; they lend a paint film its hue and hiding (or covering) power. Pigments are subdivided into the following three categories:

a/ inorganic — natural (minerals or earths)
— artificial
b/ organic — pure (without a base)
— with a base
c/ metallic — metals finely divided to a powder

Dyestuffs are coloured organic substances which, unlike pigments, are soluble in a given medium and lend a paint layer only a transparent coloration of varying intensity. Traditionally, they are called lakes.

Substrates are bases onto which organic dyes are affixed (precipitated) so that they assume the properties of pigments. Apart from the dyes, this also concerns certain pigments. When substrates are used only for improving the mechanical properties of pigments, they are called fillers. The modern commercial palette of high-quality 'artist's' paints includes a number of lightfast organic dyes on bases, whose properties very well match those of the classical pigments.

Binders are substances which are mixed with pigments to form suspensions; with dyestuffs they form transparent lake films. In a binder, pigment particles are held together by the medium's adhesive property and so facilitate the adhesion of a paint layer to the ground (the surface of the painting). Binders can serve as solvents for dyestuffs. Physically, they are either colloidal solutions (glues), emulsions (organic resins), or drying liquids (oils and resins). The important features of binders are their ability to wet pigment particles, to create stable paint films (in terms of volume) and the capacity to be thinned by appropriate diluents. However, the optical qualities of binders are also important as they directly influence those of colour film. For example, binders with a higher refractive index reduce the pigment's hiding power. But if the bin-

6
Grinding cinnabar for book illumination
Medieval illustration

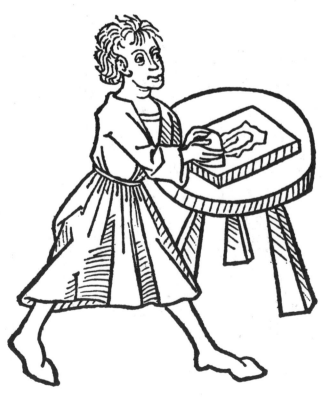

der's and pigment's refractive indexes are the same, the pigment's colour intensity drops. Chemical changes in binders (such as oxidation) adversely affect paints and cause ageing.

Hiding Power

The 'hiding' power of pigments denotes their ability to cover a surface and depends not just on the thickness of the applied paint (this is referred to as 'covering' power), but above all on the optical properties of the pigment and the amount of light it can reflect. This is determined by the refractive index which defines the ratio of the velocity of light in the air to its velocity in the substance or paint in question. The boundary between two mediums both retards the beam of light and changes its direction. The ratio of the beam's angle of incidence and its angle of refraction is called the refractive index. This value is very exact, and may help determine the pigment's purity as well as its hiding power. Refractive index depends to a great extent on the structure and size of the pigment's particles and is always somewhat lower for finer particles (of colloidal to amorphous nature), while being higher for crystalline ones. This accounts for the subtle gradations of hue achieved with the same pigment by the old masters. The majority of natural, or inorganic, pigments originally had a very coarse structure (their grains were coarse), unlike that of the modern, precipitated or finely ground pigments. The hiding and tinctorial power of pigments is enhanced by the minuter the size of pigment particles, but only to a certain degree. Naturally, particle size influences the pigment's colour quality, the condition of the paint film, and the consumption of binders. However, it varies widely from one painting technique to another. Thus, a minute particle size is required for watercolours since the paint film is extremely thin and transparent; in tempera and oil painting a fine grain pays off only for thin glazes, while it can cause cracks in a thick layer of paint. A coarse grain is very important for fresco.

Texture

The texture of pigments implies the hardness of the particles, regardless of their size. Pigments of soft texture are delicate and silky to the touch (such as barytes and ultramarine). The texture of pigments is of major importance in pastel painting, because it determines the quality of the pastel stick, which cannot be improved. Pigments that have a very hard texture should be treated with fillers for better spreading. However, soft texture is detrimental to oil colours prepared by blending.

7
Sap-flow of gum arabic
Medieval illustration

Oil Absorption

An important condition for preparing oil colours is the lowest possible quantity of oil used to create a cohesive, workable paste. Oil absorption is defined by the quantity of linseed oil needed to grind 100 g of a pigment to paste. As oil absorption for different pigments differs significantly, the actual amount of oil needed for the preparation of colours is first determined by tests, because the values given by paint manufacturers refer to very pure linseed oil and certain, specific conditions of production. Some painters prefer to make oil paints themselves, so it is worth mentioning here a simple method of determining oil absorption for individual pigments. The advantage of freshly made paints is that pigment powder has an almost unlimited life, so paints made with fresh oil will have superior qualities.

Use a mortar and pestle. Weigh a small quantity of the pigment (about 5 g) on a piece of paper, and pour it into the mortar. Then weigh a 50 ml dropper bottle filled with oil. Add the oil into the mortar — at first, five drops at a time (at the beginning of the test) and one drop at a time afterwards. After each addition stir the pigment with the pestle, but without exerting pressure. The lumps that form at first will gradually turn into a doughy substance as the pigment absorbs all the oil. When the paste gets stuck to the pestle leaving the mortar clean, use a palette knife to scrape it off the pestle into the mortar and start stirring again. If the paste behaves in the same way, the test is completed. If the paste does not adhere to the pestle, add more oil and repeat the test. When it is over, add one or two drops of oil to see that the paste readily spreads on the sides of the mortar — this indicates the correct consistency of the paste for painting. Now weigh the bottle with the remaining oil, compare the weights before and after the test to calculate the actual absorption of oil for the given pigment.

The test can be carried out in a still easier way with the help of a palette knife and a glass plate. Though acceptable for practical purposes, this method gives less accurate results. Pour 2—3 g of the pigment onto the middle of the glass plate, add a drop of oil, and grind with the side of the palette knife. When the paste flows from the knife in a continuous stream, stop the test — the paste has acquired the right consistency (the oil has given it the same flow as that of standard tube oil paint).

Colours made with linseed oil have superior gloss to those made with poppy oil which gives 'short' pastes. To adjust oil-based paints (to reduce their gloss or to obtain a 'short' consistency), special admixtures, or mediums, are employed.

8
A boiler for making oleo-resinous varnishes
Zahn's wood engraving (1683)

14

List of Pigments and Dyestuffs

WHITES

Barites (Mineral White, Heavy Spar, Barium Sulphate)
Obtained by grinding the natural mineral. It has a crystalline structure and soft texture. Its hiding power is comparatively low. Being absolutely stable, it is used mainly as a filler in paint manufacture. Its oil absorption is relatively low.

Chalk
Specified according to deposits as French chalk, Bolognese chalk or German chalk; it is natural pure calcium carbonate. According to age and origin, chalk can have a crystalline to cryptocrystalline structure (the finest variety is composed of the shells of sea organisms from the cretaceous period). Soft in texture, it has poor hiding power in oil, but covers well in water binders. Chalk is also available as an artificial calcium carbonate which is very fine in structure and has good hiding power. It is permanent to light, mixes with all pigments, but can be decomposed by even weak acids.

Gypsum (Brilliant White, Lenzine)
Fine gypsum, $CaSO_4.2H_2O$, which is generally used as a substrate or filler for other pigments. It is stable but poor in tinctorial and hiding power. It mixes readily with all pigments and is suitable only for water binders.

Lithopone
A co-precipitated mixture of zinc sulphate and barium sulphate, first prepared by Douhet in 1847. Its dyeing principle is zinc sulphate. The pigment is soft in texture; its tinctorial and hiding power are average. It is compatible with all binders, but turns grey in light. At present, this is the most frequently used white for latex and acrylic paints.

Permanent White *(Blanc Fixe)*
Essentially barium sulphate of high purity obtained by precipitation. It has poor hiding power, a fine structure, and is medium to hard in texture. Its oil absorption is rather high, up to 20 per cent. The pigment ranks among the most stable, and it mixes readily with all binders. In painting, it is more commonly used in mixtures, particularly as an extender for titanium white.

Titanium White
Pure titanium dioxide. Its two varieties are anatase white and rutile white which differ from each other in crystalline structure and properties, due to the minerals in which they are found in nature. Anatase white was manufactured exclusively in the first half of the 20th century and is responsible for the low esteem of titanium white as a whole. Apart

9
Grinding pigments with oil
in a 16th-century painter's workshop
Copper engraving after
Jan van der Straet, called Stradanus (1570)

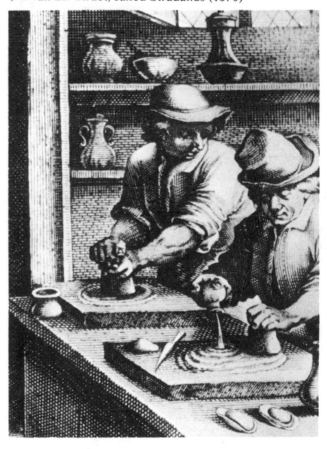

from a lower covering power and refractive index, its main drawback is low resistance to light, air, and moisture. Exposed to ultra-violet rays, it disintegrates, turns chalky and grey. Rutile white is medium-hard in texture and fine in structure, has fair tinctorial power, good covering power, and is superior in the clarity of shade to a number of whites. It is also far more permanent than anatase white. Manufacturers often use the name titanium white for mixtures of rutile white with other, inferior whites, which lend paint films high stability and are especially suitable as grounds.

Transparent White

Prepared by precipitating a solution of aluminium sulphate with alkalis. Chemically, it is aluminium hydroxide. Being a light, loose pigment, it is used above all as a substrate for organic dyes and is suitable only in water binders and only as a lake. On the other hand, it is unsuitable for oil painting, because, apart from negligible hiding power, it has high oil absorption, and the oil causes the yellowing of paints.

White Lead (Cremnitz White)

Basic lead carbonate, or more exactly, a mixture of lead carbonate and lead hydroxide. The greater content of lead hydroxide ensures good properties, especially good hiding power and a soft texture. This is the best pigment for oleous binders as its oil absorption is quite low, about 13 per cent. White lead has been used since ancient times, and is prepared in different ways. The core of all methods is the action of carbon dioxide on metallic lead. Up to the 19th century white lead, along with chalk and lime, were the only whites of high tinctorial strength that were suitable for murals. Its miscibility with other pigments is limited due to its reactivity. White lead is extremely poisonous because of its high lead content.

Zinc White

Pure zinc oxide, a luminous white light powder with a cold, bluish tinge. Its refractive index is relatively high, but the pigment is defi-

cient in hiding power, it has fine structure and medium texture. Light has no undue effect on it. The pigment is more suitable for water binders, because in oil (its oil absorption being 20 per cent) and in oleo-resinous glazes it forms zincate soaps (resinates) which significantly retard drying, cause the formation of flakes, change the tint, and make the paint film brittle. In pastes, the pigment causes cracks. It is easily affected by chemicals. Zinc white is not poisonous; it was first marketed as an artist's pigment by Winsor and Newton in 1834 under the name Chinese white.

YELLOWS AND ORANGES

Barium Chromate (Lemon Yellow)

Prepared by precipitating a solution of neutral potassium chromate and barium chromate, it has great chemical stability as well as significant colour brilliance and a good hiding power. As a pigment, it was first prepared in the first half of the 19th century. It is compatible with all binders.

Cadmium Yellow

Cadmium sulphide, prepared by precipitating an acid solution of a cadmium salt with hydrogen sulphide or alkaline sulphide. Its tint may vary from fair yellow to saturated orange. If precipitation also involves barium sulphate, it results in what is known as cadmium lithopone (cadmopone, for short), a material with deficient properties. Cadmium yellow is a brilliant pigment with good tinctorial and hiding power and high refractive index. In pure form, it combines with all pigments. In painting, cadmium yellow was not used until the mid-19th century.

Cadmium orange is a variety of cadmium yellow.

Chrome Yellow

Varies from light to dark. Bright chrome yellow is a mixture of lead chromate and lead sulphate, or lead phosphate. It is a lemon-yellow pigment of fine crystalline structure and good tinctorial and hiding power, which is

10
A medieval artist painting a mural
An illustration from the 'Beheim Codex' (Cracow, 1475)

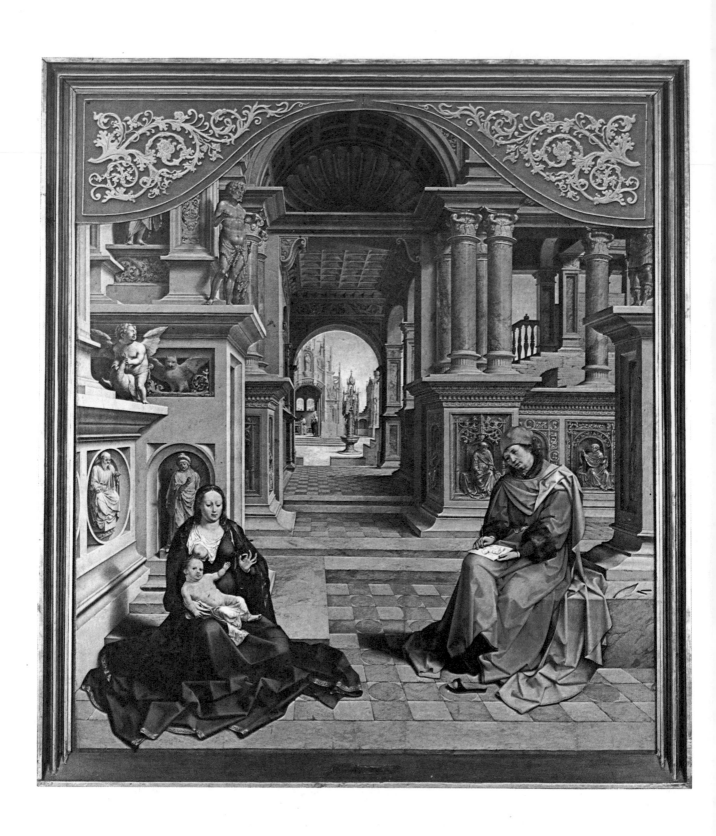

11
Jan Gossaert, called Mabuse (1478—1533)
St Luke Drawing the Madonna
Oil on wood, 2300 × 2050 mm

18

suitable for all binders, especially for oil. It has been known as a pigment since the 19th century.

Dark chrome yellow is pure lead chromate, with a vivid gold-yellow shade and properties equal to yellow.

Chrome orange is a basic lead chromate, which differs from chrome yellow only in shade.

Cobalt Yellow (Aureolin)
A complex chemical compound (potassium cobaltnitrite); it has a very pure yellow colour and fair hiding power. As all pigments prepared by precipitation, it has fine structure and soft texture. It is also fast to light, but not to acids or alkalis. As an artist's pigment, it has been around since 1861. Cobalt yellow is most suitable for tempera, watercolours, and gouache. It fades in excessively acid oils.

Gamboge
For centuries this yellow gum resin has been used as a pigment in the Far East. It is obtained from trees of the genus Garcinia, indigenous to India, Sri Lanka and Thailand. In the 17th century it was very popular with Flemish painters who used it in yellow glazes. The pigment is stable in oleous and oleoresinous binders, but in watercolours it fades in light. Combined with dragon's blood and shellac, gamboge is used as gold lake.

Hansa Yellow
This stable dyestuff has good tinctorial and hiding powers; it is permanent to light, and mixes with all binders. It has found great favour in making lakes, and is a useful pigment in all techniques of painting.

Indian Yellow
A yellow dyestuff of organic nature, originally made in India from the urine of cows fed on the leaves of the mango. Its colouring principle is the magnesium salt of euxanthic acid. Modern Indian yellow is a synthetic dyestuff made on the same chemical basis as the natural one. Indian yellow is intensive in colour and is suitable for making lakes and in watercolours.

Massicot (Litharge)
A chemically pure lead monoxide that is made by carefully heating metallic lead at a temperature of about 300°C. It is a sulphur-yellow, heavy powder that lacks a vivid shade, but is very soft in texture and has great hiding power. The pigment is stable in light, but decomposes in an acid medium. As a pigment, it has been known since medieval times.

Molybdenum Orange
An artificial pigment prepared by mixing lead chromate with lead sulphate and lead molybdenum. It has a minute, homogeneous structure, a high refractive index and soft texture. Molybdenum orange is stable in all binders, but slightly darkens in light.

Naples Yellow (Antimony Yellow)
Lead antimonate made by mixing the monoxide of lead and antimony. Depending on the ratio of the two ingredients, its tints range from light yellow to egg yolk yellow. The pigment has a very fine and homogeneous structure, and good hiding power. It is lightfast, but should not be mixed with sulphide-based pigments. It is more suitable in oil binders than in watercolours or tempera. It is hazardous to health because of its lead content.

Ochres
These natural clays contain various hydrated iron oxides as their colouring substances, and the mineral, goethite. As a pigment, it has been known since prehistoric times. It is treated and adjusted by means of precipitation, grinding, and melting. On heating, it turns red to brown, a property that is used to obtain the different shades. High-grade ochres (the best are found in France) have good hiding power, but are slow-drying. They are excellent for water binders.

Natural ochres are today increasingly replaced by artificial iron oxides.

Orpiment (King's Yellow)
Natural arsenic trisulphate, used in antiquity. It has a brilliant tone and excellent hiding

power. It is perfectly stable in light and is decomposed only by strong acids. Its structure is homogeneous, texture is soft, and the index of refraction is high. This material is incompatible with the lead pigments. Today, it is more of historical significance because of being highly poisonous.

Quercitron (Yellow Lake)
A natural yellow dyestuff made from the bark of a species of oak, *Quercus tinctoria,* native to North America. Its colouring principle is quercetin, that is, chemically, tetrahydroxyflavonal. The pigment is unstable in acids, and is adversely affected by light.

Realgar
The natural sulphide of arsenic, associated in nature with orpiment. Its refractive index is low, hiding power is poor, and chemical reactivity is significant. This orange-red pigment is more of historical importance. It is highly poisonous.

Weld
This natural yellow dyestuff, extracted from dried Dyer's Rocket *(Reseda luteola),* which was cultivated in medieval Central Europe. Its colouring principle is luteolin. The pigment lends an intensive yellow to lakes, and when precipitated by alum, it gives a light yellow pigment. Though compatible with all binders, it is unstable in light.

Zinc Yellow
A complex chemical compound that contains zinc chromate. It is made by mixing the hot solutions of potassium dichromate with zinc sulphate. As a precipitated pigment, it has a very fine structure and soft texture; its shade is a pure lemon-yellow; it is moderate in hiding and tinctorial power. Zinc yellow is rather unstable in light, gradually turning grey-green. This is caused by the formation of chromic oxide. The pigment is employed in oil and watercolours. It was first marketed in the mid-19th century.

REDS

Brazilwood
A natural, red dyestuff, extracted from the wood of the species *Caesalpinia braziliensis* in Brazil, or from *Caesalpinia sappan* L., indigeneous to India. Ever since the 16th century, it has been widely used as a dye and for ink.

Cadmium Red
Precipitated cadmium sulphide and cadmium selenide. The ratio of the two ingredients determines the shade, which ranges from orange to deep maroon. The pigment is fine in structure, soft in texture and has a good hiding power and a high refractive index. It was introduced into painting in the early 20th century. Just as cadmium yellow, cadmium red can be precipitated with barium sulphate to obtain a cheaper product — red lithopone, which is harder in texture and inferior in covering power to cadmium red. Often used to replace vermilion.

Chrome Red
A basic lead chromate, known as a pigment since the middle of the 19th century. It has a high refractive index, soft texture, and a brilliant shade. In normal conditions, it is stable and suitable for all techniques of painting.

Cinnabar (Vermilion)
A natural pigment that has been widely used since antiquity. Chemically, it is a mercuric sulphide that can also be obtained from an artificial process. Cinnabar, one of the densest pigments, has excellent tinctorial and hiding power; it is stable, but darkens in sunlight if exposed to it for a long time. It should not be mixed with copper and lead pigments. It is mainly used in water and emulsive binders, and in oil mediums.

Cochineal (Crimson Lake, Carmine Lake)
A natural organic dyestuff that is obtained from the dried bodies of the female of the insect *Coccus cacti,* which lives on cactus plants, originally in Mexico, and now mainly in Central and South America (Honduras and

Peru). These plants are also cultivated. The pigment's colouring matter is carminic acid. Carmine is a calcium salt of this acid, while carmine lake is the extract precipitated by alum. The material has been used for the artist's purposes since the 16th century. Carmine is not fast to light and turns brownish, especially in watercolours. It is more stable in oil.

Dragon's Blood
A dark red dyestuff extracted from the fruit of the rattan palm *(Calamus draco)*, indigenous to East Asia. It is readily soluble in alcohol, organic solvents, and in balsams. According to Pliny the Elder, dragon's blood was used as a pigment in antiquity. It is employed in lakes, especially in making gold lakes, with which medieval painters imitated gold leaf.

English Red
A light red iron oxide, made artificially by heating ferrous sulphate (iron vitriol) mixed with chalk or lime. It contains a considerable amount of gypsum, is hard in texture and average in covering power. Its tinctorial power is low. The pigment is very fast to light and chemicals; it is not suitable in oleous and oleo-resinous binders, but is very good in tempera, gouache and fresco.

Indian Lake (Lac Lake)
A natural red dyestuff prepared from the resin-like secretion of the lac insect *(Coccus lacca)*, which lives on trees of the species *Croton ficus* in India, Burma, and in the Far East. It is essentially the most intensive shade of shellac. Its colouring matter is either laccaic acid or its salts. The pigment is readily soluble in alcohol and is used in oleous and oleo-resinous mediums.

Indian Red *(Caput Mortuum) see* Iron Oxide Red

Iron Oxide Red
This pigment has been known since prehistoric times. Originally obtained by mining the deposits of the mineral, haematite, it is now made artificially, either as the anhydrous form of ferric oxide, or as a hydrated oxide. The anhydrous oxide can reach dark purple in tone (Armenian bole), while hydrated oxides, according to the content of impurities in them, can be dark yellow to brick-red. Iron oxide red is fast to both light and acids and alkalis. Its specific density is rather high. Depending on the area it comes from, its structure ranges from fine to fibrous, and its texture is medium hard.

Madder Lake (Natural Alizarin)
A natural dyestuff from the roots of the madder plant *(Rubia tinctorum)*, which used to be cultivated in eastern Europe and the Near East. The pigment is prepared by precipitating the extract with alum. It is the oldest of all organic dyestuffs, suitable for practically all media. In the Middle Ages, it was used in wall painting. Today, preference is given to artificial alizarin.

Mars Colours
The generic term for artificial ferric colours whose shades vary from yellow, red to violet. They are made by precipitating iron and aluminium salts to get mars yellow, which, if heated, takes on different tones at certain temperatures. The pigments thus prepared are very fine and homogeneous in structure and medium in texture. The rest of their properties match those of natural iron pigments.

Minium (Cinnabar, Red Lead)
Prepared by heating litharge or metallic lead at a temperature of 480°C, it is one of the oldest artificial pigments. It was known in antiquity and found great favour in manuscript painting; in medieval times it was used in wall painting. The pigment is fairly red in tone, brilliant, and has good hiding power; its texture is soft and its structure is amorphous. It is permanent, but moisture can cause it to brown. The so-called 'orange cinnabar', which is very light in tone, is prepared by oxidizing and heating white lead carbonate; it is very fine in structure. It combines with all binders and quickens the drying of oils. The pigment is poisonous.

Molybdenum Red (Chrome Scarlet)
A bright red pigment, composed of the blended crystals of the chromate, sulphate and molybdate of lead. It is permanent to light and suitable for practically all painting techniques. It was first marketed in the 20th century.

Pozzuoli
A natural red iron oxide of volcanic origin, which is found at a place of the same name near Naples. It is marked by a saturated, red-brown tinge, fine structure, and a good covering power. It is suitable for all techniques and is very stable.

Saffron
This natural yellow-red dyestuff is obtained from the dried stigmas of the crocus (*Crocus sativus*). It is soluble in fats, oils, and resins. It was brought to Europe by the Arabs in medieval times as a flavouring for food. Saffron is used for illuminating the pages of books and in gold lakes.

Vermilion *see* Cinnabar

PURPLES

Cobalt Violet
The anhydrous phosphate or arsenate of cobalt, or a mixture of both. Cobalt phosphate is darker in tint; its texture and covering strength are weak. It has, however, proved stable in all techniques. Its application in painting is insignificant and starts in the second half of the 19th century. The pigment is costly, and, due to the arsenic in it, poisonous.

Manganese Violet (Permanent Violet)
A chemically complex compound: manganese ammonium phosphate. It is somewhat dull in tone and has poor hiding power. It is stable in light, but is decomposed by strong acids and by alkalis, which makes it unsuitable for fresco. It mixes with all pigments. It was first introduced as a pigment in 1890 by Winsor and Newton.

Tyrian Purple
One of the most important and rare pigments of antiquity, which was prepared from molluscs, such as *Murex brandaris* and *Purpura haemostoma*. It is a very stable colouring matter, which is fast to acids and alkalis. It is insoluble in most organic solvents. In Byzantium, the pigment was used for the preparation of inks for codices and the illumination of manuscripts.

Ultramarine Violet
Prepared by heating ultramarine blue mixed with sal ammoniac at 150°C. It is stable in alkalis, and is thus suitable for fresco, a feature which notably distinguishes it from other violets. It is more suitable for use with water-based media than oil.

BLUES

Cerulean Blue (Coelin's Blue)
Chemically, cobalt stannate. It was first introduced by George Rowney in 1860. This is a very stable pigment, with a high refractive index, fine amorphous structure, soft texture, and good hiding power. The presence of cobalt accelerates its drying in oil. It has unlimited miscibility with all pigments, and is suitable for all techniques.

Chrysocolla
A natural copper silicate, outwardly strongly resembling the mineral, malachite, but richer in tint. Its structure is fine to amorphous, and its texture is rather hard. Being fast to light, it is unstable in acids and alkalis. Its use in painting can be traced back to ancient Greece and the Middle East, and many examples are offered by Byzantine manuscripts. Today, the pigment is of purely historical importance.

Cobalt Blue (Thénard's Blue)
An amorphous solution of cobalt oxide in aluminium oxide, it may be regarded as a cobalt aluminate. Cobalt blue has a pure blue shade, like ultramarine. Its texture is soft, its refractive index is 1.65; hiding power is low.

The pigment is stable in acids and in other mediums.

Egyptian Blue (Pompeian Blue, Blue Frit)
One of the earliest pigments to be made artificially. It was prepared by heating a mixture of copper salts, silica, lime and soda. It had a crystalline structure, hard texture, and medium hiding power. It was fast to light, acids, and alkalis. Its miscibility with pigments was unlimited. Mainly used for tempera and gouache, and more suitable for fresco than oil painting.

Indigo
A dyestuff of vegetable origin, employed in dyeing textiles in Asia since time immemorial. It is extracted from plants of the genus *Indigofera*, especially from the species *Indigofera tinctoria*. The colouring principle is indigotin. Its tinting strength is considerable. However, in Europe it did not come into use as a precipitated pigment until the 17th century. In an oil medium, its stability is quite poor; it is good for water and emulsive mediums.

Manganese Blue
This relatively new pigment was first prepared in the 20th century. Chemically, it is barium manganate on a barium sulphate base — a perfectly stable pigment even in strong alkaline mediums such as fresco. It is medium hard in texture, but its hiding power is poor.

Mountain Blue (Azurite)
Originally obtained from the mineral, azurite, it is, in chemical terms, a basic copper carbonate. Its artificial counterpart was prepared as far back as the 17th century. It is medium-hard in texture, fine in structure, and has a high refractive index but medium hiding power. The pigment is permanent to light and alkalis. In the Middle Ages it was used for panel and wall painting. It is decomposed by acids.

Phthalocyanine Blue (Monastral Blue)
Copper phthalocyanine, an organic, synthetic dyestuff, which has been known as an artist's pigment since 1938. Tinctorially, it is very strong, has a brilliant tone, and is fast to light. It is good for all media.

Prussian Blue (Berlin Blue, Paris Blue, Antwerp Blue, Milori Blue)
A complex chemical compound, ferric ferrocyanide, first made by Diesbach in Berlin in 1704. Deep blue in tint, with a bronze lustre, the pigment is very fine in structure and stable in weak acids. It is decomposed by alkalis and turns brown; therefore it is unsuitable in fresco. In oleous and oleo-resinous mediums its colour changes slightly. It is largely used in tempera, aquarelle, and gouache. A still finer variety of Prussian blue, Milori blue, is obtained by precipitation.

Smalt
The earliest of the known cobalt pigments, a cobalt silicate (coloured with cobalt oxide) with poor tinting and hiding power. It was used during the 17th and 18th centuries.

Ultramarine Blue, Artificial
(Permanent Blue, French Ultramarine)
Chemical composition is similar to natural ultramarine blue, but it is quite different in structure. It was first made around 1830 and was produced commercially soon afterwards. It became an artist's pigment almost immediately. Unlike the natural pigment it has a homogeneous structure, soft texture, and a low refractive index. It also has an excellent colour brilliance and good hiding power. The pigment is permanent to light, but is sensitive to acids. In an oil medium, it often turns grey (a phenomenon known as 'ultramarine sickness'). This is caused by the release of fatty acids as the result of the oxidation of the oil. Its capacity to mix with lead and copper is very limited.

Ultramarine Blue, Natural (*Lapis lazuli*)
Obtained by grinding *lapis lazuli*, a natural semiprecious stone. It was known as a pigment in Egypt and Central Asia since ancient times. It is fast to light, its refractive index is low (1.5), which is lower than that of linseed oil, making it more suitable for tempera and gouache than for oil.

GREENS

Cadmium Green
A pigment made by mixing chromium oxide and cadmium yellow in the proportion of 93 : 7 parts, respectively. Its properties are similar to those of chromium oxide.

Chrome Green (Cinnabar Green)
A pigment prepared by mixing Prussian blue with lead chromate. It has fine, amorphous structure, excellent hiding and tinting power. It is not light-fast and has a tendency to darken. By mixing different proportions of the two ingredients, different shades can be obtained. Chrome green is good for practically all techniques.

Chromium Oxide Green (Opaque)
Lightfast and stable in all mediums. Its use in painting started at the end of the 19th century. It has a yellowish, rather dull tint, soft texture, and medium hiding power. It can be mixed with all pigments.

Cobalt Green (Rinmann's Green)
Prepared by thoroughly mixing the oxides of cobalt and zinc. This is a pigment of great tinctorial power, high refractive index, and moderate to good hiding power. It has proved stable in all techniques and mixes with all pigments. It was first prepared by Rinmann and appeared in painting in the 19th century.

Emerald Green
(Paris Green, Schweinfurt Green)
An artificial pigment, introduced by Schweinfurt in 1814. Chemically, it is copper aceto-arsenite, a colouring matter of a sharp, brilliant, green-blue tone, fair hiding power, and soft structure. It is fast to light but sensitive to sulphuric compounds, and its compatibility with pigments is restricted. It reacts with acids and alkalis to produce arsenic trihydride. Emerald green is highly poisonous, it is no longer manufactured and its significance today is purely historical.

Green Earth
(Terre Verte, Bohemian or Veronese Earth)
The mixture of the minerals, glauconite and celadonite; a pigment known in antiquity. Its shades range from yellow-green to green-grey, depending on the deposits from which it is made. It is hard in texture and low in hiding power, especially in oil; it is employed mainly in water media. The pigment is fast to light and to weak acids and alkalis. It turns brown on heating.

Guignet's Green see Viridian

Mountain Green (Malachite)
Perhaps the earliest of the green pigments. It is the basic copper carbonate of the mineral, malachite. It is stable in light and alkalis, but is decomposed by acids. It is hard in texture and medium in hiding power, and is more suitable for tempera and gouache. However, in the Middle Ages it was also used in fresco secco. In an oil medium, the pigment loses its tinctorial strength.

Sap Green (Stil de Grain)
A natural, organic dyestuff, obtained from the berries of the buckthorn (Rhamnus). The juice may be used directly, or it may be first precipitated by alum. In medieval times, it was used in the illumination of books, and was very popular in Dutch and Flemish painting of the 17th century as a lake. The pigment is not fast to light.

Scheele's Green
An acid copper arsenite prepared by Scheele in 1778. It is unstable and is decomposed by acids; it blackens in hydrogen sulphide. The pigment is highly poisonous, and today it is more of historical importance.

Ultramarine Green
Prepared in the same way as artificial ultramarine, but the proportions of its components are different. It was first introduced on the market in 1856. Its properties are similar to those of artificial ultramarine.

Verdigris (Copper Rust)

A green-blue pigment with a sharp tone. Chemically, this is the basic acetate of copper. Its preparation, by applying vinegar or fermented grape skins to copper plates, was known in antiquity. It is very reactive and unstable; it reacts with hydrogen sulphide and darkens. The pigment was very popular with medieval illuminators of books and in panel painting, and it was widely used in the 18th century (by artists such as Antoine Watteau). It was employed in the preparation of green lakes, which found great favour in the combined technique. Another name for it is 'Van Eyck Green'.

Viridian

(Transparent Chromium Oxide Green)

Essentially, a hydrated oxide of chrome, which, when compared with opaque chromium oxide, has a richer and livelier shade, greater tinctorial and hiding power; it is very fine in structure and is soft in texture. In other respects, both chromium oxides have similar properties.

BROWNS

Bistre

A brown-black pigment of organic origin, made from wood soot. Its colour is similar to that of Asphaltum (bitumen). It has been used mainly in drawing and watercolour painting since the 15th century.

Sepia

The dark brown or black secretion of the squid *(Sepia officinalis)*, characterized by great tinctorial strength. Chemically, it is a nitrogenous compound. Evidence about its first use in painting is obscure, but some records indicate that it might have been known in the 16th or 17th century. The pigment dissolves in alkalis, but is stable in water and organic solvents. It loses its colour in acids or chloride solutions.

Sienna (Burnt Sienna)

A yellow ochre found in Tuscany, in the Hartz Mountains in Germany, and in North America. Essentially, it is the mineral, goethite (hydrated ferric oxide), with impurities of aluminous and siliceous compounds. Its properties are identical with those of the natural ferric pigments. It is calcinated to change its shade to a warm, rich, black-brown tone. Due to its partial transparency, it is widely used in lakes. The pigment is suitable for all techniques.

Umber

A natural earth pigment, the mixture of ferric hydroxide and manganese oxide, which is heterogeneous in structure, hard in texture, and average in hiding power. It is very stable, compatible with all pigments and suitable for all techniques. The presence of manganese in the pigment accelerates the drying of oils. Its oil consumption is rather high (80%). Burnt umber is darker, with a richer shade, bordering on red.

Van Dyke Brown (Cassel Brown)

A brown pigment of organic origin — highly bitumenous lignite, known since the 17th century. It is not fast to light, and is therefore little used in watercolour tempera. It is chiefly used in lakes for oils.

BLACKS

Bone Black (Ivory Black)

Made by charring the bone waste left over from the production of glue. It has fine structure and soft texture, its refractive index is average (1.7). Its finest grade used to be made by the same method but with ivory waste. 'Ivory Black' today describes the best kinds of bone blacks. Since it is not fat, the pigment works well in a water medium, especially in watercolour.

Lamp Black

A kind of soot that used to be made in China

especially for the preparation of Chinese ink. The original fuel was vegetable oil, particularly tung oil, which was burnt in lamps with clay cylinders, in which the soot precipitated. This is the finest carbon, which has excellent hiding and tinctorial power. It is suitable for all techniques.

Vine Black (Frankfurt Black)
The term for all carbon blacks of vegetable origin that were manufactured in Westphalia from vine twigs. In Spain it was made from the waste of corkwood and was called 'cork black'. It is also made by carbonizing walnut shells and beechwood shavings. Vine black is very soft in texture, has good tinctorial power, and medium hiding power. It is very suitable in tempera, watercolour and gouache. In an oil medium, it extends the drying of the oil, which makes it unsuitable.

The rendition of light is one of the fundamental techniques of painting. Light helps create mood and space, to enhance or subdue colours, and to model shapes. The effects of light and shade were not known to primitive painters who treated their subject matter as flat shapes. In medieval times painters began to use light and shade to model objects. In this way a local tone, originally seen as a sharply defined area, could either be emphasized or subdued by means of a gradual tonal transition. In shadows, the local tone is reinforced and darkened until it obliterates the initial hue of the colour; in highlights the local tone is reduced until it disappears entirely. In watercolour this reduction of local tone can be achieved by leaving patches of the ground unpainted.

Sharply lit areas do tend to outshine the surrounding areas, detracting from their impact. However, the contrast of light and shade is not only a matter of the contrast of black and white, but also of warm and cool colours. Warm shades call for cool lights and vice versa (a method firmly established in classical painting). Delicate, misty transitions between local tones are termed 'sfumato' (from Italian *sfumare* — to fade), while a technique of abrupt transitions, executed with semi-dry pastes, is known as scumbling.

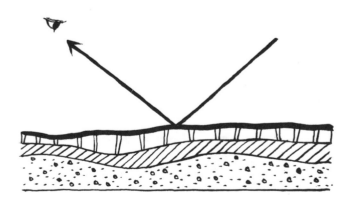

Light is an important illusionistic element of painting, which determines the optical effect of the colour of the paint layer. These are five basic methods of applying paint:

1/ **Laying a wash:** a transparent colour wash applied to a reflective ground (for watercolour)

2/ **Highlighting:** the application of areas of colours on a dark ground which absorbs light (for pastel, gouache, and tempera)

3/ **Glazing** *(pittura lucida)*: building up the layer of colour in several superimposed layers of translucent glaze on a coloured underpainting (sometimes metal foil) which reflects light. The light is reflected as it passes through the layers, and creates an illusion of depth and light (for tempera, the mixed technique, oil)

4/ **'Alla prima':** direct single layer painting; the colours are mixed on the palette and applied to the ground, without any underpainting. The main role is played by the reflection of light from the surface of the paint layer and its tactile qualities

5/ **Underpainting and overpainting:** application of colours to an underpainted canvas or ground

It is useful to distinguish the following optical phenomena:

a/ the normal reflection of light, often enhanced by the application of thick layers of paint (impasto), and by adding to the paint layers with different structure-accentuating materials, including artificial ones (assemblage); in medieval painting this effect was achieved by giving the ground a patterned or sculpted surface particularly in gold backgrounds

b/ the refraction and diffusion of reflected light as it passes through the transparent layers of paint

c/ additive and subtractive changes in colour quality (value) as reflected light passes through paint layers. For instance, the weakening of the light top layer with white gives so-called optical greys which manifest themselves in expressive cool shades.

12
Diagram showing refraction of a beam of light, reflected by the surface

13
Diagram showing refraction of a beam of light, reflected by the glaze layers of a painting:
a glazes, **b** ground

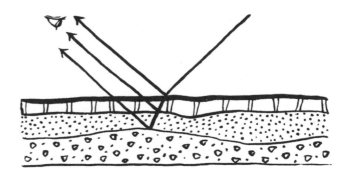

Technical Aids
for the Artist

In medieval times, the complexity of the painting process left almost no room for correction during work, so the execution of a painting required meticulous preparation. The old masters devoted great attention to preparatory drawings and did not hesitate to resort to various aids, particularly those based on optical laws.

The common aids for preparing cartoons were a plumb line, rulers, and compasses. To obtain an accurately scaled-down model, artists long used a wooden frame with a mesh of horizontal and vertical strings which divided the subject into regular areas that could be transferred to a drawing, so keeping everything in proportion. The frame was used not only to transfer existing drawings, but also as a drawing frame, placed between the artist and the subject. It is known that Leonardo da Vinci and Albrecht Dürer made use of the drawing frame.

Later, painters began to employ the *camera obscura,* a device which projects an image onto a flat surface. It was described by an Italian artist as early as 1420, and a detailed description of an improved version of the instrument was given in the work *Ars magica lucis* by Athanasius Kircher, written in 1646. Research has also shown that Vermeer also made use of the *camera obscura.* The invention of photography in the 19th century was appreciated by the painters who used it to aid them with their work; for some it provided a safer way of earning a living.

19th-century landscape painters used a 'scene viewfinder' — a frame which could be adjusted to the proportion of the canvas to isolate the composition.

The old masters used lay-models to assist with drawing the figure. These were small wooden or clay models that would be draped and placed on rotating supports so that the model could be viewed at different angles and the painter could study the distribution of light and shade.

14
A grid for scaling down the model
An illustration from Dürer's treatise
'Underweysung der Messung'
(Nuremberg, 1525)

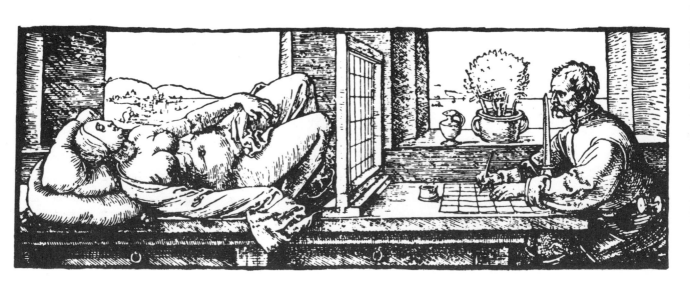

Brushes

The mirror was an important aid for checking the accuracy of an image. Positioned so as to reflect both the model and the painting, it immediately revealed any errors in design and proportions. The 'Claude glass' (or 'black mirror') was used by landscape artists to control the colour patterns, enabling them to see their paintings in monochromatic light which revealed the relationships of tone and hue. A Claude glass can be made by painting one side of a piece of glass with black enamel paint, or by using a piece of smoked glass.

The most important tool in classical painting is the brush — it enables us to apply colours in any way we like, and its properties make it possible for the painter to vary his or her artistic 'handwriting' in order to work out an individual and unique style.

Brushes are made from hair or bristle, and synthetic fibre brushes are also available. There is a wide range of shapes and sizes; size is graded on a numerical scale from 00 (smallest) to 36 (extra large). Brushes from 0 to 3 are suitable only for miniature painting. It is more expedient to get used to thicker brushes for everyday work and to use them also for detailed work and for drawings, because larger brushes, which hold more paint and are firmer than thinner ones, leave a more robust, expressive stroke.

In the Middle Ages brushes were made exclusively from squirrel hair; their manufacture is described in detail by Cennini. He notes that brush manufacturers used the finest hairs from the squirrel's tail; they were then sorted out and bound together into brushes of specific sizes.

Long hairs were used for extremely soft brushes. Since painters preferred to make their own brushes they introduced their own innovations into the craft — for instance, Leonardo da Vinci used silk-fibre brushes for achieving the most delicate tonal transitions.

15
Drawing with the help of projection onto a screen
Illustration from Dürer's treatise
'Underweysung der Messung' (Nuremberg, 1525)

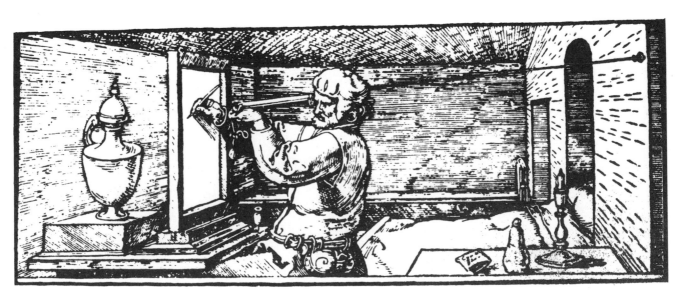

In fact, the generally popular method of blending brushstrokes at that time dictated the use of brushes with stronger hairs that were more hard-wearing and could retain their shape for a longer time. So, badger-, polecat-, marten-, and calf-hair brushes gradually came into use. Chinese brushes are usually made of wolf or goat hair.

Wall painting called for brushes of a different sort — far more abrasion-resistant, with short hair, and flat, suitable for covering large areas quickly. The most appropriate material for this type of brush has proved to be hogs' bristles. (Cennini recommended the bristles of domestic white hogs, but never those of black hogs or boars!)

17
Marten brushes
for watercolour and gouache
with handles of goose feather shafts

16
Palette knives

30

Selection and care of brushes

The chief requirement of hair brushes is that they retain their pointed shape. Before buying one, try it out by dipping it in water and then flicking it dry. A good brush will keep its pointed form, while a bad one, with its hair held together by size, will not. Bristle brushes should keep their flat shape and the bristles should return to a tight bundle.

Brushes must be well cared for, if only because they entail a substantial investment, particularly sable brushes. On finishing work, they should be washed immediately in water, or in white spirit if using oil. Alkaline solutions (including excessively strong alkaline soaps) should never be used to cleanse them, because alkalis damage the hairs.

The safest way to store brushes is hanging them up with their points down, for only in this position can they maintain their form for a long time. To smooth damaged hair brushes, wet them, then wrap them up in soft paper, and wind string around them.

Do the same to bristle brushes, but after wrapping them up, secure the paper with clothes pegs to shape the bristles. Brushes can be stored, bristles up, in a pot, or horizontally in a box.

Never trim brushes in order to change their shape — they will lose the natural strength of the tips of the hairs or bristles which would soon begin to fray. If you want to make a brush shorter use a strong thread to tie the hairs, or bristles tight above the ferrule.

18
Mongoose and polecat brushes
for watercolour

19
Mongoose brushes
for oil painting

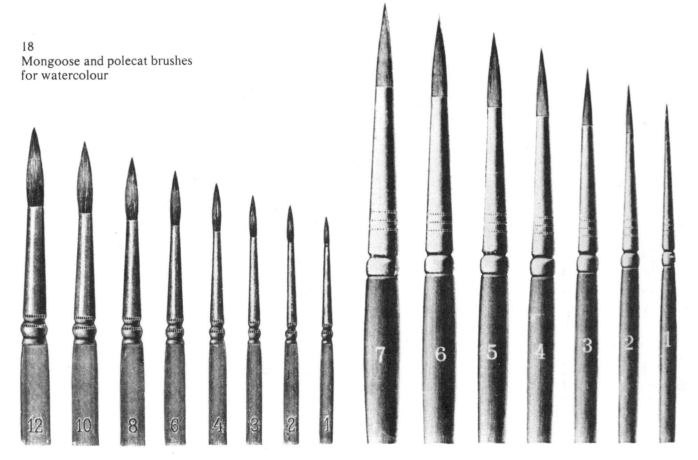

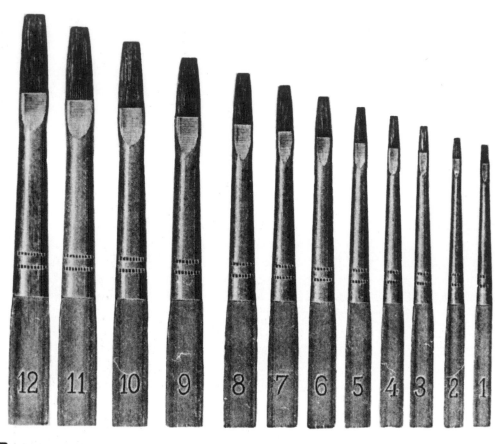

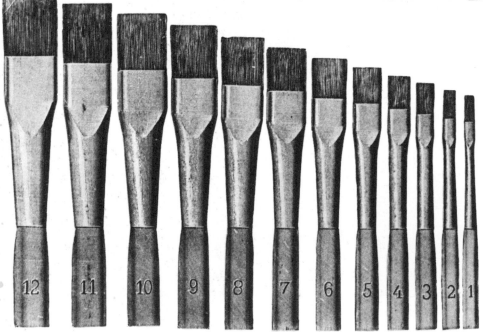

20
Flat brushes
for mural painting and tempera

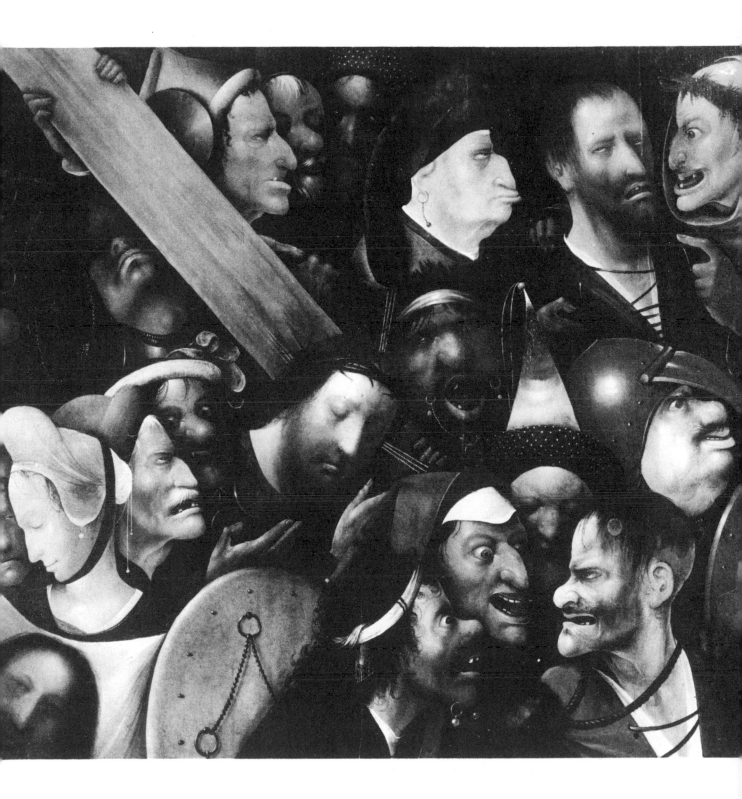

21
Hieronymus Bosch (1450—1516)
Carrying the Cross, detail of brushstroke
Tempera on wood, 740 × 810 mm

Pastel

Principles and Historical Development

Pastel painting is derived from a drawing technique, and it remains on the border between drawing and painting. The powdered pigments are rubbed on a suitably prepared surface in the same way, but there is a difference in the way that the coloured pigments are applied to give subtle colour transitions characteristic of a blended brushstroke. The disadvantage of the technique is that the pure pigment is applied to the surface only by pressure, not adhesion, and so much is lost. (The pigment is bound to a fragile stick by just enough gum to hold it together.)

Colour is generated by the reflection of light from the fixed pigment particles, so this technique has nothing to do with the effect of glazing (produced by light passing through colour layers).

Provided the quality and optical brilliance of the pigments applied are high, pure and clear colour can be attained; it also remains very stable, because it is unaffected by ageing binders. The problem of poor adhesion of the colour layer is resolved by the use of fixatives.

Pastel painting stemmed from the medieval technique of drawing with a combination of media — charcoal, graphite, crayon, or ochre. However, there was little possibility of blending the strokes because the natural pigments used at the time were solid and unprocessed, they did not spread readily and tended to crumble. Nonetheless, the technique of painting with solid pigments attracted artists as it offered a way of applying colour directly and spontaneously, an advantage especially appreciated in portrait studies. We do not possess records about pastel from the early Middle Ages; the first mentions of them date back to the 15th century, while a detailed description of painting in pastels is not in evidence until the beginning of the 17th century when the British physician and technician Thomas de Mayerne published his work on the technique of painting, entitled *Pictoria sculptoria et quae subalternarium artium.* The very term 'pastel' suggests its Italian origin (*pasta* — paste). Indeed, the first mention of the technique, *a pastello,* is found in a treatise on painting by the Italian Giovanni

Paolo Lomazzo, in the 16th century, which analysed Leonardo da Vinci's method of drawing preparatory sketches for his *Last Supper.* In that same century we find the first paintings in pastel, exemplified, above all, by Holbein's portraits, although these are essentially preparatory studies which depend largely on drawing techniques.

Hans Holbein was introduced to the technique in France, where it was called *manière à trois crayons;* he soon perceived the potential of its immediacy and aesthetic value. Holbein's pastels provide us with reliable evidence as regards the roots of this technique, stemming from drawing in colour, and remaining a means of achieving a direct coloristic effect. It did not reach its flowering until the 18th century, when its full expressive potential was explored. Maurice-Quentin de la Tour, Jean-Baptiste Perroneau, Jean-Étienne Liotard, Jean-Baptiste Greuze and other painters put that potential to use in much of their portrait and genre painting. Jean-Baptiste-Siméon Chardin explored through pastels ways of expressing his own complex approach, while François Boucher and Jean-Honoré Fragonard applied the technique to executing large paintings. At the end of the 18th and the beginning of the 19th century pastel became quite common in European painting, not only in portraiture, genre painting, and miniatures, but also in panoramic landscape painting. Later on, the immediacy of the technique was appreciated by artists who preferred to work in *plein air* as pastels enabled them to work more quickly — so much so that a study often ended up as the final version. The optical properties of pastels, particularly that of producing the effect of the shimmering glow of colour particles, found great favour with the Impressionists. In this century it was used by the decorative artists of the Art Nouveau style; the great experimenter of modern painting, Pablo Picasso, used pastels in his work; and in recent years pastels have acquired a renewed popularity.

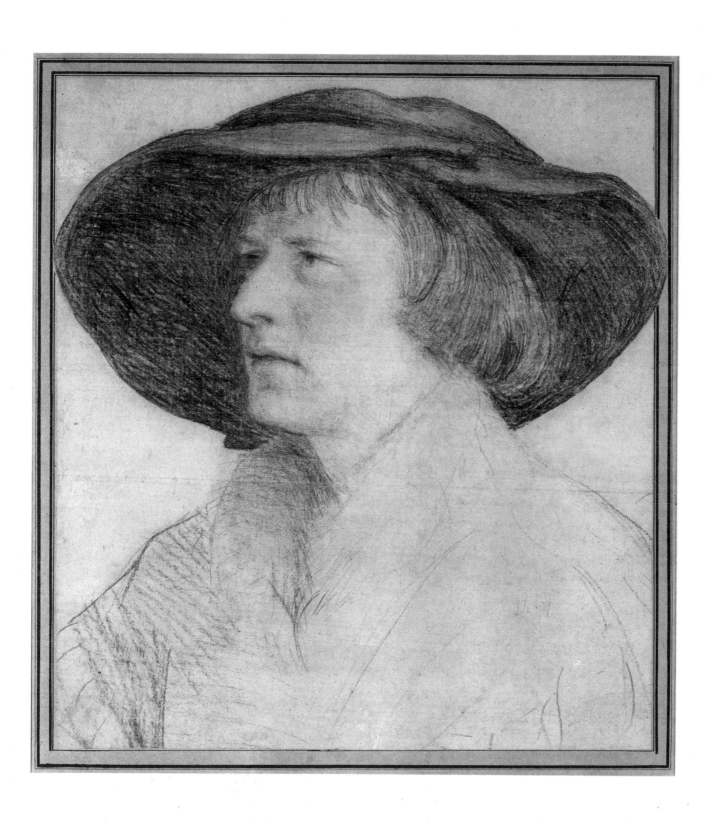

22
Hans Holbein the Younger (1497—1543)
Portrait of Thomas Paracels
Coloured chalks, 400 × 368 mm

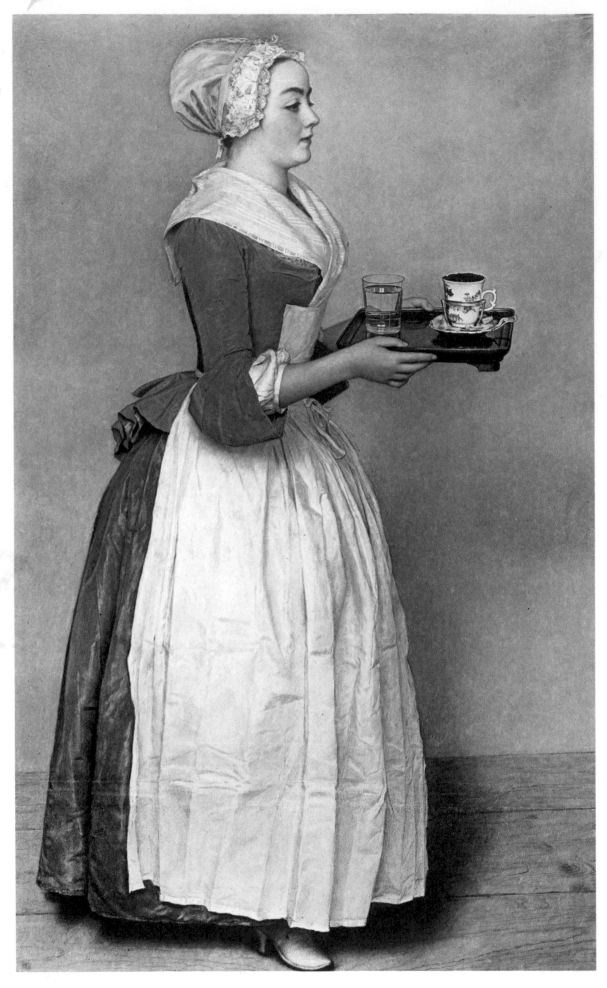

23
Jean-Étienne Liotard (1702—1789)
Girl Serving Chocolate
Pastel on parchment, 830 × 530 mm

24
Artist unknown
Pastel on velour, 430 × 260 mm

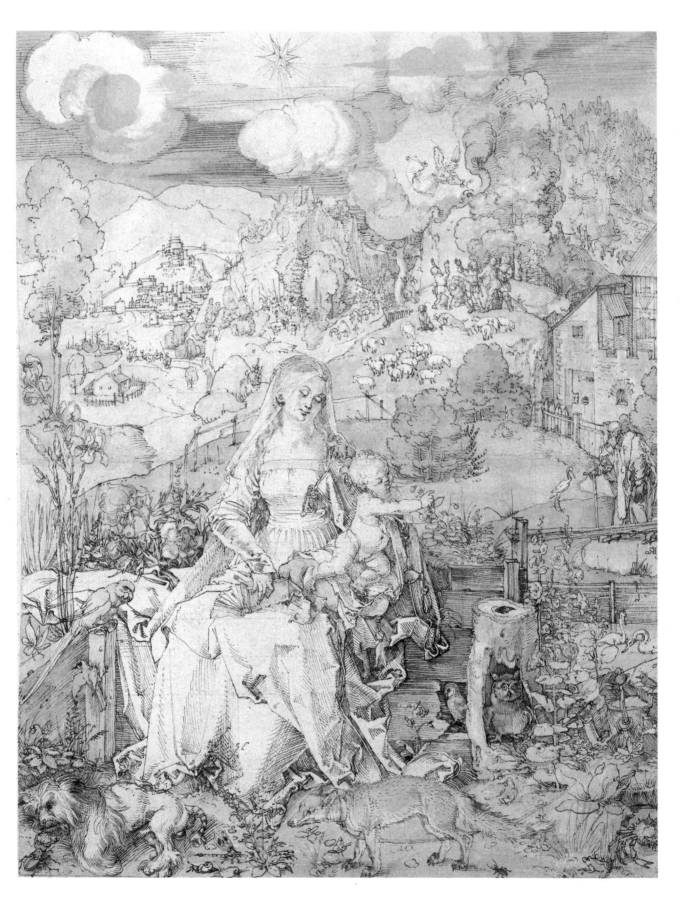

38

Paper and Other Supports

Preparing a Ground

Textured paper is a good support for pastel painting. Its fibrous structure offers the right kind of surface, or 'tooth', for catching pigment particles. The paper should be a good quality, thick, handmade cotton rag. It should be at least 150 g in weight to allow for vigorous working on the surface.

Bockingford and Saunders produce good suitable papers; Fabriano, Ingres and Canson papers are available in a wide range of subtle colours. There are also 'velour' papers which give a slick, modulated effect to the painting.

Prepared boards are also available; these are sturdy boards, mounted with thin paper of various surfaces and colour. You can prepare your own paper by glueing it to a board made of cardboard, plywood or chipboard, depending on the strength you require (and also on the size of your work). Canvas can be glued to a support in the same way — make sure it is pressed well down as it dries. Canvas offers a distinctive pattern and texture, which some painters like to use with pastel. The choice of canvas and its treatment is a matter of individual taste and experience. It is elastic, so the mode of painting has to be adjusted accordingly.

For work on a smaller scale smoother papers should be used. Miniature painters have used specially treated sheepskin parchment or calfskin vellum. Due to its tendency to shrink, it is more suitable for smaller paintings.

Pastel painting can be executed directly onto paper without any preparation, but in order to increase the stability of handmade paper it should be dampened before use. On drying, its minute fibres loosen and make the surface rough, and this facilitates the adhesion of pigment particles. Fine pumice can be used to achieve the same result. The roughening can be carried out in two ways: by rubbing with a pumice stone directly on the surface in a soft, circular motion, or by dampening. This is done by coating the paper with a 3-per cent solution of gelatine or starch. Finely divided pumice is then sprinkled onto the glutinous film. When this is dry and solid, the excess powder is shaken off the paper. Gelatine should be applied in a thin coat so that brush marks are invisible — a sponge can also be used. Such grounds hold the colours firm and lend pastels great durability.

A ground on canvas is prepared in a similar way: take the pre-washed canvas and use a broad soft brush to apply a thin solution of gypsum bound with gelatine or methylcellulose; then sprinkle the wet coat with finely divided pumice, which has been passed through a piece of silk tissue. In a different method the pumice is added directly to the gypsum, in which case more binder is required (5—10-per cent solution). This ground is elastic, but when dry it has to be roughened with pumice or fine sandpaper.

An elastic and moisture-resistant ground can be obtained by first sizing the canvas and, when the coat is dry, laying a ground of chalk, gypsum, bole and oil. When the ground is still wet, it is sprinkled with pumice powder. If a tinted ground is required, pigment should be added to the ground before it is applied, and pumice powder is not used necessarily.

Parchment and vellum are prepared to some extent during manufacture, but they might need some extra pumice or sanding, depending on the surface that is required, and also to make sure that it is free from grease.

25
Albrecht Dürer (1471—1528)
Maria mit den vielen Tieren
Drawing coloured with watercolour, parameters unknown

The Palette

The range of commercially available pastels is impressively rich. There are at least 60 pigments, and their tints are graded from 0 to 8 (light to dark). However, this wide range does more for commercial effect than it does for the artist, since the pigment, which is combined with chalk and bound together with gum, has to be pure to be effective. Pastels made from mixtures of pigments often tend to lose their brilliance and expressiveness because of the subtractive combination of colours. The mixing of pigments always results in darker colour shades. Only by mixing two rich pigments that are coloristically close to each other can we obtain a rich shade again. Consequently, the farther apart the mixed pigments, the less saturated and more dark is the resultant colour.

Titanium white and barites are suitable vehicles. Listed below are good light-fast pigments suitable for pastel:

whites	titanium white zinc white	chalk
browns	Cassel brown umber	burnt sienna pozzuoli
yellows	ochres raw sienna zinc yellow	cadmium yellow strontium yellow
greens	green earth cobalt green	chrome green
reds	cadmium red cinnabar caput mortuum	English red alizarin
blues	ultramarine Prussian blue	cobalt blue mountain blue
violet	manganese violet	
blacks	ivory black vine black	

Making Pastels

Up till the end of the 19th century artists had to prepare their own pastel sticks. They heated the finely ground pigment to remove excess water, and mixed the pigment with a solution of gum tragacanth, gum arabic or gelatine, with different softening admixtures such as glycerine or soap. The amount of binder used was determined by trial and error. The first attempt at devising a system of recipes was made by the German chemist and colorist Ostwald, who used a tragacanth gum solution with the basic concentration of 10 g per 500 ml of water, and then adjusted it according to the specific weight of pigments. Max Doerner, in his book *The Materials of the Artist* recommends wheat starch for the same purpose, or, as an alternative, a 2-per cent solution of gum arabic or 3-per cent solution of gelatine. He also cites old recipes based on the astringent properties of milk, more specifically of its protein, casein. The milk must be separated before use. It is also possible to employ a weak, tempered emulsion. After binding, the paste was kneaded into sticks which were then allowed to dry at a moderate heat or in the shade outdoors. The moulding was often done with the help of wooden forms or glass tubes. This method of preparation has remained unchanged to this day and many artists still make pastel sticks themselves.

Excessively sized pastels tend to leave grooves on application and do not give the typical pollen-like cover, while pastels deficient in gum are too powdery, or they crumble in the hand. To avoid this manufacturers add ground mastic, which binds pigment particles firmly and makes the pastel stick supple. This admixture, however, reduces tinctorial power and colour saturation. The preparation of shades and tints from the basic hues is very simple. The kneaded pigment paste is divided into halves, one of which is used for moulding sticks of the basic tone, whereas the other is mixed with an equal quantity of a white pigment (zinc or titanium white). This is again divided into two equal parts, one part is retained for making the sticks, while the other part is again mixed with an equal quantity of white pigment. In this way a whole

scale of gradated shades can be prepared. The preparation of mixed hues is not of value as it gives muddy colours, as already described. Should the white pigment be substituted by precipitated chalk or whiting in the preparation, the pigment may lose its hiding power when the painting is fixed, resulting in a change in tone. Originally, painters bypassed this problem by using only lead (Cremnitz white), but this is now known to be poisonous.

In the preparation of pastels care should be taken to avoid using poisonous or harmful pigments, such as Cremnitz white, Naples yellow or emerald green, or minium, because the dry particles are easily inhaled. Use pigments that are recommended for use as pastels as some of them may be soluble in diluents used in the preparation of fixatives. This dilution is termed 'bleeding': the colour layers spread and leave a stain.

In the 19th and at the beginning of the 20th century, the technique of pastel painting saw some innovations which may have been successful at first but soon sank into oblivion. For example, Bossenroth's pastel (pigments bound by the blood protein, fibrin) enabled the use of a combined technique, with pastels applied in washes, like gouache. They were fixed and made hard with a formalin solution.

Oil pastels have also been developed. Their composition and effect is very different from the chalkiness of the traditional soft pastels; the two types do not work successfully together. Oil pastels can be applied in layers and scraped through, and colours can also be fused by gentle heating or mixing with turpentine.

Coloured chalks and crayon sticks are not a substitute for the high quality soft pastels. Pastel pencils are available — they produce a different, harder mark, and are more suitable for drawing than for painting.

Tone can be applied in a drawn manner and then rubbed with the fingers or with a paper stump. Large areas can be hatched in with the long side of the stick. Warm tones can be juxtaposed with cool ones, and vice versa. Applying strokes of light colour over darker ones is usually not that easy and so broken strokes, dots and hatchings (methods associated with the style of the Neo-Impressionists) should be used. If the paper or canvas is light, bare patches may be left unpainted to stand for light areas. Dark grounds and tinted papers may be exposed in this way; these areas will help create transitions and shadows as well as contrasting with the build up of light areas with pure whites.

Depths of volume can be achieved through delicate transitions and by laying down light, delicate tones over darker ones. However, care should be taken not to use too much pressure, which would disturb the underlying pastel layers. Pastel painting requires a light touch — if it is overworked it loses its freshness. The basic method of applying strokes of colour side by side and rubbing them into subtle transitions is the most reliable one.

Due to the seemingly restricted range of marks that can be made, pastel has often been combined with other techniques, most frequently watercolour and gouache. Generally, these are used for an underpainting onto which pastels are laid down. Also, pastels can be applied to a wash: the fine pastel powder is sprinkled onto the dampened ground to obtain a grainy surface which enhances the characteristic pollen-like appearance of the colour layer. It should be noted that a strong overfixing of pastel actually produces gouache.

In the first half of the 20th century the pastel technique returned to a more graphic technique; to describe form pastels were rubbed to give a subtle modulation, best suited to use on a white ground. This was combined with the use of coloured crayon and charcoal to add contours.

Fixing

Corrections, or the removal of the colour layer, should be done by blowing, or gently brushing it off, with a soft brush or cotton wool; never use physical pressure to erase the colour — this would only serve to press the pigment further into the ground.

Basically, the less pastels applied the better. Thick, saturated tones look heavy and dull and are easily smudged, and the characteristic lightness of the medium is lost.

To fix the minute particles of pigment that are on the surface of the ground so as to avoid any optical change in the colour layer is no easy matter. It is accomplished by using colourless solutions of substances with adhesive properties, especially resins or glues, suspended in fast-evaporating solvents. Once they have evaporated, a glutinous and cohesive film is formed which attaches the pigment to the ground. As individual pigments have different specific weights and different absorption, fixing is not uniform, nor can the bond between the colour layer and the ground ever be perfect. Attempts at achieving a maximum fixing often lead to the oversaturation of the colour layer with a fixative, producing glossy stains of irregular shapes. The wrong composition of a fixative can bring about a change in the optical properties of some colours, for instance, loss of hiding power — the underlying layers of light areas will show through, while darks alter their tones.

Originally, pastels were fixed by spraying with a mist of a weak solution of glue or gelatine, or they were simply dipped into such a solution. Later, natural resins came into use, such as dammar, mastic and sandarac, dissolved in spirit or ether. Today, the optically stable polymers of synthetic resins such as methyl methacrylate in spirit, acetone or chloroform, serve this purpose.

Fixatives thinned with water have a tendency to create irremovable stains caused by the surface tension of the water as pigment is being washed on the surface. Nonetheless, some artists keep on using them because they believe that they give a firmer bond between the ground and the colour layer which develops through swelling and slow drying, and because water does not change the colour.

26
Composition of a colour layer in panel painting:
1 wood board, 2 gypsum ground, 3 glue sealant, or size, 4 drawing in charcoal, possibly incised, 5 primer, 6 underpainting in basic tones, 7 glazes, 8 varnish

Mounting

Water fixatives

Gelatine — a 4-per cent solution in water with the same quantity of spirit. The alcohol reduces the surface tension of the water, prevents flowing and accelerates drying

Casein — a 5—10-per cent solution in water with a little spirit

Acrylic emulsion — a 3—5-per cent solution in water

Polyvinyl acetate emulsion — the same concentrations as above

Volatile fixatives

Mastic — a 2-per cent solution in ether or alcohol

Dammar — a 2-per cent solution in pure benzine

Venice turpentine — a 2-per cent solution in alcohol

Sandarac — a 3-per cent solution in toluene

White shellac — a 2-per cent solution in high-grade spirit

Synthetic resin fixatives

Polyvinyl acetate — a 2.5-per cent solution in acetone

Regnal 7 — a 2-per cent solution in alcohol

Methyl methacrylate — a 2-per cent solution in chloroform

Maximum caution should be taken when applying fixatives. The pastel painting should be laid down flat on a table or on the floor. Using a spray diffuser, first test to get a fine and even spray. Then apply a thin mist of spray, aiming it into the air above the picture, so that it falls down onto it indirectly. Inspect the picture and repeat the operation in the same way. The second spraying is usually sufficient. Never aim the spray directly at the picture, or the force of it will take away a layer of colour. Commercial aerosol fixatives are also available and are sometimes more convenient to use. Always make sure that you use spirit-based fixatives in well-ventilated areas — the fumes are toxic.

Proceed with caution when framing pastel paintings. Perhaps it would be wiser to leave it to an expert. Two principles must be observed: there has to be a gap between the glass and the colour layer; and the attachment of the picture to the frame must be dust-proof. A window mount will separate the painting from the glass, and gummed brown paper strip should be used to seal the gap between the edge of the mount and the frame. It should also be backed by a layer of brown paper, securely attached. Pastels on unbacked canvas can be stretched on frames as long as they are tightened by means of a screw device, rather than being driven in with wedges, which would dislodge the pigment.

The glass used for glazing pastels should be thin, clear, and without flaws. Be sure to clean the inner surface of the glass with white spirit before assembling the frame.

Watercolour

Watercolour is a technique of applying transparent colour washes (or layers of pigments finely dispersed in binders that can be thinned with water). The effect of transparency is the intrinsic characteristic of the technique and it calls for a method of working that is the reverse of other techniques. The most intensive whites are created exclusively by the ground, while the most intensive shadows are made by the thickest colour layer, or succession of layers (which still remain, to some extent, translucent).

Watercolour is in essence an illusory technique, it alludes to a relationship between colour and light rather than producing one.

The knowledge of grinding of pigments and dyestuffs with water can be traced back to man's earliest attempts at primitive decorations and also the embellishment on manuscripts (the oldest known being the Egyptian Books of the Dead). The technique was widely used in Japan and China to ornament decorative items (such as fans, lanterns, lampshades) and to paint screens and pictures.

Watercolour did not come into its own as an independent technique until the end of the 17th century, although German painters of the first half of the 16th century, such as Albrecht Dürer, Hans Holbein, and some exponents of the Danube school (such as Albrecht Altdorfer) employed it in much of their work. For a long time watercolour remained an auxiliary technique for preparing a painting and colouring drawings. 17th-century Dutch and Flemish painters used it in their wash sketches of landscapes and interiors, while the great fresco painters used watercolour as an aid in composition studies. It began to be widely used in miniature painting, particularly in miniature portraits, a tradition which began with the paintings of Hans Holbein the Younger. First executed on parchment and later on ivory and bone panels, watercolour began to take an independent course of development, often involving related techniques, mainly gouache and pastel. It reached a high point in its development in the work of the French painters Nicolas Poussin (1594—1665) and Claude Lorrain (1600—1682), especially in their remarkable landscape studies, perfect in their rendition of light. But they had no direct successors.

Among the first great painters to give preference to this technique as a means of expression and to pave the way for its independent development were the British painters William Turner (1775—1851) and Thomas Girtin (1775—1802). Turner's engagement in the study of light was undoubtedly influenced by Claude Lorrain. They were followed by a number of contemporaries including David Cox and John Sell Cotman; in 1804 the Old Watercolour Society was formed. Richard Parkes Bonington and Eugène Delacroix and their followers brought watercolours in France. By the beginning of the 19th century, watercolour found its way onto the curricula of art schools and academies.

27
Rudolf Alt (1812—1905)
A View of Salzburg, detail
Watercolour on paper, 290 × 350 mm

Supports

Watercolour requires a light, absorbent support that will reflect light. Special grounds are not prepared for this method of painting although the surface of the support can be adjusted or primed. The most suitable and widely used support is paper; parchment, silk, bone and chalk-ground cloth supports are known to have been used at the beginning of this century, although this is unusual.

The paper for watercolours should be handmade, of a heavy weight, absorbent and long-fibred. It is available in sheets, mounted on board, in pads, or in blocks. Whatman, Arches, Bockingford, R. W. S., and Strathmore produce good handmade or mould-made paper for watercolour. Japanese papers are of high quality and give an interesting range of surfaces, their composition being more varied.

Chinese rice paper can be used for watercolour and gouache; the colour will stain both sides of the paper, and if used very wet, each colour wash will be edged with a watermark; it can be used to provide some interesting effects. It is available in rolls, and a better quality paper, with a slightly creamy tone, is sold in large sheets. These oriental papers are very long-fibred and strong.

The paper for watercolour has to be sized completely, not just its surface. Greasy and water-repellant paper should be treated with ox gall. The surface should be textured enough to accept colours properly.

Always store paper flat. If it is rolled up it will be difficult to unroll and keep flat when you want to use it, and the small flaws that it will have inevitably acquired will show through on colouring (because a compressed sheet of paper accepts colours differently).

When choosing paper, it is recommended to test its fastness to light, particularly if you are buying large quantities. To do this, cut off a strip of paper, cover one half of it well, or close it in a book, and leave it in sunlight on a window sill, for instance, for at least 14 days. If after the 14 days the exposed part of the strip is not visibly yellower than the covered part, the light-fastness of the paper can be deemed satisfactory.

Unless you are using a sketch block, you will have to stretch the sheet of paper over a support before starting work. This can be done in the usual way, by dampening the paper and stretching it on a board by attaching brown gum strip around the edges and allowing it to dry. A stretching frame, which consists of two interlocking parts, can also be used. The paper is put on the internal one and stretched as the external frame is being pressed over its edges. It is then easy to moisten the paper from the back.

Preparing the Surface

There is no need to adjust the surface of high-quality watercolour paper. The painter, if working on damp paper, will have to continue to moisten the paper as he works. In the past, preparation of the surface used to be very popular in order to facilitate rubbing or spreading colours. It was done either with an alum solution (10 per cent by weight in water), or with spirit mixed with 2 per cent glycerine, or with fish glue (a 3 per cent solution in water with a little glycerine), and similar recipes.

The surface of excessively absorbent or fluffy paper used to be treated by coating it with fish glue which was then hardened with an alum solution or by exposing it to formalin fumes in order to adjust the absorbency and to achieve the required behaviour of the paint on the surface. However, painting on a ground treated in this way necessitates precision in applying individual tones; corrections by washing off or cleaning are difficult and visible.

Silk supports used to be modified mainly with a very thin solution of ox gall or with fine starch size to make the material tougher and to prevent the brush from slipping. The required whiteness was achieved by coating the surface with a thin wash of whiting bound with dextrin or fish glue.

Canvas is not a typical support for watercolour. It has been used with a gesso and size ground with a very thin priming of white lead in order to prevent the ground from being washed away.

28
Luděk Marold (1865—1898)
In the Studio
Watercolour on paper, 510 × 360 mm

Parchment or vellum, used especially for painting portrait miniatures, was made from the finest quality of calf or lambskin, often from unborn animals. Its prepared, thickly chalked and limed surface was further adjusted by grinding with fine pumice and then priming with thin white lead or chalk, bound with parchment size (offcuts of parchment boiled to form a glutinous liquid). The surface was often coated with the milk of figs. Before painting, the surface of the parchment was dampened with spirit to remove grease stains.

Panels cut from bone or ivory were allowed to whiten in sunlight, then they were degreased with spirit, after which the painting surface was ground with fine pumice powder rubbed with a cork spatula. To ensure the adherence of colours to the surface, the panels were first coated with ox gall. Later, the thin, translucent panels came to be overlaid with gold or silver foil to increase the reflection of light, or, for the same purpose, their reverse side was coloured.

29
Josef Holler (1903—1981)
An Egyptian Family
Watercolour on paper, 400 × 500 mm

48

Pigments

High-grade watercolour pigments have to be very finely divided so that they will easily form suspensions and mix with water in any proportions. Such pigments can be removed from the ground without trace even after it has dried, unlike organic dyestuffs which fuse with the ground and give it a permanent colouring. Although the use of lightfast organic dyestuffs is widespread at present, a traditional watercolour palette could easily do without them.

The vegetable pigments, gamboge, Indian yellow, sap green, Hooker green, Delft blue and indigo have played an important part in the history of watercolour, although their fastness to light is deficient. However, this holds true of a majority of colours applied in thin watercolour washes — they are much more sensitive to the action of ultraviolet rays which cause them to oxidize.

A watercolour palette may contain the following colours:

yellows	natural ochres
	sienna
	ultramarine yellow
	Indian yellow
	cobalt yellow (aureoline)
	cadmium
reds	caput mortuum (red ochre, burnt)
	cinnabar
	madder lake
blues	ultramarine (natural and artificial)
	cobalt blue
	Prussian blue
	cerulean blue
greens	chrome oxide
	earth green
	cobalt green
browns	burnt sienna
	umber
	sepia
blacks	ivory or bone black
	bistre
	Chinese ink

Unlike the classical English watercolour tradition, which made no use of whites, modern watercolourists may also use kaoline (China clay). When choosing colours, one should bear in mind the saying: the poorer the palette, the more colourful the painting.

Binders

Manufacturers such as Winsor and Newton, George Rowney, Talents, Lefranc, Grumbacher and others offer a wide range of top quality watercolours. They are available in tubes, pans, cakes and sticks. However, we should not ignore the interesting opportunity of experimenting with recipes in order to prepare our own paints, be it experimentation aimed at verifying old recipes or at developing new ones. It is useful to know the composition and properties and the methods of preparing various watercolour binders.

Binders for watercolours are natural gums that are soluble in water: gum arabic, dextrin, tragacanth, and other gums. In the past, the function of binder was performed by the milk of figs, the sap from the blossoming ash-tree (*Fraxinus ornus*), and by gelatine and egg white. A binder should meet two basic requirements — namely, that the suspended pigment should remain stable and that it should not coagulate even at a maximum degree of thinning. If it is not up to standard it will create stains, pigment clusters or opaque patches.

This is why binders are usually mixed with extenders — substances with a polysaccharide base (honey, candy, maple sugar, glycerine), which act to stabilize the solution and supress the colloidal tendency of the binders, and at the same time prevent the excessive rigidity and brittleness of the paint film.

To reduce the solubility of paint film, special admixtures are often introduced to watercolours. The admixtures are very thin solutions, such as shellac dissolved in borax, wax, and so on, but they do tend to give watercolours a characteristic that is more typical of tempera.

Binders and admixtures for watercolours usually have the following compositions (proportions by weight):

gum arabic : sugar, 2 : 1
dextrin : sugar, 4 : 1
tragacanth : sugar, 1 : 1

Painting Techniques

Examples of the composition of binders for watercolours:

gum arabic	26
water	52
glycerine	8 (1 : 1 solution in water)
glucose	10
ox gall	4
dextrin	40
water	42
borax	2
glycerine	6
glucose	10 (1 : 1 solution in water)

Honey is also used as a binder. Its application is most frequently mentioned in Russian sources — the binder was widely used in Russian folk arts. According to one method the honey is first purified by boiling in water, then thickened and mixed with a solution of gum tragacanth in the proportion of three parts to one part by weight. When gum arabic is used, the proportion is 1 : 1. The honey is mixed with 0.2 parts of glycerine, in terms of volume. To give extra durability to the colour layer, the gum arabic solution is adjusted by introducing copaiba balsam with wax.

For use in miniatures, honey has always been used as an extender for egg white, which otherwise gives a very brittle result, with a tendency to separate from smooth supports, such as ivory.

The technique of watercolour requires considerable experience and a feeling for building up colour layers in transparent washes. It may be applied freely with mixing of colour shades directly on the paper, or by successive, transparent washes over monochrome underpaintings of usually brown or grey shades. When applying these successive, transparent layers, it must be remembered that shades of an absolutely different character than the directly mixed hues will result from the subtractive mode of building up the colour layer.

In the classical watercolour, or 'aquarelle' technique, the underpainting was executed in light, neutral tones on to which more saturated shades were laid. Lights were obtained by leaving patches of the support unpainted, or by taking out the colour with a brush or piece of chamois leather. Resins were also used: a transparent gum solution was used to coat the white patches. This was then removed with a soft eraser after the work has been completed.

In the 19th century the technique of watercolour loosened up — the dry-brush technique was used, and white was used to accentuate lights, or for partial underpainting. In some cases, watercolour was combined with pastel as well as opaque gouache. Also thick priming of fish glue and white was employed. Tonal depth, especially in shadows, was obtained by way of stabilizing individual colour layers with a spirit fixative to prevent them from fusing.

Watercolourists usually developed their own highly individual techniques, ignoring the traditions of the classical approach as well as contradicting the technical principles.

Watercolour was used for miniature painting on ivory. After careful degreasing and preparation the damp support was covered with a light-tone colour layer, applied in very short, measured brushstrokes, with the paint having moderate fluidity. Attempts at achieving fine modelling and avoiding the free flow of the paint led to a brushstroke characterized by little dots and patching. The brush had to be dry and the strokes were usually made in a downward direction.

Fixing and Care of Watercolours

Cleanliness is very important for watercolour. The brushes need constant care and cleaning as dirty brushes give opaque tones and ill-defined shades. When working keep a jar of clean water, rags for cleaning the brushes and a clean sponge or a piece of soft chamois leather (handy for 'washing off' lights and creating fine transitions).

To protect colour layers special watercolour fixatives are used, mainly alcohol solutions of white shellac and, more recently, polyvinyl-acetate or acrylate, matt lacquers applied with spray guns or aerosols.

It is not recommended to fix or varnish watercolours with anything that will give them a shiny surface as this will detract from the chief merits of the medium: its intimacy, lightness and luminosity. Watercolour paintings should be stored horizontally between sheets of cardboard or in a portfolio. Framed paintings should be protected with glass to prevent damage from dust. When framing the picture, it is desirable to provide it with a firm support, preferably hardboard, in a thick mount which will also provide the required gap between the picture and the glass (2 or 3 mm). The frame should be sealed to make it dust-proof. When hanging the picture on the wall, care should be taken not to place it in direct sunlight; ideally it should be illuminated by dispersed and subdued daylight or artificial light. Only in this way can the original colours of the painting be preserved.

Gouache

Principles and Historical Development

30
Otto Dix (1891 – 1969)
A Prostitute
Gouache on paper, 220 × 310 mm

The term gouache (derived from *guazzo*, Italian for puddle) describes a technique of painting on a damp ground, that is 'painting wet', as Vasari calls it. The difference between gouache and watercolour is that gouache is opaque. The thick, loosely bound layer of pigment differs in its optical properties from those of watercolour mainly in the stronger reflection of light. A gouache colour layer resembles opaque pastel, but it is luminous and offers wide possibilities of gradating tonal depth.

This technique can be traced back to medieval book illumination, and even to ancient Egypt; it was rediscovered, just as watercolour and pastel, in the 17th and the beginning of the 18th century, finding application largely in the painting of small, decorative still-lifes and particularly in miniature painting. The brilliant colour and minute detail of Persian and Indian miniature paintings testify its suitability. The 19th-century Bohemian artist Josef Navrátil explored the potential of this medium. Starting with small genre paintings, he gradually developed an individual technique which he then also employed in creating large murals decorating the interiors of the castles at Jirny, Ploskovice and Zákupy. By the end of the 19th century the technique of gouache was mastered by illustrators who appreciated its fast-drying qualities. The medium has been used more recently by artists such as Klee, Kandinsky and Picasso.

A combined technique was used by the Bohemian painter Luděk Marold, who made use of watercolour glazes for his underpainting, over which he applied lightly handled gouache.

Some ranges of gouache are described as 'designer's colours' due to their commercial application. Derivatives of gouache are poster paints (which are also used in design), and distemper, which is used for scene painting.

31
Michael Rittstein (1949)
Appliances
Pen, gouache, 370 × 500 mm

Supports and Grounds

Supports for gouache can be the same as for watercolour, such as untreated paper and parchment. Canvas, wood and plaster that have been prepared with a ground, can also be used. Gouache is very effective on tinted paper, or the support can be overlaid with a darker priming which must be insoluble by water.

A wooden support is usually given a chalk and size ground; the surface of the plaster needs to be smoothed out and covered with gesso or a fine lime *intonaco* whose absorbency is adjusted by giving it a light coating of size. A canvas support should be treated in the same way; when it is still damp, the surface should be roughened with pumice.

Pigments and Binders

Gouache requires mainly pigments which are permanent and stable, because in gouache the unprotected surface of the colour layer is sensitive to environmental influence and liable to chemical changes. Therefore, the palette must respect the sensitive character of gouache and should avoid as much as possible pigments that are chemically reactive or have low hiding power.

Listed below are the most suitable pigments:

whites	titanium white (rutile white)
	lithopone
	permanent white
yellows	ochres
	sienna
	ferric yellow (a Mars colour)
	cobalt yellow (aureolin)
	Hansa yellow
reds	ferric red (English, Venice)
	pozzuoli
	Mars red
	caput mortuum
blues	cobalt blue
	cerulean blue
	manganese blue
	phthalocyanine blue
greens	green earth
	chromium oxide, opaque and transparent
	cobalt green
	phthalocyanine green
violets	cobalt violet
	manganese violet
browns	umber
	green earth, burnt
	Prussian brown
blacks	bone black
	vine black
	ferric black
	manganese black

Gouache colours are sold in small tubes, and contain an admixture of white, most often barytes or lenzine, which enhance the colours' hiding power and adjust their shades to fit the standard.

Gouache colours can also be prepared in the studio from powdered pigments and an

33
Jean-Étienne Liotard's workshop
Portrait of F. V. Wallis
Miniature
Gouache and watercolour on ivory, 32 × 26 mm

32
Carl Hummel (1769—1840)
Portrait of Prince Schwarzenberg
Watercolour on cardboard, 130 × 92 mm

34
Franz Eybl (?) (1769—1840)
Portrait of a Young Lady.
Watercolour on paper, 170 × 135 mm
Chinese watercolour. The blended brushstroke used for
the drapery contrasts with the broken treatment of the
face

35
Rudolf Alt (1812—1905)
A View of Salzburg
Watercolour on paper, 290 × 350 mm

36
Chi-Pai-che (1860—1957)
A Night Feast
Ink and paint on paper scroll, 370 × 970 mm

56

appropriate binder. Listed below are recipes for three basic kinds of binders suitable for gouache:

1/ Gum arabic

Its solutions have low viscosity in water even in high concentrations, a property which makes gum arabic different from all other glues. To make a very elastic binder, you need (proportions by weight):

 100 parts of gum arabic
 200 parts of water
 40 parts of sugar of glucose (may be replaced by glycerine)
 plus 1 or 2 parts of formalin as a preservative

The acidity of gum arabic is neutralized by adding 3 parts by weight of borax.

2/ Tragacanth or Fruit gum

Cherry and plum-tree gums are more of historical relevance nowadays, as they were mainly used in book illumination; milk of figs was used for the same purpose in Byzantium. Today, tragacanth has taken its place — it lends pigment suspensions the correct thixotropic quality and makes them thick and plastic even if bonds between particles are loose. It is the most suitable binder for gouache.

3/ Starch paste

This binder lends solutions high viscosity, so they have to be considerably diluted (by about 30 per cent). The paste is made either from potato starch, which should be immersed in cold water, or from rye flour. It is

prepared as a concentrate which is afterwards thinned with water according to requirement. To make the paste from potato starch, you need:

 150 g of potato starch
 100 ml of cold water
 2500 ml of boiling water
 50 ml of formalin (a preservative)

The recipe for preparing starch paste from rye flour is as follows:

 100 g of rye flour
 200 g of cold water
 800 ml of hot water
 50 g of formalin

To prepare a wheat-starch binder, take 100 g of wheat starch, mix it with 1300—1500 g of water, and add 7.2 g of sodium hydroxide; then add the solution with pigments which were previously mixed in water.

A binder with an admixture of glue can be prepared in a similar way: add 10 g of glue to 100 g of starch, then add 7.2 g of soda lye, and use 1400 g of water for swelling and dissolving. The preservative agent is formalin. This binder is good for pigments with medium and high specific weights, such as ferric pigments, or those used for painting on canvas.

4/ Casein

To prepare the casein binder, mix 50 g of casein powder with 250 ml of cold water, heat it to 60°C constantly stirring the mixture, add ammonia by drops until the opaque solution turns transparent. Then keep stirring until the casein dissolves completely. The ammonia may be replaced by 20 g of borax. The concentration of the casein binder for mixing with pigments must not exceed 5 per cent in a water solution.

The casein binder lends insolubility and rigidity to the colour layer, qualities which enable quick painting in superimposed layers, especially when applying thicker whites during modelling. This technique has been used in decorative wall painting and in painting on a stable support, as in the decoration of furniture. Casein is unstable in a permanently damp environment and is decomposed by the action of microorganisms. With age, casein

37
Josef Holler (1903—1981)
An Egyptian Family, detail
Watercolour on paper, 400 × 500 mm
The free preliminary drawing shows through the paint

colours with an excessive amount of the binder tend to flake off the ground.

5/ Glue binders

In the 19th century colours bound by glue were used for the decorative painting of interiors and for the painting of stage scenery. Since glue solutions are highly viscous and form gels even at normal temperatures, they must be either greatly thinned down (by at least 20 per cent), or paints with a glue-binder base should be kept warm. The inconvenience has forced painters to develop a special glue mixture consisting of 1 part of glue to 5 parts of slaked lime and the mixture is warmed up over a warm bath until the glue ceases to gel. Paints bound by this glue stock are then improved by the introduction of a little glycerine which prevents the colour layer becoming brittle. If a 3-per cent proportion of size is used as the binder, it should be mixed with 1.5 per cent chloral hydrate in order to keep the paint liquid. Gouache painting using a glue binder has not been a particularly successful technique of painting; during the last century painters attempted to modify the medium, trying particularly to reduce its sensitivity to moisture and to enhance the adhesion of the colour layer to the support. The Bohemian painter and scene painter Josef Navrátil experimented with recipes for the preparation of glue binders from a modified gouache technique of monumental mural painting. Here are some notes from his recipe book:

1 Boil 1 ounce of glue (32 g) in enough water to give a consistency somewhere between carpenter's glue and water. After the glue has melted, take the pan off the heat and add the white of 4 eggs along with their shells. Return the pan to the heat and, stirring constantly, allow the mixture to boil until the white precipitates. Filter through a piece of canvas. Put some glue in a pan and heat it until it begins to boil. Add a drop of alum dissolved in water and stir to prevent the glue from coagulating. Mix the glue with colours.

2 Shellac dissolved with soda in water: dissolve 4 parts of shellac and 1 part of soda crystals in a little water and gradually add more hot water.

3 Shellac, beeswax, and borax melted in a little water by heating. Dissolve 17 g of shellac with half as much borax and a little spirit; paint with this. Add to the mixture dissolved in borax. If the mixture gelatinizes, paint with it. The solubility of a glue binder is reduced by adding egg white or saponized shellac, while for wall painting a combination of shellac and casein is more suitable.

4 Methyl cellulose. Modern binders for gouache are derivatives of cellulose: methyl cellulose or carboxyl methyl cellulose. These binders lend pigments qualities similar to gum arabic or tragacanth; they are also used in combination with different stabilizing admixtures which improve their microorganisms and improving the durability of the colour layer.

Painting Techniques

The traditional technique of painting with gouache is executed on a damp ground allowing the paint to blend on it in a way similar to oil painting, achieving very delicate gradations and subtle, blended transitions. It must be remembered though, that the wet paint will dry to a lighter tone. It effects a uniform change, rendering the general tone of the dry colour layer at least two shades lighter than the initial tone. This technique is best suited for work on paper, canvas with a ground, and on fine plaster. Thick cardboard can warp after repeated moistening.

In painting on a dry ground it is best to start with a preparatory drawing in pencil, ink, or sepia, then follows underpainting with thinned paint, and after it has dried, the work is completed with overpainting using thicker covering paints. The final touches of light modelling are applied with whites of a moderate impasto. It is important not to allow the layers to become too thick, or else it will tend to crack and separate from the ground.

In painting on a dark ground we again begin with glazes, often in watercolour, and finish with the brightest white impastos in order to attain tonal depth and the opaque lustre of the colours. This mode of building up the colour layer gave rise to the combined technique of watercolour and gouache (or 'body colour') in which whites and local colour are applied to a watercolour underpainting, giving the painting luminosity and depth. This was a very popular technique with miniaturists of the 18th and 19th centuries.

Gouache can also be combined with pastel. The simplest way to do this is to mix ground-up pastels with a gouache binder, Such combinations bring interesting results, at the same time securing the characteristic structure of pastels.

Gouache painting is done with the same type of hair brushes that are used for watercolours, sable in particular; large bristle brushes can be used too, particularly for large paintings or mural paintings.

Fixing and Hanging

Gouache can be fixed with very thin pastel fixatives. Care should be taken to avoid over-fixing, as the surface then loses its luminosity and structure.

Pictures should be protected against dust by framing and glazing. If the picture is to be hung in a room that is not centrally heated precaution should be taken against the capillary action of damp and condensation — allow a gap between the frame and wall by inserting a spacer.

Tempera

Principles and Historical Development

The term tempera encompasses all paints in which pigments are bound by emulsive binders. It derives from the Italian word *temperare,* meaning to mingle, which characterizes the substance of this technique — the use of a mixed, or emulsive binder. Emulsive binders, and emulsions as such, are subdivided into two types: 1/ oil dispersed in water (emulsion thinned with water); 2/ water dispersed in oil (emulsion thinned with solvents). Though both are used in tempera, the oil-in-water type is more common, for it is easier to work with. Such emulsions can be applied in a sharp, linear brushstroke, and they are easier to handle than the greasy tempera of the water-in-oil type. Water-thinned tempera colours have the advantage of becoming waterproof when dry.

The technique of tempera painting is very old, it was known in ancient Egypt, and is mentioned in all classical sources on the history of the techniques of painting. The finding that aqueous emulsions dry to a waterproof finish widened the use of the medium considerably, especially because egg yolk could be used in it as a natural emulsifier, which significantly simplified the preparation of emulsive binders.

According to ancient Byzantine records, tempera dominated the other techniques of panel painting, and its strong traditions endured in the Russian art of icon painting. Used in the 'alla prima' technique of the primitives of Italian trecento, tempera techniques developed to attain the finesse of an optically complex build-up of the colour layer, manifested by the panel painting in central and western Europe as far back as the 14th century. In the 15th century, tempera began to be used in the 'mixed' or 'combined' technique which ushered in the slow transition to oil painting, which became established at the beginning of the 16th century. In the Renaissance, tempera asserted its place as a medium in mural painting, decorative painting, and in (by then technically old-fashioned) panel painting. It was not rediscovered until the 18th century, when its technical qualities were used for mural painting. In the 19th century, tempera re-emerged as a technique in its own right, popularized by the quick-drying quality of the paint to matt colour film, and meeting the needs of monumental painting in a historicist style. It has been revived again in the 20th century, as can be seen in the work of the American artist, Andrew Wyeth (born 1917).

38
Preparation of a wooden support for a panel painting: fixing with dowels

39
Preparation of a wooden support for a panel painting: strengthening with battens

Supports and Grounds

The original support for tempera was wood. Painters of antiquity and ancient Egypt used sycamore and cedar, Italian trecentists used poplar, walnut and chestnut as well as pine. In northern Italy and Germany they mainly used oak and pear, and only rarely beech, lime, or the wood of coniferous trees. In Holland, it was oak, pear, and poplar, while in England, oak and wood of coniferous trees. Wooden boards were made up of 3—5 mm-thick planks held together by pegs or battens; their painting surface was first made even by planing and then by sanding to a smooth finish. Artists' guilds ruled that only the dry, at least 5-year-old wood of trees cut in winter should be used for their important customers. To prevent the contraction and expansion of the material due to fluctuations in humidity, it was coated with parchment or linen or both, and these provided the substrate for a ground. Later, supports for tempera came to include paper, cloth, plaster, and nowadays, also fibreboard and plywood.

The classical ground for tempera was gypsum in glue, or chalk in glue. In the 14th century, the time of the flowering of tempera, artists devoted great attention to its preparation. Apprentices would specialize in preparing the boards for painting. The linen-coated board was first primed with a wash of grey chalk and size. When dry, the surface was rasped with a dried fish skin. This priming was then repeatedly overlaid with washes of pure chalk until the surface became uniform and could be polished. The perfectly smooth surface was then insulated with a coat of size or a pure, very thin layer of tempera emulsion. This adjusted the absorbency of the chalk ground so as to prevent the paint from penetrating the ground too deeply, and at the same time would give it better adhesion. This insulation was then primed, often in two layers.

40
Frans Franken (1542—1616)
Wing of the Family Altarpiece
Tempera on sized gesso spruce support, using blended brushstrokes, 1030 × 420 mm

A brilliant white chalk or gypsum ground (gesso) was of great importance for a painting executed in translucent to transparent colours; also important was thin priming. Italian trecentists also employed the technique of modelling the backgrounds with haloes, edging and overall patterns, incised and built up from the gesso. These areas were covered with gold leaf or with silver or tin foil coated with gold lake; they too were given an oil or resin-based tempera emulsion.

White grounds are still in use in modern tempera painting if it is executed in the traditional way on a wooden support. However, today it is more common to use chipboard, plywood panels, and linen. Linen, however, requires an elastic, sized, semi-chalky ground. Most suitable for this purpose are chalk and casein grounds, further hardened with an alum admixture. As long as the usual glue-chalk ground is used, this is hardened by spraying with a 4-per cent water solution of formalin. It is also possible to use a chalk ground bound by dispersed synthetic resins, which ensure the optimum elasticity of the layer and a lasting resistance to water.

A recipe for the preparation of a glue-chalk ground (according to the Bohemian artist Bohuslav Slánský):

Put 50 g of the purest (edible) gelatine (or 60 g of glue) into 1 litre of water; as soon as the mixture has swelled, heat it over a water bath to about 50 °C so that the gelatine dissolves. Never allow the gelatine to boil. Clean the surface of the board with glass paper or pumice and score criss-cross grooves on it with a sharp point. Then coat both sides of the board with the gelatine water and allow it to dry.

Glue a piece of linen to the painting surface — most appropriate is a thin, loosely woven and pre-washed piece of linen. First, dip the linen in the warm gelatine water or size (prepared from double the quantity of the gelatine or glue used for binding the chalk), and while it is warm, attach it to the board and smooth it on by hand. When it is completely dry, and not before two days, coat it with a primer of the following composition: 2 parts by volume of French chalk, 1 part by

volume of gelatine water (prepared in the way described above). After having thoroughly stirred the mixture (to prevent the formation of chalk clusters), filter it and, after it has cooled off, apply it to the surface with a broad bristle brush. After the first coat has set, apply the second one in a perpendicular direction to the brush strokes of the initial coating. Repeat to create a layer of about 1 mm, thick enough for safe grinding down. French chalk can be replaced by slaked whiting which, however, is more difficult to grind because it is softer in texture and tends to smear.

A chipboard or plywood support should be coated with a thin white ground using titanium or zinc white after the surface has been sized. To prepare the ground, you need:

1 part by weight of titanium or zinc white
1.5 parts by weight of chalk
2 parts by weight of gelatine water

If the ground has been carefully prepared, the surface does not need to be rubbed. It is also possible to use commercial emulsion paint (latex), which has been diluted with an equal quantity of water and mixed with chalk (15 per cent of the volume). Such grounds adhere well even to smooth and particularly impermeable supports.

A linen support should be coated with an elastic ground — either the glue-based one, already described, to which about 15 per cent glycerine should be added for greater plasticity, or an emulsive one, prepared in the following way:

2 parts by volume of chalk
2 parts by volume of zinc white
2 parts by volume of size or gelatine water
1/4 to 1/2 part by volume of linseed or polymer oil
a minute admixture of a siccative

The mixture must be stirred well. The ground is applied to the previously sized linen with a broad, flat brush or a palette knife. The ground's absorbency can also be adjusted by means of additional priming.

41
A Russian master (1st half of 15th century)
The Saviour among Deities
Tempera on wood, 190 × 155 mm

Pigments and Emulsions

In tempera painting all the known pigments and natural dyestuffs (lakes) can be used. The only exception to this is that the highly concentrated alkaline emulsions, such as casein emulsions, are incompatible with pigments affected by alkalis. Such pigments include, for example: chrome green, chrome yellow, cobalt yellow, crimson lake, emerald green, Indian yellow, Naples yellow, sap green and manganese violet (permanent violet).

Tempera colours are prepared by mixing pigment powder with the chosen emulsion binder. To facilitate its binding action, pigments should first be mixed to a paste. Aqueous pigment pastes, unlike commercial tempera colours, can be stored for a long time without any risk of drying or mould formation. For those who often use this medium, it is preferable to prepare their own colours because even top quality commercial colours have a limited lifespan and they incorporate considerable quantities that exceed the requirement of the artist. They are not readily thinned with water either, while a greasy colour layer distorts the optical properties, more like those of oil paint.

The classical tempera medium normally requires emulsions of the oil-in-water type, that is, oleous or resinous substances dispersed in water. As long as the quantity of oil in the emulsion is below the critical value, it is readily thinned with water and its prevailing qualities are the same as those of all water-thinned colours. The only role that oleous or resinous ingredients play is that of lending colours greater elasticity and adhesive power after the evaporation of the water. A tempera medium with a small oil or resin content is very stable and does not change its optical properties for years — proof of this survives in medieval panel paintings.

Water-in-oil emulsions can also be used. These have a greater content of oleous and resinous binders, but cannot be thinned with water — instead, they are thinned with turpentine. Such emulsions give the medium the properties of oil colours, along with their drawbacks: the colour layer lacks hiding power and darkens, often producing a patchy effect of glistening and dull areas, and its transparency decreases. Nonetheless, such emulsions apparently played an important part in efforts to improve the mixed technique in the 15th century; later at the end of the 19th and the beginning of the 20th centuries, they were employed in monumental painting, but were soon abandoned due to their disadvantages.

Egg-yolk and casein tempera emulsions possess properties superior to other tempera emulsions:

Egg-yolk tempera
3 parts by volume of egg yolk
1.5 parts by volume of poppy oil
1 part by volume of water
1 part by volume of gum arabic solution
(1:1 in water)
Stir the yolk with a hard bristle brush, add to it the oil, water and gum arabic by drops.

Egg tempera
3 whole eggs
1.5 parts of polymer oil
0.25 part of glycerine
(one egg is counted as one part by volume)

42
Boards fixed within a frame in a Gothic panel painting. The frame was an integral part of a painting, both technically and artistically

43
Hieronymus Bosch (1450—1516)
The Temptation of St Anthony
Tempera on wood, 700 × 1150 mm

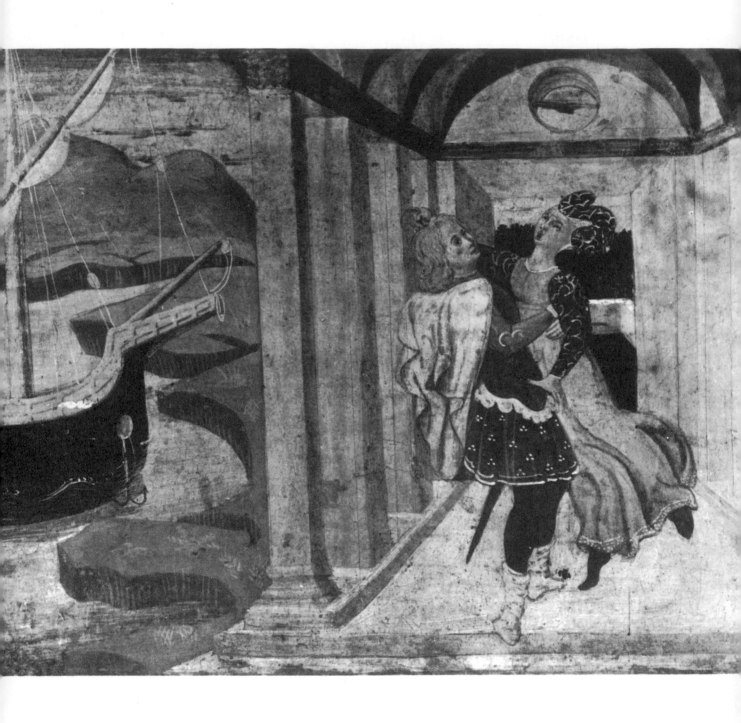

44
Apollonio di Giovanni (14th century)
The Abduction of Helen
Tempera on wood, 340 × 410 mm
The preparatory drawing is obvious on the gypsum
ground

45
Cosimo Rosselli (1439—1507)
St Catherine
Tempera on gypsum ground, 530 × 270 mm
Broken brushstroke is used, characteristic of the early
period of panel painting in Italy

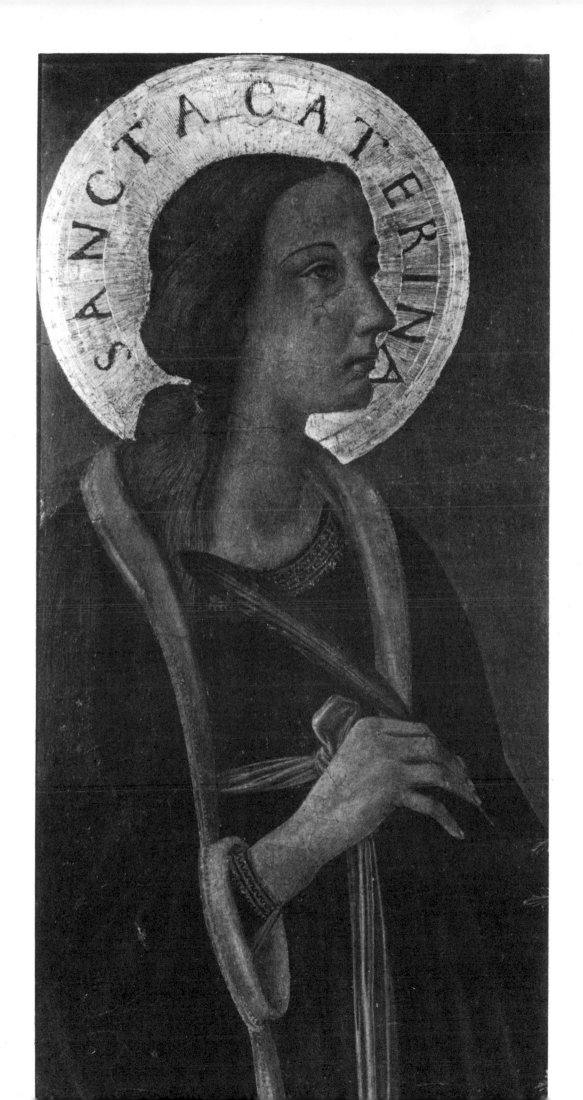

A binder for mural tempera

1 egg yolk
½ to 2 egg shells of linseed or poppy oil
3 parts by volume (3 egg shells) of a weak
saponaceous solution
7 parts by volume of thinned vinegar

The egg shell is an old measure for preparing
tempera emulsions, it is a simple means of
obtaining equal proportions of ingredients
with respect to the volume of yolk: half of
the egg shell equals one yolk.

Casein tempera with oil

100 parts by weight of casein
250 parts by weight of water
8 parts by weight of ammonia
50 parts by weight of poppy oil

After emulsification, add 300–500 parts by
weight of water. Allow the casein to dissolve
in the water, containing the ammonia, then
add the oil, constantly stirring the mixture.
The resultant emulsion can be further thinned
with water to achieve the desired density.

Casein-beeswax tempera with resin

Mix 10 parts by weight of mastic (1 part of
mastic and 3 parts of French turpentine),
with 8 parts by weight of finely divided
beeswax dissolved in a minute quantity of
turpentine, 10 parts by weight of a casein
solution, and 10 parts by weight of distilled
water.

Beeswax tempera with egg yolk

Mix 2 parts by volume of beeswax (dis-
solved in French turpentine in the propor-
tion of 1 : 2) with 3 parts of egg yolk. Then
thin the mixture by slowly adding distilled
water (its ultimate quantity should equal 2
parts by volume).

Starch tempera

Mix 100 g potato starch in 2000 ml of wa-
ter and add 10 g of nitrogen hydroxide.
Warm it up in a water bath. As soon as the
starch has dissolved, add 50 g of Venice
balsam and 50 g of linseed oil, constantly
stirring the mixture. The emulsion can be
further thinned according to requirements
by the addition of 1000 ml of water. Due to

the alkaline character of the emulsion,
choose suitable pigments.

Mixing a pigment with a tempera binder,
use only as much binder as is necessary for
the paint not to be 'short' and to readily leave
the brush. It has to be borne in mind that an
excessive amount of binder causes darkening
of pigments in the colour layer and often
cracking and separation of the colour layer
from the ground.

Doerner mentions a recipe for a tempera
binder composed of egg white and alum.
This binder must be very old in origin, for this
compound was commonly used in medieval
book illumination. The binder is prepared in
the following way: dissolve 1 part of alum in
10 parts of water and add egg white in the
quantity corresponding to a quarter of the
total volume. The mixture can also be emulsi-
fied by the addition of oil or dammar resin. It
is recommended to harden the colour layer
with formalin, because the egg white can still
be affected by water. If alum is used, ultramar-
ine must be replaced by cobalt blue, for alum
makes the medium acid, and in an acid medi-
um ultramarine changes its hue.

Undoubtedly the recipe for a tempera
emulsion based on cherry-tree gum is also of
medieval origin. It is prepared by adding to
an egg yolk tempera a solution of cherry-tree
gum thinned with water in the proportion of
1 : 20, and dammar or mastic varnish in the
quantity corresponding to a tenth of the total
volume. Although this tempera has only
a moderate adhesive power, the colour layer
remains light, similar to gouache.

So much depends on the quality of the ma-
terial used, so first experiment with these re-
cipes. An indication of the consistency of an
emulsion can be seen in its application to
paper and linen both in washes and impasto.
A properly made emulsion will retain its oil
and not result in greasy margins; similarly,
the oil must not separate from the emulsion
in long storage. To avoid trouble, it is recom-
mended to paint in freshly prepared colours.

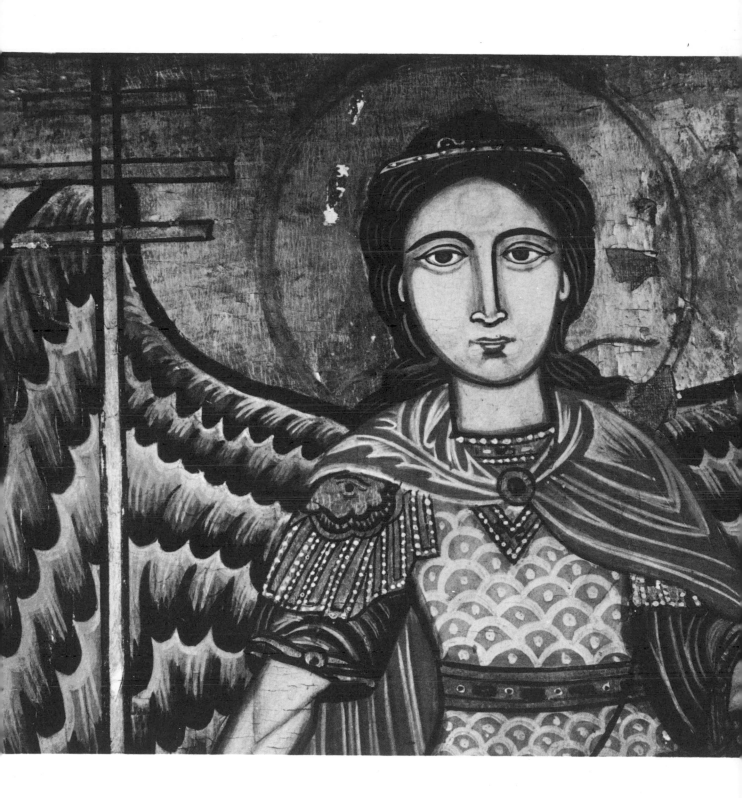

46
Artist unknown (18th century)
St Michael
Byzantine tempera technique on canvas,
460 × 310 mm

47
Master Theodoric (active *c.* 1360)
St Elizabeth
Tempera on wood, 1140 × 900 mm
X-ray picture
An early example of free brushstroke and soft
modelling with visible brush marks

Painting Techniques

Palettes suitable for tempera are white ena-
melled ones with indentations for the pre-
pared colours. Rounded bristle brushes are
used for underpainting and local tones, while
fine, sable hair brushes are used for short and
fine brushstrokes of a more detailed charac-
ter. The palette and brushes must always be
kept in order and after use they should al-
ways be cleaned immediately with water, be-
cause nothing will remove hardened tempera
colours completely after they have dried. Ir-
reparable damage can be caused to brushes
and the surface of the palette by belated,
over-vigorous cleaning.

When building up a painting using tradi-
tional techniques, it is best to respect the his-
torical process — to execute the drawing in
ink or grey colour on a chalk and size ground,
to prime appropriate areas in a warm brown,
and to underpaint the whole area. Then move
on to modelling by adding highlights and, fi-
nally, complete the shadows in transparent
washes and apply the sharpest whites.

50 →
Master of the Třeboň Altarpiece
(active before 1400)
Crucifixion
Tempera, 1255 × 950 mm
Preliminary drawing
A thick chalky ground on canvas, stretched across
a pine board

48
Composition of a colour layer on a Byzantine icon:
1 support (board), **2** canvas or parchment coat, **3** sized
gesso ground, **4** proplasmos (olive shade), **5** glycasmos
(a flesh shade), **6** sarca (pink), **7** lights (white), **8** drying
oil varnish

49
Example of the composition of complexion colours in
a Gothic panel painting (Master of the Třeboň
Altarpiece, *St Catherine*):
1 chalk ground, **2** white lead, **3** mixture of white and
vermilion

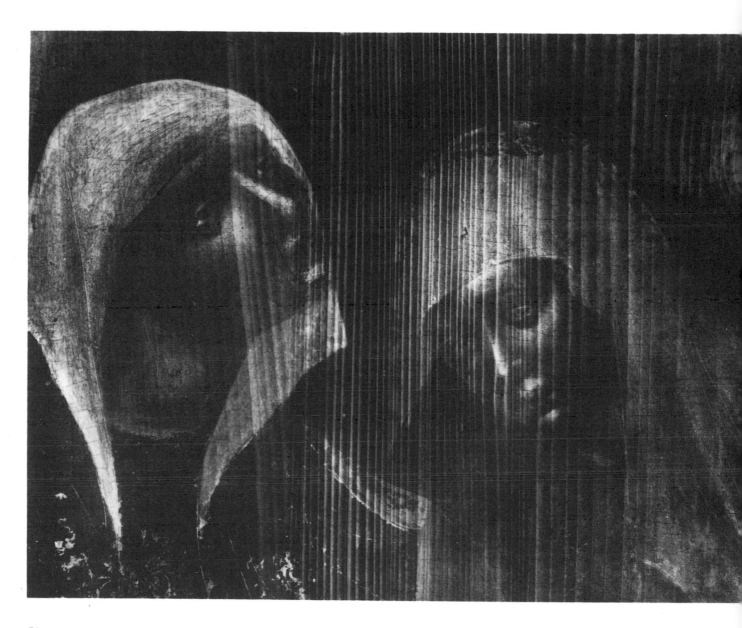

51
Example of the composition of complexion colours in a Gothic panel painting (Master of the Třeboň Altarpiece, *The Crucifixion*):
1 chalk ground, **2** preliminary drawing in red, **3** white, **4** yellow-brown to olive glaze, **5** complexion lights, **6** complexion darks in shadow modelling (mixture of white and vermilion)

52
Example of the composition of complexion colours in a classical Central European panel painting (Vyšehrad *Madonna*):
1 siliceous ground, **2** underpainting in brown-red, **3** white lead, **4** underpainting in brown-green, **5** mixture of white and vermilion

53
Folk-art wardrobe
Bohemia (18th century)
Glue tempera

54
The coffin of Ameun Pentahuthes, the temple attendant
(Egypt, 21st dynasty)
Tempera on sycamore, length 1830 mm

55
Mogul painting
India (17th century)

56
Artist unknown (early 19th century)
Folk painting on paper
Gouache, 370 × 230 mm

76

57
Josef Navrátil (1798—1865)
The Singer Grosserová as Norma
Gouache on paper, 205 × 175 mm

58
Josef Navrátil (1798—1865)
Detail of the decoration of the castle at Jirny
Combined technique, using mainly gouache with a free
brushstroke

59
Egon Schiele (1890—1918)
Still Life with Flowers
Tempera, 260 × 320 mm

60
Jan Kratochvíl (1941)
Too Small a Bridegroom
Tempera, 1500 × 1000 mm

The original tempera technique must have relied upon the partial solubility of the underlying layers, for modelling was carried out by fine hatching, which can be seen in the paintings of Italian trecentists, especially by those of the Tuscan and Sienese schools.

It is important to respect the fundamental principle of classical tempera — namely, the layer by layer build-up of a painting. Tempera colours cannot be blended into one another because of the rapid rate of drying. This makes gradual modelling in tempera a very difficult matter; it is carried out either by hatching or through highlighting on the local tone or directly on the tinted priming. To en-

hance the luminosity of the painting, modelling may be executed in transparent washes applied onto intermediate layers of sealant (usually gelatine, hardened with alum). For this purpose, Doerner recommends using shellac saponified with borax (100 g of shellac powder and 50 g of borax allowed to swell in 1 litre of water and heated until completely dissolved). The preparation can further be thinned with water or alcohol. He recommends that this layer is applied before the final varnishing of a completed and perfectly dry painting. The varnish must be very thin in order to form a fine coating.

In tempera painting loose, dry colour layers are overlaid with greasier ones — this is why priming and underpainting must be very thin. Russian icon painters invariably followed this rule, they painted in colours in which pigment particles were loosely bound by a thin egg yolk binder incorporating an admixture of dextrin. This enabled them to obtain a highly transparent colour layer, very much of a watercolour character, which they lavishly varnished with bleached drying oil. Although their paintings darkened on ageing, the varnish-protected colour layers remain light and intact. When painting on gold leaf, they always used emulsions with an alum admixture; fresh tints were painted in the Byzantine tradition, which prescribed underpainting in a natural grey (*proplasmos* in Greek, or what Cennini calls *verdacci*). On these areas forms were modelled in successive light and dark tones, with the edges of each consecutive tone vanishing into the preceding one. In this way they achieved subtle transitions which were otherwise hard to attain.

A combination of three successively applied light and warm flesh tones was called *glykasmos*. Final touches in modelling were applied in a paint with a large addition of white, or in pure white only. In the past, temperas used to be richly varnished. In contrast, modern tempera gives preference to a pleasant matt appearance which is achieved with the help of aerosol matt varnishes. Pictures in tempera may also be varnished with a thinned solution of dammar or mastic resin in turpentine.

61
Miroslava Zychová (1937)
The Coat
Tempera in splatter technique, 1200 × 820 mm

Oil

Principles and Historical Development

The origin of oil painting is rather obscure. Some sources from antiquity relate that artists of that period were aware of the properties of drying oils and their application in the preparation of oleous and oleo-resinous varnishes. The major medieval recipe books, *Mappae Clavicula* and that by Heraclius, both refer to colour in which pigment particles were bound by oil and used for special purposes, such as painting on stone, or for decorating shields, and the like. They specifically mention in this connection the use of linseed or walnut oil. Cennini comments on the popularity of the oil technique north of the Alps. Although his recipe book dates from the end of the 14th century, it is understood that the technique of oil painting was developed in these areas much earlier.

In a manuscript of the French monk Pierre de Saint-Aumemar, an assessment of pigments suitable for painting especially recommends tempera binder for mural painting, and oil binder for painting on wood. Oil painting developed from a 'mixed' or 'combined' technique — its use in the second half of the 14th century can be proved, and some of van Eyck's paintings provide evidence of his mastery of this technique. The mixed technique stemmed from tempera, but made a much wider use of oleo-resinous varnishes and glazes, particularly for priming, intermediate layers, top glazes, and for achieving the effect of depth in local tones. However, the tempera emulsions did not meet all the requirements, and there was a need for non-aqueous mediums and diluents. Although we do not know what sort of diluent was used by van Eyck, it is turpentine that should be credited for the development of oil painting. Evidence of this is offered by the then popular *pittura lucida* — painting on metallic foil (gold, silver, or tin) which was employed for decorating reliefs, sculptures, altarpieces, and picture frames; these necessitated the application of oil or oleo-resinous varnishes, because the effect of transparency they created was superior to that of normal tempera. However, it took quite some time for the oil technique to develop into an independent painting method. Tradition has it that around 1475 Antonello da Messina brought this Flemish technique to Italy, where it was elaborated by the keen experimenter Leonardo da Vinci and other Florentine painters. The combined and tempera techniques were commonly practised in Europe up until the end of the 16th century. The merits of oil were not revealed until the loosening up of technique came in the wake of fresh approaches to style. The advantages of painting wet on wet, of easily achieved smooth transitions, and of virtually unrestricted ways of building up the colour layer were immediately appreciated by such great exponents of the Renaissance as Correggio, Giorgione, Titian, El Greco, and others. With the advent of Mannerism, a new way of working developed in oil painting — that of modelling through highlighting on dark grounds and completing a painting in a series of glazes overlaid with a finishing varnish. The principle lasted into the 18th century. Many artists contributed their own findings to oil painting, and there were many who experimented with it tirelessly, often for their entire lifetime. It took a long time for artists to loosen up their brushstroke technique, to really explore the limits of oil painting. At first, artists kept to blended brushstrokes, obliterating the brushmarks on completing the picture by using very fine, badger or squirrel-hair brushes. In so doing they further refined and softened colour transitions, giving the painted area a uniform appearance, and only retouching lights and darks in conclusion. Credit for breaking away from the tradition and for developing a freer handling of paint rests with two great personalities of 17th-century painting, Frans Hals and Rembrandt van Rijn.

62
Petr Brandl (1668—1735)
St Paul
Oil on canvas, 915 × 742 mm

63
Petr Brandl (1668—1735)
St Simeon with the Christ Child
Oil on canvas, 780 × 800 mm

64
Petr Brandl (1668—1735)
St Simeon with the Christ Child, detail
Oil on canvas, 780 × 800 mm
The X-ray photograph reveals a fast and nervous
modelling of the lower layer of complexion colour in an
expressive, broken brushstroke

63
Petr Brandl (1668—1735)
St Simeon with the Christ Child
Oil on canvas, 780 × 800 mm

Supports

Owing to the adhesive power of oil binders, oil painting can be executed on practically any support. Furthermore, the high elasticity of the colour layer helps to reduce the damaging effect of the warping which is characteristic of some support materials, mainly wood.

Boards

Wooden supports were used for a long time in oil painting — especially oak panels in Flemish and Dutch painting — they gave a compact, firm and lasting material. Most suitable were panels made from the planks of wrecked ships or parts of sluice gates and bridges. It was known that oak wood developed great solidity and stability after exposure to water. Rubens was among those artists who favoured oak panels, even for his largest works; in one of his letters he notes that a wooden support, especially for small pictures, is the most suitable one.

A wooden panel for oil painting is usually prepared by impregnating it with warm or hot drying oil on both sides in order to curb the adverse effect of humidity and to stabilize the wood. (What actually happens is that the cells are destroyed as the hot oil contacts the water contained in them and, as a result, the wood's swelling capacity drops.) The polymerized oil gradually fills in the pores, substantially curbing both evaporization and absorption of moisture. Panels should be cut from the inner part of the trunk where there is little tendency to warp; boards obtained by tangential cuts (plain-sawed) have a strong tendency to develop one-sided arching.

Slots are usually made on the back of a panel for battens which prevent the warping of the panel caused by fluctuations in humidity. The very thick boards used for Russian icons have deep-set battens, unless the board is cut from a single piece of wood (for small icons). The battens have to be movable and should be positioned perpendicularly to the fibres of the wood so as to prevent shrinkage, which is strongest in this direction. Thin panels can also be strengthened by fixing a wooden lattice or cradle to the back; the fixed planks run parallel to the board's fibres and perpendicular movable planks are set in notches cut in the fixed planks. Instead of wooden planks bronze or aluminium bars can be used. Their expansion should be closer to the degree of the board's change in volume. This type is more often used in the restoration of damaged panel paintings. However, it should be noted that even the most ingenious devices cannot ward off warpage of wooden panels in extreme conditions. It is wiser, therefore, to be careful when choosing wood, avoiding fresh wood and assembling panels exclusively from used but intact planks, such as old beams and building materials.

To protect the ground and colour layer from the harmful effect of shrinkage and expansion it is wise to glue a canvas covering to the panel, also because canvas accepts a ground more readily. The canvas for such a coating must be loosely woven but firm, and it may be glued to the surface with an acrylic emulsion, now often used instead of size. Solid wood is seldom used for large-scale works.

A thin sheet of plywood, strengthened with battening is a good support, and is also successful with an additional canvas layer; blockboard and thick chipboard are both heavy, and chipboard tends to be affected by the moisture in the atmosphere; hardboard is a useful surface (both sides can be used); composition board is light and gives a good surface to work on.

Canvas

There is little surviving evidence of painting on canvas in Europe before the 15th century, although it is known that a tradition exists of painting on fabric which goes back to ancient Egypt. Its availability and popularity grew rapidly in the 19th century with the invention of mechanical looms for the mass-production of large canvases.

Pure linen canvas is the most suitable for painting. A mixed-fibre canvas of linen with cotton tends to shrink unevenly, due to the different nature of the materials. Canvas of hemp or jute can be used for large paintings;

it has a pronounced texture, but its life expectancy is not great. Cotton is very white and very absorbent, but it tends to stretch; use the heavier weight. The weave should be very even and free from flecks; it should not be bleached as this affects the paint layer.

It is in the nature of canvas to stretch and shrink when affected by moisture, but there is no advantage to pre-washing, or dampening the canvas before it is prepared as it will continue to react in the same way.

Stretching Canvas

The canvas is stretched over a wooden frame, or 'canvas stretcher'; it should overlap the frame by at least 3 cm on each side. Mark the warp and the weft at the edges of the canvas and put the same marks on the back of the frame so that the warp and the weft are parallel to the edges of the frame — otherwise there will be problems during stretching. First, carry out provisional stretching and fix it with drawing pins. Coat it with size and, when dry, with an initial layer of glue and chalk ground. Never treat the canvas with oil or drying oil, for the intensive oxidation that accompanies the drying of unsaturated oils can impair it. The insulation given by the size is important. The final stretching is done only

65
A 'blind' frame with wedges

after the first coats have dried, because as they turn dry, the canvas slackens. Make sure that the parts of the frame are fitted together tightly at right angles and start stretching the canvas at opposing points, beginning at the middle of the longest side and proceeding to the corners; use canvas pliers with the broad, flat jaws. It will take two people to stretch a large canvas. Instead of nails, the canvas is fixed with staples from a staple gun. The stretcher frame must have wedges (a feature that has been around since the 18th century) to enable the canvas to be tightened if it slackens due to climatic changes. In order to prevent the inner edges of the stretcher bars from protruding through the stretched canvas and possibly harming the colour layer, the front side of the frame must have bevelled edges. The canvas is then covered with an appropriate ground on which to paint.

Fibreboard sheets with canvas glued to them either with glue, or starch, or an emulsion adhesive can be used. These help the canvas preserve its structure, which is of importance in painting, and they lend it stability, making the painstaking job of stretching unnecessary. The size and weight of the fibreboard sheet should always be strong enough to support the size of the canvas. Thus, thin masonite boards must be cradled. Such supports guarantee long-term stability.

Ready-primed canvas can be purchased, but it tends to be a little more difficult to stretch onto a frame as it is less flexible. It is a good general-purpose surface.

Metallic supports

Painting on metal supports has been known since the 17th century, though there are even older examples (some museums of armour exhibit items from the second half of the 16th century with decorative paintings of ornaments and images on them). Today, it may be used for signs billboards and for commemorative and heraldic plaques. Metallic supports appeared to meet the need for perfectly stable supports which would resist the elements. Apart from steel, armour frequently included bronze, later followed by tin and by

66
Domenico Tintoretto (1562—1635)
Crowning with Thorns, detail
Oil on canvas, 1265 × 1120 mm
Modelling is done with a broad brush in bold
downward strokes; the colour is put on in a semi-glaze

67
Domenico Tintoretto (1562—1635)
Crowning with Thorns
Oil on canvas, 1265 × 1120 mm

zinc iron and pure zinc sheets in the 18th and 19th centuries. Copper is the only material whose corrosion does not affect the colour layer of the paint, whereas the corrosion of the other metals listed always destroys it. Generally, metallic supports do not hold the colour layer well enough due to their expansion and contraction in different atmospheric conditions, resulting in cracks and flaking of even the most elastic colour layers.

Although copper reacts with varnishes which contain unsaturated fatty acids and forms resinates which ensure the adhesion of the paint film to the metal, at the same time the resinates bring about the uniform darkening of the painting. For all that, old paintings on copper are now in relatively better condition than those on the other types of metallic supports. Copper needs no special preparation before painting, except for several coatings of zinc white which protects the plate from the resinates already mentioned.

Sheet iron is least suitable for painting. But if used, it must first be thoroughly prepared with phosphatizing salts which form minute phosphate crystals and so prevent corrosion. This is then overlaid with a coating of partially burnt-in varnish (the varnish should not be overheated). After this layer has dried, it is coated with a layer of white oil colour to provide the ground for painting.

Aluminium has recently been discovered as a fairly stable and lightweight support; it should be treated chemically or sandblasted to ensure good adhesion of the ground and paint layer.

Cardboard

In the 19th century cardboard was a popular support for studies and practice. A thick, high-quality material of handmade rag paper, provided with an appropriate impervious coating, cardboard was in fact a very stable support, particularly useful for spontaneous work and sketches in *plein air,* or for portraits. In order to protect the back of a cardboard panel from humidity, it is often lined with loosely woven bookbinder's cloth, and coated with heavily thinned mastic.

Grounds for Boards

Oil painting can be executed on the same kind of chalk and glue ground as tempera, but it requires a more durable sealant than that offered by gelatine — either mastic or dammar varnish, which should be diluted with turpentine in the proportion of 1 : 5.

A fibreboard sheet is usually given a white oil ground prepared from Cremnitz or barites white, which is extended with ready-made paste of titanium white, alabaster plaster, or French chalk in turpentine. The proportions should be approximately 1 : 5. The surface of the support should be given a coat of drying oil or heavily diluted copal lacquer, and when dry, the surface should be rubbed down with fine glass paper or pumice. The ground is then applied to the support and allowed to dry in a warm and dry place. Its surface is then rubbed down with powdered pumice in order to remove the thin oil film that has formed on it. An alternative method is to apply a 15-per cent solution of ammonia with cotton wool. Fibreboard sheets can also be coated with emulsion grounds. Latex can be used, first thickened with plaster or titanium white, and then thinned with water to the point when it spreads readily, while the surface remains matt and absorbent. The support requires two coats of ground — it dries quickly and can be used in a few hours. Before painting, its surface should be lightly rubbed with pumice.

To give a glossy or lustrous coat or 'imprimatura' for underpainting and preparatory modelling a chalk ground is primed with oil or oil-resin. This is prepared by mixing a small quantity of mastic or dammar varnish with oil paint of the required tone, such as umber, green earth or bone black and then by thinning the mixture with turpentine (in the proportion of at least 1 : 3). It is applied in broad sweeps, and any excess should be immediately removed with a soft cotton rag.

Grounds for Canvas

Prior to the application of the ground, the canvas must be sealed, or sized. Take 50 g of

gelatine or glue, dissolve it in 1 litre of water and add 15 g of glycerine. The solution is applied warm with a broad brush. Canvas requires either oil or emulsion grounds.

Oil grounds

 3000 g of white lead or barites
 300 g of polymerized-linseed oil with siccative
 100 g of xylene

The mixture is fairly thick and should rather be spread out with a palette knife as evenly as possible in order to fill in cavities in the

68
Jean-Baptiste Chardin (1699—1779)
Still Life with a Pipe
Oil on canvas, 320 × 420 mm
The underpainting is done in blended brushstrokes; laid down onto it in short brushstrokes is a stratified, fine and uniform impasto

Pigments

canvas. This coating must be allowed to dry thoroughly, which, depending on the thickness of the coat, might mean a wait of up to 20 days. The remaining mixture for the ground should be thinned with the xylene and brushed on the surface, using a broad flat brush, to form a thick finishing coat. Since it can take many months for the second coat to dry out, it is recommended that several canvases are prepared at the same time.

Emulsive oil ground:
- 2 parts by volume of chalk
- 2 parts by volume of zinc white
- 2 parts by volume of gelatine water with glycerine
- 1.5 parts by volume of linseed oil or polymerized oil
- a small quantity of cobalt siccative

It is very elastic but tends to yellow. Apply with a broad brush.

Emulsion grounds

The highly elastic and quick-drying emulsion grounds can also be used on canvas. Preference is usually given to acrylic emulsions as the most stable of all. First, seal the canvas with an aqueous solution of an emulsion, thinned with water in a proportion of 1 : 2. When completely dry, prepare the ground from chalk and an emulsion. Combine 2 parts of chalk with 1 part of titanium white and mix the powder slowly adding water to it to obtain a thick paste; add the emulsion thinned with water in the proportion of 1 to 2 (based on the premise that the concentrated emulsion contains about 40 per cent of dry matter).

The mixture should be finely ground with a spatula or with a pestle and mortar so as to prevent the formation of lumps. Apply it to the surface with a broad brush. It is possible to use an electric blender, but it tends to make the mixture foam — so proceed with caution!

Although all usual artist's pigments can be used in oil painting, regard should be paid to their behaviour in oil as well as to the chemical reaction of some pigments. For instance, chrome and baryte whites react with oil and turn grey. Similarly, Naples yellow should be avoided, for this is unstable and reacts with other pigments. The cadmium yellows are absolutely incompatible with the cupric colours — this is why neither those yellows nor the cupric blues can be used for blending green shades. Alizarin lake retards the drying of oil. Likewise, the traditional brown pigments' behaviour in oil is not fully satisfactory. In contrast, natural dyestuffs, generally referred to as lakes, have proved themselves in oil painting. In oil and especially oleo-resinous binders they give subtle glazes. Two of these dyestuffs, saffron and gamboge, are the traditional materials for making gold lake and gold glaze. They were used as far back as the Middle Ages for imitating gold on silver of tin foil. Indian yellow, an archaic dyestuff, should not be substituted for Indian lake (lac lake) which is essentially a kind of shellac resin. The favourite glaze colours of Dutch and Flemish painters, sap green and buckthorn green, are of vegetable origin as well, while Hooker's green is an artificial mixture of Prussian blue and gamboge. The reds suitable for oil paintings are carmine and madder lake (the natural alizarin dyestuff has now been replaced by artificial alizarin). Recently the natural lakes have been successfully replaced by synthetic organic dyestuffs, particularly those known for their fastness to light and excellent solubility in oils and resins (vat dyestuffs).

69
Rembrandt van Rijn (1606—1669)
Self-portrait
Oil on canvas, 860 × 705 mm
The X-ray photograph shows the underpainting modelled with white lead

TR

93

94

70
Rembrandt van Rijn (1606—1669)
The Annunciation
Oil on canvas, 855 × 675 mm

71
The Virgin Mary in the Temple
Icon in egg tempera on spruce board, 220 × 380 mm

72
Master of the Litoměřice Altarpiece
(active *c.* 1500—1530)
Detail of the decoration of the St Wenceslas Chapel in
St Vitus' Cathedral, Prague
Combined tempera technique

73
Frans Franken (1542—1616)
Wing of the Family Altarpiece, detail
Tempera on sized gesso spruce support, 1030 × 420 mm
Layer upon layer of glaze coats are revealed in the
build-up of this painting

96

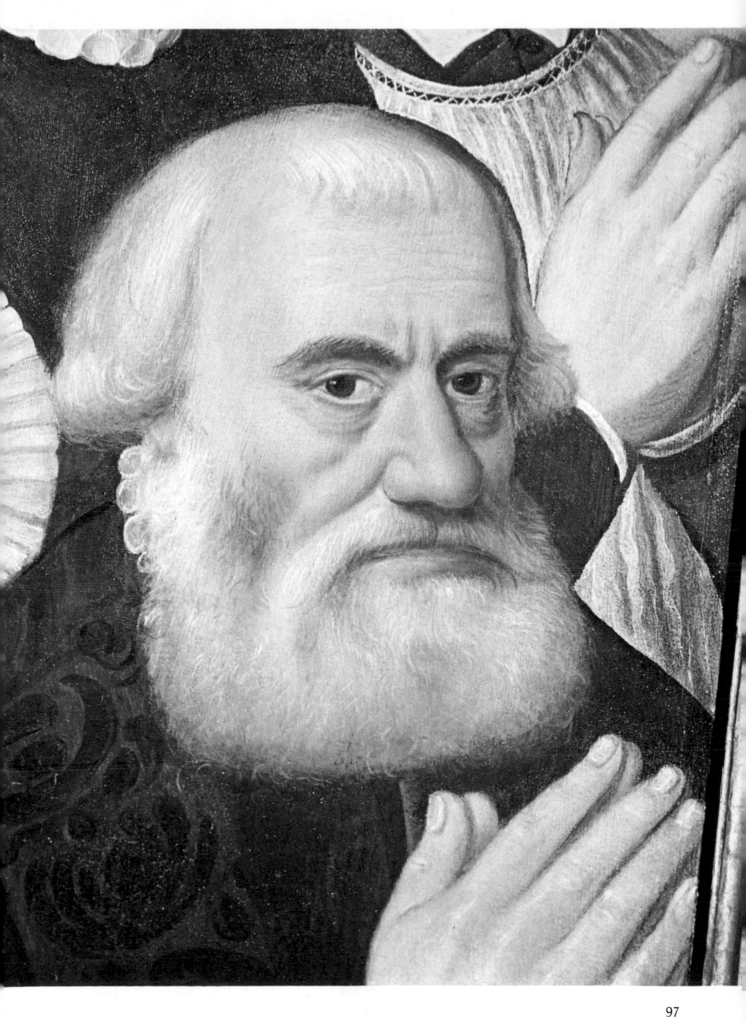

74
Detail of Renaissance ceiling paintings
in Martinic Palace, Prague
Casein tempera on wood

75
Folk-art wardrobe, detail
Bohemia (18th century)
Glue tempera

98

Binders

The basic binder used in the making of oil paints is pure linseed oil which is obtained by pressing the seed of the flax plant. The first pressing of cold-pressed oils is used because this has the highest purity. To be perfectly sure of its quality painters have used small hand-operated presses and produced linseed oil of their own.

The purity of linseed oil has always been a matter of particular importance to painters as is suggested by a number of surviving old recipes for purifying linseed oil with salt water, by exposing it to sunlight, or to cold, and so on.

The simplest way to purify oil is to use water and sunlight: first, mix 2 parts (by volume) of linseed oil with 1 part (by volume) of water in a closed glass vessel and shake well to ensure proper mixing; then put the vessel in sunlight. The water and oil will soon separate and the impurities will start precipitating on the surface between the two liquids. After carefully removing the oil, repeat the procedure as many times as is necessary to free the oil of all impurities. As a result of purification, the oil acquires strong coloration.

Polymerized linseed oil
Obtained through a special process designed to considerably reduce the content of unsaturated fatty acids in linseed oil and thus enhance its stability and limit its tendency to yellow. The oil obtained by this purifying method was known in Holland as far back as the 15th century and was called stand oil. In the past, it used to be prepared by a time-consuming process of heating at 200 °C, while it is now commercially produced by heating in a vacuum. Polymerized oil is colourless, thick, highly stable and, consequently, slow-drying.

Poppy oil
Made from the seeds of the white poppy. This oil is almost colourless or slightly reddish. It is fast to light but forms a soft, readily soluble and slow-drying film. Therefore, it is suitable only for the 'alla prima' technique or as a softener or admixture for some resinous vehicles.

Walnut oil
Obtained from the kernels of walnuts. It has low viscosity and, therefore, readily mixes with pigments. Though slower in drying than linseed oil, it forms an optically stable and rigid film. Walnut oil was held in high esteem, especially in 16th- and 17th-century Italian painting.

76
Typical arrangement of colours on the palette in the 16th and 17th centuries:
1 white lead, 2 light ochre, 3 dark ochre, 4 Naples yellow, 5 English red, 6 umber, 7 black, 8 vermilion, 9 rose madder, 10 green earth, 11 cobalt, 12 dark blue

Mediums

Mediums, or vehicles are added to paint to change its character. The most common medium is a mixture of polymerized oil and copal resin. Unless a proprietary brand is bought, it involves a rather painstaking preparation which can, however, be bypassed by the addition of polymerized oil to thinned copal varnish (2 parts of turpentine and 1 part of varnish). B. Slánský, a Bohemian artist, recommends the following composition for a medium with a normal drying rate:

Melt 3 parts of dammar in 1 part of polymerized oil and thin it with 5—9 parts of turpentine. However, the bad solubility of dammar in oil poses difficulties in preparation. A soft medium can be made by mixing the same proportions of poppy oil and dammar, previously dissolved in 2 parts of turpentine.

The vehicles in which oil colours form glazes increase, for the most part, the shine of the film. Therefore beeswax is sometimes used as an admixture making the film soft and matt. Such a medium can be prepared in the following way: dissolve 3 parts of dammar in 6 parts of turpentine and add 1 part of beeswax dissolved in 3 parts of turpentine. A thick medium of highly resinous mixtures (such as 1 part of beeswax, previously melted and mixed with 3 parts of copal or dammar varnish), can also be made in this way. Since beeswax prolongs drying, this mixture requires a greater amount of siccative, which, however, causes glaze to harden and to darken. Vehicles for glaze pastes can also be prepared as emulsions of gum arabic solution in lacquer or oil. Such vehicles were in great favour in the 19th century, but, due to their disadvantages (considerable coagulability, only enhanced by certain pigments, and a tendency to produce opacity) they cannot be recommended for common use.

Mediums are used to accelerate or retard the drying of the colour layer. Quick-drying mediums are chiefly used to ensure the quick drying of an underpainting or the underlying colour layers of a painting built up in stratified colour layers. A solution of turpentine with an admixture of 0.5 per cent cobalt siccative would be suitable. Admixtures that retard the drying of a painting and would therefore be used in the 'alla prima' technique, are the essential oils, such as lavender oil, oil of spike and clove oil. Added to diluents or to colours on the palette, they retard the drying of the colour layer by up to several days, giving time to paint wet on wet.

There is a group of resinous balsams which improve the flow and adhesion of oleo-resinous lacquers:

Copal balsam — a viscous solution of copal resin; it is a clear, slightly yellowish, highly viscous and very sticky liquid.

Venice balsam — also called Venice turpentine — a thick solution of resin yielded by larch trees.

Strasbourg balsam — also known as Strasbourg turpentine — obtained from silver firs (*Abies pectinata* D. C.) native to Italy; its colour is less strong than that of Venice balsam.

Balsams, due to their high adhesive power and owing to a content of resin in them, are widely used as admixtures to glazes for increasing the shine of the colour layer and for the preparation of adhesive emulsions.

77
Jan Kupecký (1667—1740)
Portrait of Michael Kreisinger
Oil on canvas, 760 × 600 mm
The X-ray photograph testifies to the characteristic brushstroke of this Baroque portraitist

Painting Techniques

The technique of painting on oil includes the following basic methods:
1) Underpainting and overpainting
2) 'Alla prima'
3) Impasto

Underpainting and Overpainting

The classical stratified building up of a painting depends on the careful preparation of the ground and underpainting. The principle to be strictly observed is that the underlying layers must always be drier, or 'leaner' than the superimposed ones.

Start with a preparatory drawing on a dry ground with watercolours or tempera, charcoal, crayons, or ink. Overlay the drawing with broad areas of underpainting, arranging the basic colour pattern of the picture's composition — this is the basis for the future application of local tones.

In the 19th century it was popular to underpaint in monochrome (*grisaille*). This technique was employed by artists as far back as the 16th and 17th centuries to provide an optically active base for semi-glaze oleo-resinous layers with a high refractive index. The contrast between the thick top tones and the transparent intermediate layers increased the tonal depth of the colour layer.

As already mentioned, the underpainting must contain less oil binder than the successive layers of paint. The paint for underpainting should not, however, be thinned with a solvent, for this diminishes the paint's hiding power. It is better to use less oil and to mix white paints, enriched by one eighth of its volume with a pigment powder. Since the layer is lean and, consequently, absorbent, the colours applied to it adhere well, especially if laid in the 'alla prima' technique. Underpainting can also be done with paints thinned with sylene instead of turpentine. The addition of siccative to these will ensure their quick drying to a matt finish. This also has the effect of reducing hiding power and, consequently, has an optical effect on the ground which can be used to advantage, if this is what is required. Tempera is often used for underpainting, but it must be adequately light in tone, because saturated tones would show through the colour layer too strongly. A light tempera underpainting favourably enhances and influences the reflection of light by the colour layer.

The actual painting is then carried out with fluid, binder-rich paints, usually containing an admixture of a resinous lacquers. Artists of the period when panel-painting and blended-brushstroke were in fashion used to grind down the excessively thick and uneven layers

78
Composition of a colour layer for the combined technique:
1 support (canvas), **2** ground, **3** underdrawing,
4 primer, **5** undercoat of lights in white,
6 undercoat of local tones (oleo-resinous binder),
7 finish in egg tempera, **8** wax varnish

79
Francisco de Goya (1746—1828)
Don Miguel de Lardizabal
Oil on canvas, 860 × 650 mm

of underpaintings to a smooth finish. Successive colour layers were also ground down before laying down other colours or glazes. The method of executing an underpainting in a free manner and completing the painting with smoothly blended brushstrokes to obscure brush marks endured well into the Baroque period. Naturally, there were painters who tended to reject this convention. Frans Hals was one of the pioneers of 'broken' brushstroke. In the course of the 17th and 18th centuries the brush technique loosened up, allowing artists to express their creative individuality more freely.

Intermediate Varnishes

In order to observe the principle of painting wet on wet the dry layers of an underpainting should be moistened with intermediate varnishes. These are heavily diluted solutions of resin in turpentine, such as Venice, or Strasbourg balsam thinned with turpentine, which form a sticky intermediate film to prevent, among other things, the soaking of the top layers of paint into an excessively absorbent ground. The use of an oil binder for these varnishes is not recommended because it stimulates the tendency of the colour layer to yellow and darken. Doerner recommends a thinned solution of dammar in petroleum ether. The creation of a painting by building up colour layers is time consuming, but adhering to the correct technical process pays off in the form of a very stable painting: the individual layers have time to dry properly, the painting does not develop cracks caused by the shrinking of the colour layer as the oil dries, and it does not darken. It also achieves the optimum luminosity of the colour layer, giving it better reflective properties.

The 'combined technique', which used to be popular in the past, may also be considered as a form of the old process of building up a painting in successive colour layers. It consists of the combination of a tempera underpainting with oleo-resinous glazes, and an overpainting of numerous thin layers. Normally, a glue and chalk, or gesso ground was primed to a dark tone, using caput mortuum and then coated with ochre. On this, drawing was transferred directly in ink, or by pouncing through a stencil. Initial modelling was done in white egg tempera and then oleo-resinous glazes were gradually applied. The Venetian painters of the Renaissance simplified the technique — they painted directly on a dark ground, or a drawing in white chalk was done on a dark priming and modelling was done with white. The picture was completed with glazes, and these were overlaid with oil layers, or impasto white was applied to increase contrast where necessary.

'Alla prima'

This technique offers the quickest way of painting, enabling a picture to be completed within one day. The ground should be thoroughly prepared, but only a thin light or dark ground should be used, and there is no underpainting. The paints are applied in a single layer, maximum two layers, with or without transitions; the brushstroke is individual. Light modelling should be carried out in the final stages when the most intensive lights and darks are applied. The 'alla prima' technique does not use glazes, colours are blended on the palette and applied directly to the canvas, with final impasto applied only in areas where it is required for modelling. The technique offers a painter great freedom and does not impose technical constraints.

80
Josef Vyleťal (1940)
The Birth of Meditation
Mixed media drawing in brown crayon, washed with sepia, oil glazes lifted with light tones and white, 280 × 210 mm

81
Petra Oriešková (1941)
A Woman with a Fat Thigh
Oil on canvas, 370 × 600 mm

82
Jaroslava Pešicová (1935)
Archimedes
Oil on canvas, 1700 × 1400 mm

Final Varnishes

Impasto

The impasto technique describes the application of thick paint on the surface of the painting. It is built up to give an expressive impact of contrasting colours that are pure and not blended on the palette, enhanced by the effect of light produced by the high relief of the colour layer. It can be applied with a painting knife or with a tough flat brush. This method of painting needs no underpainting and preliminary drawings can also be superfluous. However, the ground has to be primed to prevent the penetration of oil-intensive paints (such as blues and earth green) into it.

The effect of this technique of painting can be emphasized by changing the structure of coloured pastes. A filler such as washed sand or crushed marble can be added to accentuate the texture and to make the relief of the painting's surface more pronounced.

Oil paintings are usually coated with a 'finishing', or 'picture' varnish which both protects and preserves the painting and unifies the overall effect. The character of a varnish must correspond to the technique employed. Dark or dull pictures carried out in the classical layer technique and the combined techniques are usually coated with luminous varnishes which emphasize the depth of the colour layer and the contrasts of light. An 'alla prima' painting with a luminous surface should be coated with a semi-matt varnish, whereas an impasto painting should have a fatty varnish. They all act in their own way to subdue the reflection of light which would otherwise distort colour values.

Varnishing is done with oleo-resinous or resinous varnishes whose shine can be reduced by the addition of 'matting agents' such as beeswax or siloxide (from silicon oxide). The traditional agent, beeswax, softens the

85 →
Stanislav Podhrázský (1920)
The Couple
Oil and synthetic enamel on canvas, 1000 × 700 mm

83
Example of building up complexion tones by Jacopo Tintoretto, *The Adoration of the Shepherds*:
1 gypsum gesso, **2** underpainting in black,
3 underpainting in white, **4** green glaze (copper resinate), **5** light-green layer (mixture of mountain green, smalt, copper resinate and white), **6** ochre glaze, **7** pinks (white, carmine, vermilion, light ochre)

84
Example of the composition of a colour layer by Paolo Veronese, *The Apostles.*
St John's red cloak:
1 gypsum ground, **2** brown oil priming, **3** underpainting (mixture of lead yellow with traces of copper green), **4** colour layer (mixture of vermilion and pozzuoli), **5** red glaze

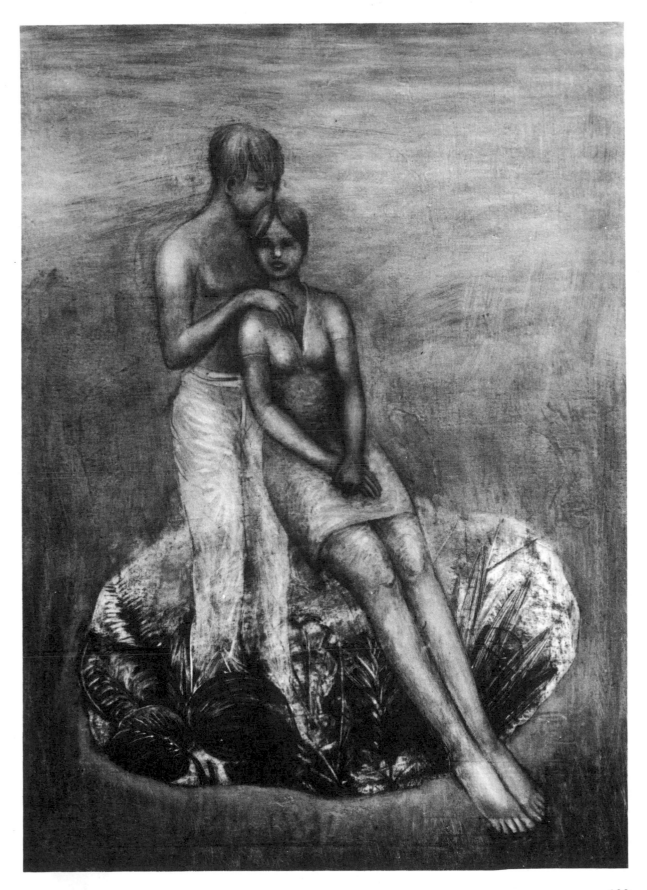

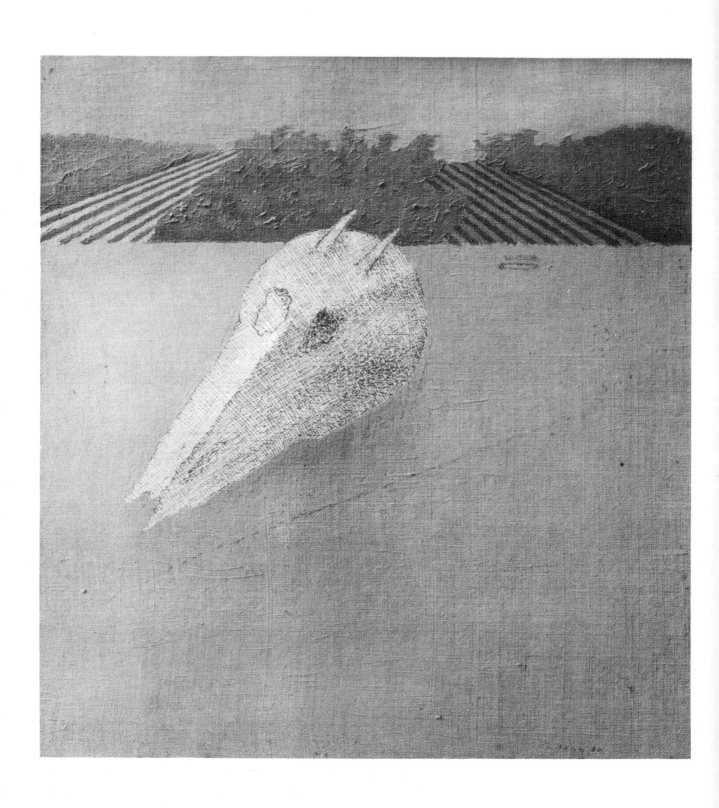

86
Jiří John (1923—1972)
A Skull in the Landscape
Ink combined with thin and impasto oil painting,
260 × 240 mm

87
František Hudeček (1909)
Horror vacui
Oil on canvas, 1160 × 860 mm

110

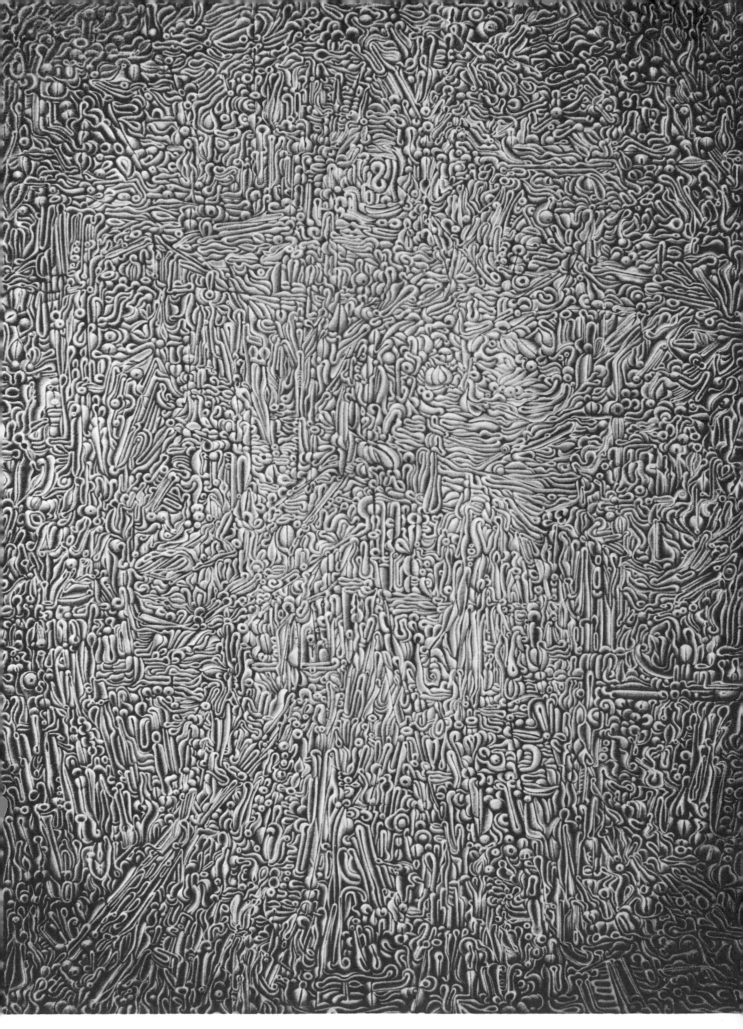

88
Zdeněk Sýkora (1920)
No. 23—30 lines. Method: Random linear systems.
Programme: Texas T 1—59
Oil on canvas, 1700 × 1700 mm

89
Theodor Pištěk (1932)
Tonca Still Life
Oil on canvas, 1000 × 1370 mm

varnish film, therefore siloxide is preferable as it affects only the film's optical quality.

The simplest and most suitable varnish for oil paintings is a solution of dammar in turpentine oil. To prepare this, put pieces of dammar into a small gauze bag and suspend it in a wide-necked vessel with turpentine. Close the vessel tightly and leave in a dark place in a warm room. The dammar will gradually dissolve forming a solution, and its consistency can be adjusted by thinning with turpentine.

To prepare this varnish with an oil admix-

ture, add to the solution 10 per cent polymer-ized oil. The varnish can be combined with beeswax, previously dissolved in turpentine. The additional quantity of beeswax must be very small (15 per cent of the total volume of varnish at most), otherwise the varnish film would be too soft and sticky.

A mixture of dammar with an equal pro-portion of mastic that has been dissolved in turpentine (as described above) can also be used. The mixture produces a varnish which develops a film with a medium lustre.

Synthetic resins with similar properties are also used nowadays for the preparation of varnishes. The most used of the synthetic res-ins has become very stable and readily sol-uble; it is polycyclohexanic resin AW 2, or MS 2, from which varnish can be prepared in the same way as from dammar. Commercial aerosols with semi-lustrous to matt varnishes are available today too. They give a high-quality varnish film that is optically stable.

The traditional way of applying varnish is with a brush, but spray diffusers are used far more often for this purpose. They allow an even application of varnish and do not leave the painting prey to the action of a solvent residue. Varnishes prepared in turpentine and those containing beeswax cannot be sprayed unless they have been diluted more than is necessary to make them brushable.

The usual proportion of resin to diluent is 1 : 4, but for diffusers it is 1 : 5 or 1 : 6. It is advisable to apply varnish in several thin layers rather than in one thick layer. When using a brush, be careful to apply the varn-ish evenly in criss-crossing movements. The brush must be soft and have long hairs so that it does not scratch the colour layer. It is easiest to use an aerosol spray.

Varnishing should be carried out only in a clean and warm room; freshly varnished pictures should be properly protected against dust and left to dry under a cardboard cover, or in a drying cabinet, with the varnished sur-face facing down.

When applying varnish with a brush, air bubbles may get trapped in cavities, especial-ly when varnishing a thin colour layer which does not cover the texture of the canvas.

When the varnish dries these areas take on a glittery appearance, which usually disap-pears after such spots have been moistened. To improve the film, remove the varnish on these areas and re-varnish them.

90
Jan van Eyck (c. 1390—1441)
St Barbara
Oil on canvas, parameters unknown
The unfinished painting on a monochromatic underpainting is partially coated with coloured glaze

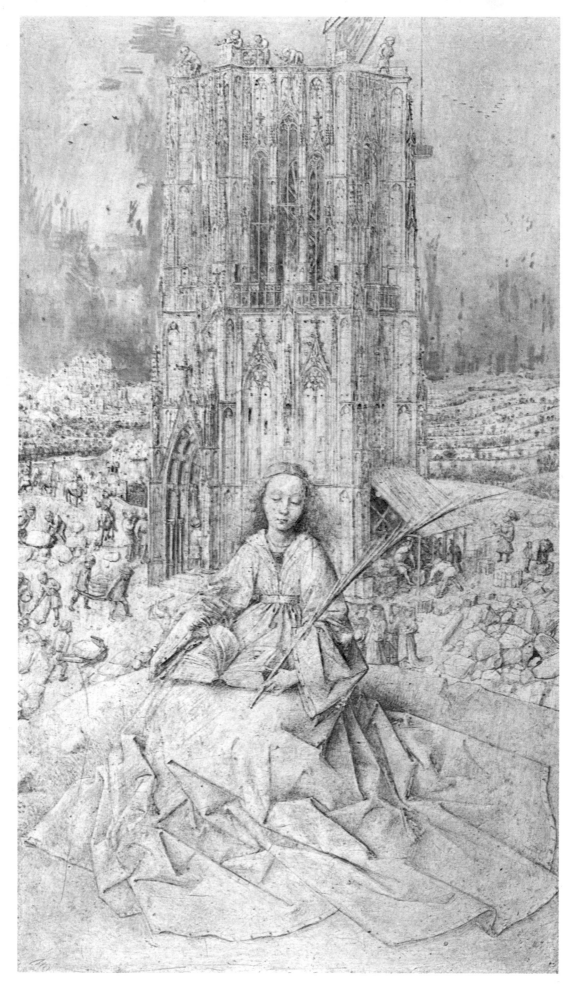

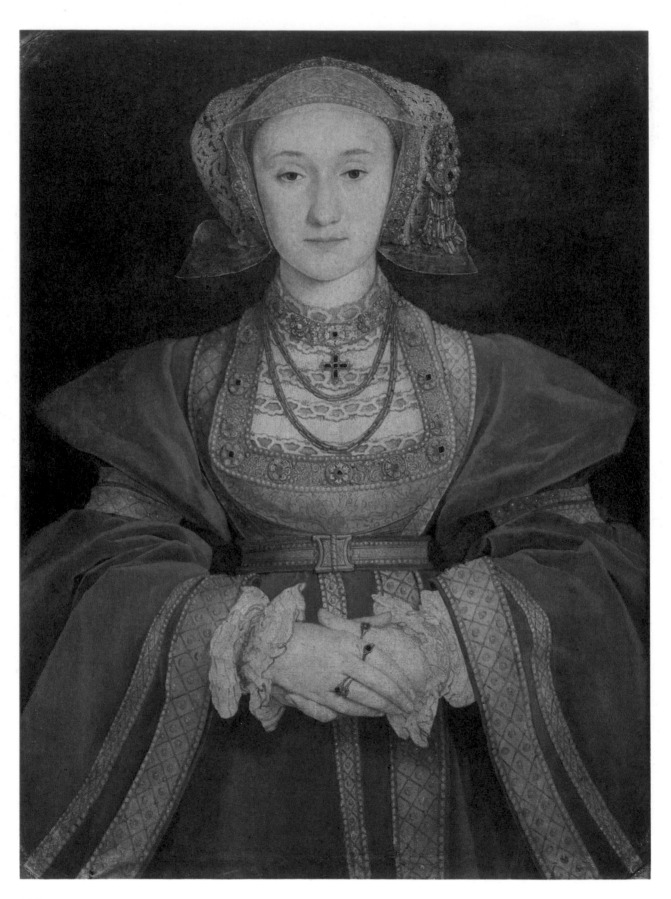

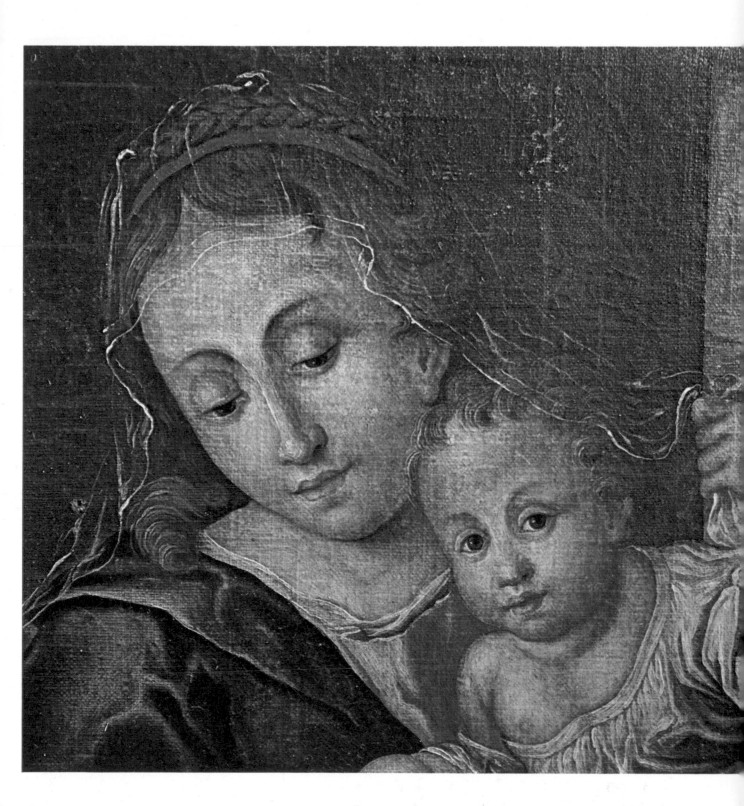

91
Hans Holbein the Younger (1497—1543)
Portrait of Anne of Cleves
Oil on parchment, 650 × 480 mm

92
Artist unknown (mid-18th century)
Madonna with Child
Detail of a 'semi-professional' Baroque painting,
720 × 550 mm
Thin oil paints allow the tinted ground to show through

117

Encaustic

Principles

The technique of painting with wax-bound colours can be traced back as far as ancient Egyptian times; it was in widespread use in the Middle Ages. The term 'encaustic' was described by Pliny as the technique in which the colours are applied hot to a surface. However, recent research into historical techniques has distinguished three methods of application:

1) painting with wax colours applied hot
2) painting with wax or a wax-resin mixture in solvent
3) painting with colours bonded by wax emulsion

Beeswax, a binder for encaustic, is traditionally obtained by melting honeycombs in hot water. In antiquity it was purified by boiling and bleached by being exposed to sunlight. Chemically, wax is a mixture of esters of fatty and waxy acids (myricyl palmitate). Though practically insoluble in water, wax can be saponified with alkalis, and the waxy soap then disperses in water. The film which forms on the evaporation of the water can subsequently be worked on with a heating element. The melting point of wax is between $61°$ and $70°C$.

A painting method using wax as a binder had a number of advantages which accounted for its popularity in antiquity. The method was very quick, despite a degree of complexity in the procedure. Unlike tempera which remains partially soluble on drying, wax colours set immediately on application to the ground. Painters also appreciated the optical properties of wax which gave the pigments depth, luminosity and shine. These properties are accounted for by the physical qualities of wax: its refractive index is very high ($n74° = 1.442$) which influences the pigments' optical behaviour. The painting thus acquires a transparency and depth in the light areas, making the pigments appear to have a dampness about them.

Some pigments such as chalk, ochres, and (to a certain extent) plaster lose their hiding power almost completely and give glaze effects. Owing to its chemical stability, wax makes the colour layer fast to humidity and also gives it optical stability. The ancient Greeks were well aware of wax's applications and used it to decorate their ships.

Encaustic technique also includes the use of wax crayons — a more recent innovation. Wax crayons are essentially colour waxes which can be applied both cold and hot, and the colour layer can be further treated with a heating element.

Historical Development

Pliny, who provides us with detailed information about the painting techniques of antiquity, writes about encaustic in his *Historia Naturalis* (dated 77 AD), saying that it enabled Greek painting to flourish. He mentions that the two most famous painters to use the encaustic technique in the 4th century BC could demand high prices.

However, records about the use of this technique are much older. As well as tempera, wax painting was used in ancient Egypt. It was used not only for panel painting — the best-known being the Fayum mummy portraits — but also for the decoration of interiors (such as the Theban tombs) and for decoration of sculptures in both monochrome and polychrome.

The condition of ancient examples demonstrates the great durability of wax-bound colours which have preserved not only their material structure but also their original coloration. The examples do indicate that wax colours were not necessarily applied as a melted mixture, but that they were also applied cold, using a solvent mainly of turpentine oil. Its preparation was known in Syria, and the

93
Petr Brandl (1668—1735)
St Paul, detail
Oil on canvas, 915 × 742 mm
Bold brushstroke and the wooden brush handle are
used to model impastos; the colour is piled up
vigorously on the canvas

oil was a trade commodity with Egypt, as was beeswax which was imported to Egypt from Sudan.

The use of a wax-resin mixture for decorative painting is testified by a number of writers. Vitruvius writes about a technique which used wax varnishes for smoothing the surface of murals and parts of architectural structures. A small quantity of oil was added to hot Punic wax, the mixture was brushed onto the wall and when it had set the surface was heated again until the wax melted and could soak into the surface, which was then polished. This procedure was also used for smoothing the surfaces of sculptures and reliefs in marble. This method of wax processing has not yet been completely understood, but the majority of researchers agree that the method significantly improved the properties of wax (particularly its melting point which was raised by the process) and made it soluble with water.

The popularity of encaustic did not end with Greek painting. The potential and scope of the wax technique was also appreciated by the Romans. Although there is no undisputed proof that the surviving examples, especially murals in Pompeii and Herculaneum, were executed by means of a certain modification of this technique (latest research suggests the use of wax as an additive), a number of records exist that show that the technique spread from Rome to the east, to Byzantium, and back to Europe again in the early Middle Ages.

There was a technique which used mainly wax soap with glue known as 'cera colla', which was used in Byzantine painting and adopted by the Italian trecentists as well. Wax soap with an addition of two parts (by volume) of gelatine solution was employed as a transparent varnish for tempera pictures. Though the method of varnish application is described by Cennini, he, unfortunately, makes no mention of its composition.

The well-known manuscript, *Mappae Clavicula,* which dates back to the year 870, contains a host of recipes for wax painting on wood, cloth, and parchment. But it gives methods of painting, rather than describing materials in detail and does not specifically mention the wax technique used. Nevertheless, there is some ground to assume that the technique used wax emulsion. Another evidence of its application is found in the *Hermeneia,* the painter's handbook from Mount Athos. It describes the preparation of Punic wax with glue and specifically says that the painting must be polished after completion. This emulsion can be varnished and overlaid with gold.

The latest known record about wax painting in the Middle Ages dates back to 1431, left by the miniaturist Jean le Begue. He describes the preparation of an emulsion from the lye of lime and ash (in the proportion of $1 : 12$) and 0.17 part of white wax, to which 0.125 part of swelled fish glue and mastic is added. The mixture is allowed to boil until it becomes as liquid as a low-viscosity glue. After filtration and cooling, it can be used as a binder for all colours. Use of emulsified beeswax as an additive to the colours is known to be quite common, information substantiated by the numerous mentions made by painters of the period, such as Andrea Mantegna, Nicola Pisano and Lucas Cranach. The 18th century was marked by numerous attempts to revive the ancient technique, spurred by the general trend of return to antiquity. The 20th century has also seen a renewed interest in the technique.

94
František Ronovský (1929)
The Fair
Scene from triptych
Encaustic, 3000 × 4000 mm
An example of modern encaustic; water and resin mixture on plywood

Ruce Vám libä vdčná dcera Anna

Preparing Wax Binders

A reconstruction of old recipes for the preparation of Punic wax according to Pliny gives the following process:

100 g of pure beeswax is melted in 1 litre of water to which 20 g of potash are slowly added, with the potash previously dissolved in a small quantity of warm water. It is stirred until a milky emulsion forms. Then 5 litres of sea water are added. The mixture is allowed to boil while being constantly stirred. The wax will separate as insoluble soap as a foaming mass which floats on the surface. The soap is collected, put into 5 litres of fresh sea water, and boiled down again. This process is repeated several times.

A German chemical engineer, E. Berger, offers a way of preparing wax soap on the basis of his own experiments:

100 g of white wax, 10 g of potash in water, and 250 g of distilled water are boiled until the wax dissolves completely. While the mixture cools off it is stirred and cold water is gradually added. If soda is used instead of potash, add 10 g of Venetian soap (soap from olive oil) dissolved in water.

Other authors recommend simply boiling down the wax in water with an admixture of Venetian soap (100 g wax, 25 g Venetian soap, 250 g water).

A wax emulsion can be prepared in the same way with the help of alkalis to give an emulsion which can be used for binding pigments and which mixes well with water. Wax soap which has been made saline in sea water (or in a solution of salt water) is not readily soluble and has a higher melting point (up to 80 °C), it is rather hard, but has excellent adhesive properties. This prepared wax can be used for the classical, 'hot' encaustic technique. Thus, the wax obtained in the process of treating Punic wax can be used for painting in two ways: as an emulsion for painting with the brush, and as a refined product to be applied with a heated spatula. The resultant colour layers are practically identical, and only modern methods, such as infra-red spectroscopic analysis, can determine which of the two methods was actually used.

Some specialists consider that painting with colours bound by a wax emulsion cannot be classified simply as encaustic technique and call it wax tempera or wax-tempera encaustic. They suppose that the binding power of a wax emulsion needs to be increased with appropriate admixtures, such as gum arabic or glue which lend the emulsion the quality of a true tempera binder. Even the known records from as early as the beginning of the Christian era document the use of wax-egg and wax-almond oil emulsions for medicinal purposes, and the use by encaustic painters of walnut oil as an admixture for enhancing the stability and durability of their works. It is simple to differentiate between wax emulsions and wax tempera. If on application the colour layer is further treated by heating, this is encaustic, whereas if emulsified wax is used as an admixture to a normal tempera binder, this is wax tempera (a technique which has nothing in common with encaustic). The Fayum mummy portraits, viewed in the light of the latest research results, prove that both techniques were known and used at that time. A wax emulsion is prepared in the following way:

25 g of bleached wax is melted in 250 g of hot distilled water. Dissolve 10 g of ammonium carbonate in a small quantity of water (100—150 ml) and mix this with the melted wax. The solution will immediately start to foam. On adding the carbonate, boil the mixture until it stops to foam and allow to cool

95
Eva Brýdlová (1926)
At a Cemetery
Encaustic, 440 × 580 mm

123

off, stirring it from time to time. The milk-white substance obtained can be stored indefinitely. It can be mixed with oil-resin varnishes, with oils and balsams (such as Venice balsam) as well as with size, tragacanth or casein, or it can be added to all kinds of tempera binders.

K. Wehlte suggests as an alternative to insoluble wax emulsion its preparation in an organic solvent medium, especially in white spirit:

Dissolve 25 g of wax with 25 g of a solvent (Sangajol, Testbenzin) in a water bath and, slowly stirring it, add a solution of 10 g of ammonium carbonate in 60 ml of water. Boil the mixture for another 45 minutes, occasionally stirring it, and then allow it to cool off. Emulsion prepared in this way is mixed with pigments that have been made into a paste with water or a solvent.

A wax emulsion can be prepared in the same way using turpentine. Such an emulsion is marked for its good workability and the considerable brightness of its tones. The method of application is simple — it can be laid down on the painting surface like oil or tempera. The surface of the colour layer, which is always slightly matt, can be treated by heating or it can be polished.

A binder can also be prepared on the basis of a pure wax-resin mixture, dissolved in turpentine or any similar solvent. Natural wax or treated Punic wax (boiled in salt water) or a harder, more and more brittle wax (such as carnauba wax or Japan wax) may be used.

The mixture is prepared in the following way: first, 1 part of resin (mastic or dammar) is dissolved in turpentine and slowly, while being constantly stirred, added to 3 parts of wax melted over a water bath. A wax-resin mixture can also be prepared by boiling 3 parts of wax with 1 part of Venice balsam.

Wax-resin mixtures can be applied in two ways: they can be brushed on cold with the help of a solvent, such as oil of turpentine (an identical substance to that used for coating ships by the Greeks), or they can be applied with a heated spatula. The surface of the coating is then treated with a heated element or polished and blended.

In ancient Egypt encaustic was applied to wood as well as to linen stretched on a wood panel. There are examples of encaustic painting on stone, mainly on granite, porphyry and marble. Supports used by the Greeks were ivory, chert and even ceramic tiles. The modern emulsion technique uses canvas and also fibreboard sheets (large pieces must be cradled for extra strength). For wax crayons, thick cardboard is also used.

96
Václav Kiml (1928)
A Summer Day
Encaustic, 280 × 320 mm

Choosing Colours

Painting Techniques

Wax paints can be prepared from all pigments of chromatically pure colours, both natural and artificial. Light-fast oil paints can be used to achieve interesting glaze effects. It has to be remembered that some pigments change their hiding power when mixed with wax. However, the specific weight of pigment when mixed with wax has not been observed to change appreciably. On application and heating an encaustic colour layer becomes matt. As encaustics are not varnished, they are polished with a soft brush or a flannel cloth. This means that the use of a vigorous brushstroke and thick impasto are not recommended.

The most detailed information about painting technique can again be found in Pliny's writings, even though certain passages and terms in it continue to be a subject of argument. Pliny describes three methods of encaustic painting: with the help of a 'cauterium', or a 'cestrum', or a brush. The cauterium, used for the hot iron technique, is the classical method in which the wax colours are applied and blended with a heated spatula. The bristle-brush technique is mentioned specifically in connection with the decoration of ships' figureheads and boards. The use of a 'cestrum' and its appearance remain unclear to this day. There is no mention, either, about

Fresco
(Buon Fresco)

the preparation of a coloured mixture, although this is not complicated: pigment is mixed with melted wax, with the vessel in a water bath, and the mixture is stirred until a saturated shade is achieved; on solidifying the coloured paste becomes dense and smooth but not hard (which would imply lack of cohesion). The colours are applied, or blended, with a hot spatula. The characteristic feature of the encaustic technique is a thick impasto which is often smoothed afterwards by ironing or grinding. Whatever the method, it is always an 'alla prima' technique in which tones and colours are juxtaposed in a direct manner. Although it is possible to experiment with glazes, especially when dealing with pigments which lose their hiding power in wax, the final result is difficult to anticipate or control.

A special technique, bordering on sculpture, was the making of wax effigies. It was particularly popular at the end of the 18th and the beginning of the 19th centuries, for it offered a cheap medium for what were often naive portraits. It was a method of modelled reliefs from coloured waxes, or reliefs with a thin polychromatic wax layer for the profile on a dark ground.

As already mentioned, encaustic resists atmospheric attack well, the colour layer does not change and never separates from the ground, but it is sensitive to physical knocks and to high temperature. Old dust is removed from its surface with considerable difficulty so it is recommended to protect encaustic paintings with glass (with a gap of at least 5 cm above the painting's surface), using a deep frame with spacer strips.

The method of true fresco (from the Italian *buon fresco*), is one of the oldest painting techniques, whose origins are closely connected with the development of architecture. The principle of fresco is simple: painting with pigments suspended in water onto moist plaster, the pigments being bound by the unslaked lime hydrate in the plaster. Due to the action of oxygen in the air the freed calcium hydroxide slowly turns into calcium carbonate, creating a firm bond with the pigment particles on the plaster surface. The process of carbonization is very long and it determines the ultimate strength and quality of a fresco painting. Its durability depends on the crystalline structure developed by the mineral calcite that forms on the surface. Although fresco is simple in principle, it is not a simple method of painting; it requires extremely careful preparation of both support and ground, and large frescoes require great physical exertion. The technical perfection of a fresco depends not only on its execution but also on the qualities of the support, the climatic conditions, and the quality of the materials applied.

Masonry affected by humidity or oversaturated with harmful salts may very soon bring about the deterioration of a fresco, as will the acidity of an environment polluted by industry. All these factors have to be taken into account before conceiving a mural painting in the fresco technique.

The origins of the fresco technique cannot be definitely established. According to Vitruvius, it was common in antiquity. The surviving fragments of Roman murals prove, for instance, that the artists of Pompeii were masters of fresco. Although the study of the Pompeian murals has brought no definitive results as yet, it can be assumed, particularly in view of the technical knowledge of the time, that they are examples of true fresco. In the early Middle Ages the Roman technique was adopted, modified and simplified; it is characterized by a transition to painting with lime-tolerant colours. Pigments bound in limewater were applied to a fresco underpainting, the liquid being adjusted with different additives to increase the suspension's bind-

Principles and Historical Development

ing power. Another interpretation of the classical, Roman fresco technique can be found in Byzantium, described in old manuscripts on painting technique, and exemplified by structures in Macedonia. The technical analyses of such paintings points to the existence of a widely used technical procedure. After the careful preparation of the material (especially the slaking of the lime) and the application of a rough plaster coat, artists always applied two more coats of plaster — a coarse *arricciato* and a fine *intonaco,* on which the painting was executed. The early records specifically emphasize the need always to paint on moist plaster because only this ensures the longevity of the work; an intonaco had to be applied to an area that could be painted before noon, and unpainted plaster should not be left overnight.

Nectarius gives a precise work schedule — the area of work had to be finished by the afternoon. Russian mural painters adopted the Byzantine technique, but in an attempt to rid the surface of a painting of visible lime residues, complex processes were employed to eliminate quick lime in plaster by making it react and turn into calcium carbonate. Because in such processes the plaster lost its ability to bind pigments, they gradually developed a sort of sized casein gesso which, however, had nothing in common with buon fresco and became a derivative of the fresco secco technique and sometimes even a technique of normal egg-yolk tempera.

The technique was further modified in Europe during the Middle Ages, and Cennini informs us about it in great detail in his recipe book. In the trecento, the principles of buon fresco were still observed, but later fresco began to be combined with the lime milk method, or with casein. This was, of course, the result of changing styles and needs when the simplified linear style and light modelling ceased to meet the needs of sophisticated artists. Experience showed that a fresco painting had to be finished in a non-conventional way in order to achieve the saturated colour shades and the desired contrast between lights and shadows. The painting process was changing too, and artists were moving more

towards greater freedom of expression. Eventually they abandoned the technique which imposed a strict timetable for painting and prevented them from introducing major changes in the composition once work had begun. Piero della Francesca, Andrea del Castagno, Fra Angelico, and others designed their preparatory drawings directly on the intonaco and finished their paintings in fresco secco. The completion of a fresco in tempera became quite a common phenomenon during the 14th and 15th centuries, but early attempts at using this method were often marked by limited durability. For example, Baldovinetti's *Baptism of Christ* and Leonardo's *Last Supper* suffered from technical imperfection, in using combined techniques whose effect had not been sufficiently tested.

97
Bartholomäus Spranger (1546—1611)
Hermes and Athena
Ceiling fresco of the White Tower of Prague Castle
Buon fresco on smoothed plaster, cartouche 2750 mm
in diameter

98
Bartholomäus Spranger (1546—1611)
Hermes and Athena
Detail shows an engraved drawing and the day work

128

Supports

Fresco can be executed on stone, brick, or a mixture of these. Other types of masonry employed in modern civil engineering such as concrete, gypsum plaster boards or compressed fibreboard do not have the physical properties required by fresco and do not act in the same way to form an organic entity with it. The basic parameters required of supports, such as water vapour permeability and heat conduction, should not differ much from the established standards.

Stone masonry must be dry, in good condition, and preferably with an even surface. Plaster layers are held better by porous masonry, such as sandstone or limestone, than by one of compact rock, such as granite. A large number of historical structures are built from a mixture of materials, which generally provide a suitable support for fresco.

Brick masonry is the best support with regard to its physical properties. It is in fact a ceramic material, fired at a temperature of about 1000 °C; it has relatively large pores, even absorbency and permeability. If there is an opportunity to choose the support material, preference should be given to top-quality bricks, of a cherry-red colour, they should ring when tapped, and have a uniform texture; when first wetted they must not develop a 'bloom' on drying.

Before plastering, the wall must be thoroughly soaked with water so that it remains moist during work, because dry masonry will absorb the water that is needed by the plaster to set and carbonize. As a result, the plaster may become loose, losing adherence to the support.

Grounds

The actual ground for fresco painting is lime plaster, generally applied in three layers. The first coat serves to eliminate the unevennesses on the surface; a second coat of sharpsand plaster, the *arricciato,* is overlaid with a fine plaster, or *intonaco,* on which painting is executed.

The physical and chemical properties of these layers predetermine the quality of the colour layer. Lime plaster is a mixture of sieved sand and slaked lime. The sand used for plaster must be free of impurities, with a low clay content and with grains of varying size (to give better bonding power). This is why glass sand or the different wastes of stone grinding or cutting, however fine they may be, are unsuitable for use in plaster. The largest grain size should not exceed a third of the total thickness of the plaster layer.

Lime

The careful choice and adjustment of materials for fresco is critical. Lime, the basic binder for lime mortars, is prepared by slaking limestone. Slaking involves the change of burnt lime (calcium oxide) into calcium hydroxide which further changes into calcium carbonate due to the action of carbon dioxide present in the air. Calcium carbonate then changes into a solid mineral, calcite.

The lime is slaked in a broad flat container by the addtition of water until the lime, which should be constantly stirred, changes into a thick but fluid mass. It is then stored in special pits or barrels to ripen and to develop the correct structure. In the Middle Ages lime slaking and seasoning were given great attention — lime was considered 'mature' only after at least five years. Slaked lime was stored in pits and carefully protected from the elements, particularly against freezing. Later, the optimum period for ripening was reduced to three years. At present, burnt lime is marketed in a very refined form, making the process of slaking easier and faster. Also, its ageing can be accelerated with appropriate additives or by special treatment. In order to obtain lime hydrate with a very fine homogeneous structure, like that of soft butter, the

slaking of lime should include up to 20 per cent industrial spirit. The slaked lime can then be stored in plastic vessels and put aside for at least three days. This is perfectly enough time for the lime to homogenize and for all the unslaked lumps and particles to disintegrate. Before usage, the water that has accumulated on the surface must be removed.

During slaking, the lime must be prevented from 'overburning', which can be identified by its 'unquenchable thirst' for water, the formation of clinkers which do not break up in mortar and bad weathering. Therefore, it is recommended to filter off the slaked lime through a fine-mesh screen or sieve before storing. On the other hand, there is also a risk of 'overwatering' lime, that is, adding too much water to the lime being slaked. Such lime acquires a low consistency due to a retardation of the hydration process.

In the Middle Ages, lime was burnt in artist's kilns, or in primitive shaft kilns and it was characterized by a content of underburnt limestone. Such high-quality lime, also called lime carbonate, develops a durable, hard plaster which is very good for fresco, because it is slower in setting than pure, quick-burnt lime and remains workable for a longer time — important for the *intonaco*.

Sand

The mortar for the first coat uses a mixture of pit sand and river sand. Because of the rounded shape of its grains, river sand creates poor bonds and its lime consumption is high. The sharp-edged grains of pit sand, owing to their irregular surfaces, develop firmer bonds; pit sand has clay impurities which, if present in small quantities, act as a plasticizer in mortar. If they exceed 5 per cent of the content, they diminish the strength of the mortar and cause the plaster coat to contract as it dries, resulting in the emergence of major cracks. The sand must be dry; wet sand forms lumps which are difficult to stir up in the lime mixture.

In order to improve the bonding power, crushed bricks or roof-tiles (up to a third of the total volume) can be added to the mortar for the first coat. These lend the mixture hardening properties and increase its strength, therefore, this option should not be neglected. It is essential that the first coat should be the most coarse and hardest of all.

First Coat — *Trullisatio*

The first coat may be a coarse-grain one, with grain size from 0.1 mm to 6 mm, prepared from 1 part of lime and 3 parts of sand. In the case of a stone with low absorbency a small quantity of a hydraulic additive (such as a 0.15 part of Portland cement) can be added. The coat is applied with a trowel or spade and the material is spread out evenly. It is an important stage as it determines the quality of the surface. Brisk plastering can cause it to literally glue to the support and become thixotropic, losing its tendency to flow. The support must first be dusted and moistened. A support with low absorbency requires only moderate sprinkling with water. On application the plaster must be spread out, but not smoothed, and allowed to set before applying the second coat. The time of setting depends on the layer's thickness, the presence of a hydraulic ingredient and the absorbency of the support. It can take between 24 and 48 hours.

To give an even surface to the initial coat, narrow vertical mortar strips should be applied to the wall; they should be levelled with the help of a plumb line. When hard, these strips serve as a guide to control the plaster surface with a straight edge. The surface must be rough and coarse, but without holes which would cause an excessive consumption of plaster and cracks in the *arricciato*.

Arricciato

The most succesful composition of the *arricciato* is considered to be 1 part of lime and 2.5 parts of sand. It must have a different composition from the previous coat because the *arricciato* is thinner and is smoothed. Therefore, the sand must be fine, with a grain size from 0.03 to 1 mm. For better binding strength, calf's hair or bristles can be added to the material. The first coat should be

moistened with water before applying the *arricciato*. If the thickness of the first coat is between 10 and 12 mm, the thickness of the *arricciato* must not be more than 5 mm. After application, the surface of this plaster layer is smoothed with a wooden float, using a circular motion. The *arricciato* is allowed to set for at least 48 hours. After that an area to be painted during the day session is marked either with charcoal or chalk, it is moistened with water and overlaid with *intonaco*.

Intonaco

Intonaco is a layer of thin, lime-rich plaster on whose fresh surface the painting is executed. Since the *intonaco* has a direct bearing on the creation and quality of the colour layer, its composition and structure are very important. Depending on the character of the painting, the *intonaco* can incorporate very fine sand to lend the plaster an extremely smooth surface, or it can be roughened by filling the material with coarser sand. A fine, smooth *intonaco* is white and therefore suitable for a painting of a watercolour character, executed in a very thin layer so that the visible ground under the local tones contributes to the desired effect. On the other hand, a coarse *intonaco* is suitable for impasto painting (the application of paints in several layers of different thickness), whereby the optical effect of the ground is of little importance. The mortar for the smooth *intonaco* is prepared by adding marble powder to very fine sand (grain size from 0.015 to 0.5 mm). According to Cennini, artists simply used to apply pure lime to the surface for a preparatory drawing. This method is closer to what is called 'lime painting', a loose interpretation of the fresco technique. Also, they used to add milk to *intonaco* to improve its properties, especially to increase the binding of pigments. The thickness of the *intonaco* should never exceed 2—3 mm, because a thicker layer has a tendency to develop cracks. The surface of the *intonaco* is always smoothed with a metal float, though felt is often used to even up the coarse *intonaco*. During work the plaster is continuously moistened with the help of a bronze roller, which draws free lime hydrate from the *intonaco*, and the lime binds the pigment to the surface. This also helps to obscure mortar joints between the old and new portions.

Pigments

Because fresco is executed in a very chemically active alkaline medium, this fact should be taken into account when choosing pigments. The most suitable are earth, mineral dyes: ochres, light and dark ferric reds, browns, natural and burnt sienna, umber, golden ochre, green earth; followed by zinc yellow, chrome green, phthalocyanine green, cobalt blue, cerulean blue, ultramarine, ferric black, manganese black, vine black, or fine charcoal. Modern cadmium yellows and reds are also quite stable in lime. In the past, the only white used by artists was carbonized lime, called 'bianco sangiovanni'. Its substitutes now are titanium white or blanc-fixe as well as finely divided barium sulphate. According to Cennini, *bianco sangiovanni* was prepared by repeatedly washing and sieving underburnt lime to obtain a paste for making cakes which were then allowed to dry in sunlight. After that they were immersed in water and turned into paste again, from which cakes were made anew and left to dry, producing fine lime white. Applied in a thin layer, it had low hiding power and was transparent. Cennini specifically points out that such a white is unsuitable for tempera painting, but it was often used, mixed with other pigments, for glazes.

Painting Techniques

Painting actually begins with the application of the *intonaco*. In order to paint on fresh plaster it must be applied swiftly and efficiently, covering an area or *giornata*, which can be painted during the day. In the climate of northern Europe, with its relatively low temperatures and higher humidity, the intonaco may remain workable for longer. The *sinopia*, or preparatory drawing, is done on the *arricciato* so that the general composition of a painting can be divided into *giornate* in the most appropriate places. Experienced artists distribute these divisions according to the forms and composition of the work.

Although old records, particularly those of Cennini, describe this preparatory stage in great detail, they make no mention of preparatory drawing, or the transfer of a cartoon. The basic axes of design were outlined on the wall with the help of a plumb line and compasses, and the wall was divided into sections. Then an initial sketch was executed in charcoal; it was kept very loose to allow for possible corrections (charcoal could be smudged off easily). Having finalized the composition the painter worked over the lines with a reddish earth pigment dissolved in water, *sinopia*, which is also the general term for the preparatory drawing. As monumental painting developed, aspiring to ever larger compositions, sinopias became increasingly insufficient. Paper cartoons were used to transfer the image by tracing the outlines onto the *intonaco*, either by impressing them into the surface while still soft with a stylus through the paper, or by pouncing it through. The *giornata* was first outlined on the *arricciato*. To transfer the composition onto the *intonaco*, the outlines on the cartoon were pricked with a perforating wheel so that when the paper was laid on the support, the linear pattern was transferred by dabbing the perforations with a muslin bag of powdered charcoal. This *spolvero* method is the older of the two; the engraved preparatory drawing method was used by artists from Raphael and Michelangelo to those of the 18th century.

Vasari provides a detailed description of preparing the cartoon in a way which excludes the use of sinopia. Such cartoons were

sheets of paper glued together with flour paste, with which they were also fixed on the wall. The artist transferred his full-size composition onto a cartoon, previously prepared as sketches and studies of details. Baroque fresco painters prepared such sketches not only for the spatial arrangement of the design but also to arrange the colour masses. A finished cartoon was then cut up into sections which corresponded to *giornate;* it was transferred, step by step, onto the *intonaco.* Fresco painting was further complicated by the need to use scaffolding if the painting was to be done on a large wall. Therefore, the painting was executed in horizontal areas, corresponding to the 'storeys' of the scaffold. These divisions are known as *pontate.*

The *intonaco* material was applied to the wall with a trowel and was spread out with a mason's board or a broad spatula; it was then evened with a metal float and, later, with a felt-covered float. For applying a thin *intonaco,* old masters used a broad short-bristle brush. Metal floats are used for a perfectly smooth finish, while a wooden or felted float is used for a coarse intonaco, applied in a thick layer.

Brushes for fresco painting must be thick and round, with long bristles which must be soft enough not to disturb the still soft *intonaco.* In order to speed up the binding of the pigments in the colour layer with the lime in the intonaco, its surface is worked over with a bronze roller, which should be applied with only slight pressure to press the limewater out of the plaster. This method is also used when the paint is applied in several successive layers, to encourage them to fuse. However, it is not recommended to exert too much pressure on the finished painting because the limewater develops a fine but visible matt film on its surface. Although it can be removed, there is a risk of damaging the fresh colour layer.

Modelling in fresco is done by lightening the dark primary shades. According to Cennini, the design and underpainting were executed in a shade called *verdaccio,* with the shadows put down in a green tone; the face was then finished in the basic complexion tone when the tones of the cheeks, the mouth, and the eyes were applied; the complexion was made uniform with glaze and, finally, the modelling was completed by using white lime. Commenting on this process, Cennini says: 'Make a brush from supple and fine bristles; it must be only as thick as it can be fixed in the shaft on a goose feather. With this brush outline the face to be painted and overwork it in this colour which in Florence is called *verdaccio,* in Sienna *barreo,* with the brush almost dry. If it seems to you that the face is not felicitous, take a bigger brush, soaked in water, and wash the plaster in this place; you can wash it off. Then avail yourself of green earth in another vessel and with a trimmed bristle brush (wrung by the thumb and the middle finger of the left hand) begin to apply shadows under the chin and then to the parts which must be dark... Then take a pointed squirrel-hair brush and with it improve all contours in the verdaccio colour. There are some painters who at this point, when the face has thus been embodied, take a little bianco sangiovanni prepared with water and proceed searching the elevated and protruded parts of that face in an orderly manner. Then they apply some red to the lips, but to the cheeks they apply a colour like that of an apple. Afterwards, they overlay all with aqueous complexion colour which flows well. Then they touch the elevated places with bianco sangiovanni, which is good...'

The process described by Cennini agrees in principle with the processes analysed by Theophilus intended for painting on parchment. This proves the fact that the painting method did not alter for several centuries. The building up of a painting was then greatly influenced by the long tradition of book illumination and, later, by the methods of panel painting This conservative technique was later modified — the primary tones were no longer mixed with white and the *verdaccio* underpainting was forgotten. The smooth *intonaco* was overlaid with thin paint layers (like watercolours) and modelling was done by fine hatching, which became the prevailing technique of modelling with some Italian masters. Since the 17th century brushstrokes

began to loosen up to result in the masterful manner of Baroque and Rococo fresco painters, characterized by boldly applied flecks and spots of colour and the use of white by such artists as Giambattista Tiepolo and Franz Maulbertsch.

The classical technique of fresco painting could not continue to satisfy the gradually changing, freeing up of technique. Therefore, the vast majority of 18th-century murals show the use of mixed media, where the underpaintings are still executed in buon fresco but the painting is completed in fresco secco, using a casein medium and often an egg tempera as well. This entailed the application of more intense colour tones and a more sophisticated binder than lime.

99
Francisco de Goya (1746—1828)
Don Miguel de Lardizabal
Oil on canvas, 860 × 650 mm
This detail shows the freely handled build-up of the paint layer into a low relief

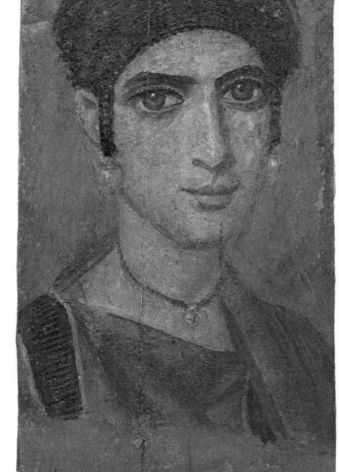

100
Mummy portrait from Fayum
(4th century)
Characteristic painting reveals
a neat technique of applying and
modelling the colour layer with a
heated spatula

101
Portrait from Fayum
(1st half of 4th century)
Portrait of a Young Lady
Encaustic on wood, 404 × 205 mm

136

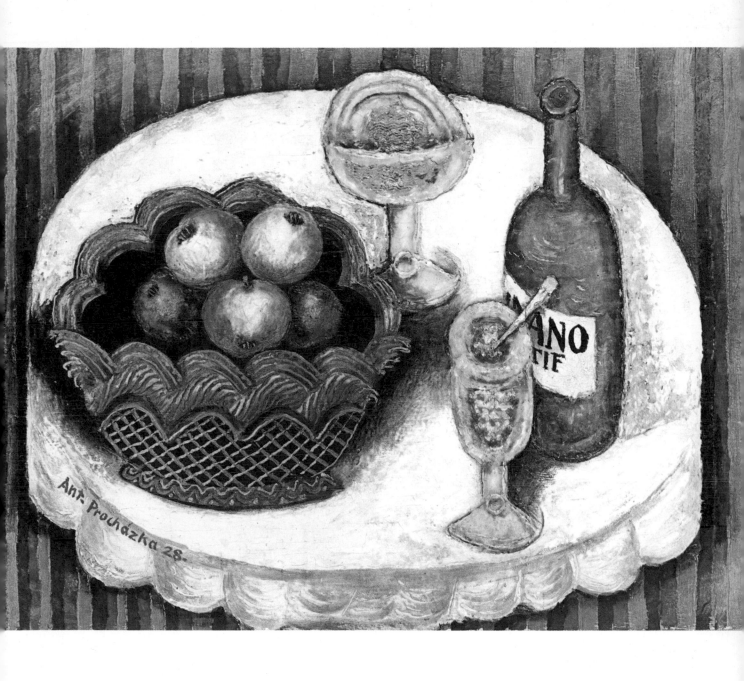

102
Antonín Procházka (1882—1945)
Still Life with a Basket
Encaustic on canvas, 440 × 580 mm

Fresco Secco

The secco technique is essentially a technique of gouache on plaster. Its development has been rather complex, from fresco and its derivative, lime painting (painting with pigments bound by lime milk), from the simple tempera technique of the late Middle Ages to the combined tempera and mixed media of 19th-century monumental painting. Unlike buon fresco, secco is the technique of painting on dry, perfectly mature plaster. The ultimate coloristic effect is always dependent on the brand and properties of the applied binders. Secco was the dominant technique of European medieval mural painting (particularly in the Transalpine region). The surviving Roman and early medieval murals were first executed in lime secco, where the main binder was lime milk or limewater with additives which enhanced their bonds with pigments. The palette of these murals was rather limited — dominated by earth pigments, ferric ochres; greens and blues were the mineral salts of copper. Other ferric compounds, particularly minium and cinnabar, were rarely used.

The radical change in the technique, facilitated by technical improvements in secco, did not come until Giotto who led Italian trecentists and whose influence spread north of the Alps as well. The change owed much to the simultaneous development of panel painting. The relatively advanced tempera technique entered mural painting notably at the time of the glorious Emperor Charles IV, and is exemplified by murals at Prague Castle from that period. Its high technical level allowed tempera to assert an equal place with panel painting and enabled it to cope with the rather demanding tasks of monumental decorations for major architectural projects initiated by the Emperor himself. Examples of such decorations can be seen in the series of murals at Karlštejn Castle, and in the St Wenceslas Chapel of St Vitus' Cathedral in Prague. These monumental decorations are embellished by moulded and gilded gesso and by semiprecious stones.

Even though the Renaissance and Mannerism largely saw a return to mural painting in true fresco, secco did retain a role in decorative painting, reaching its peak in late Baroque and Rococo interiors, and it eventually ousted fresco from monumental interior painting in the 19th century.

103
František Ronovský (1929)
The Fair
Encaustic, 3000 × 4000 mm
Detail showing brush-and-spatula modelling and an ironed finish

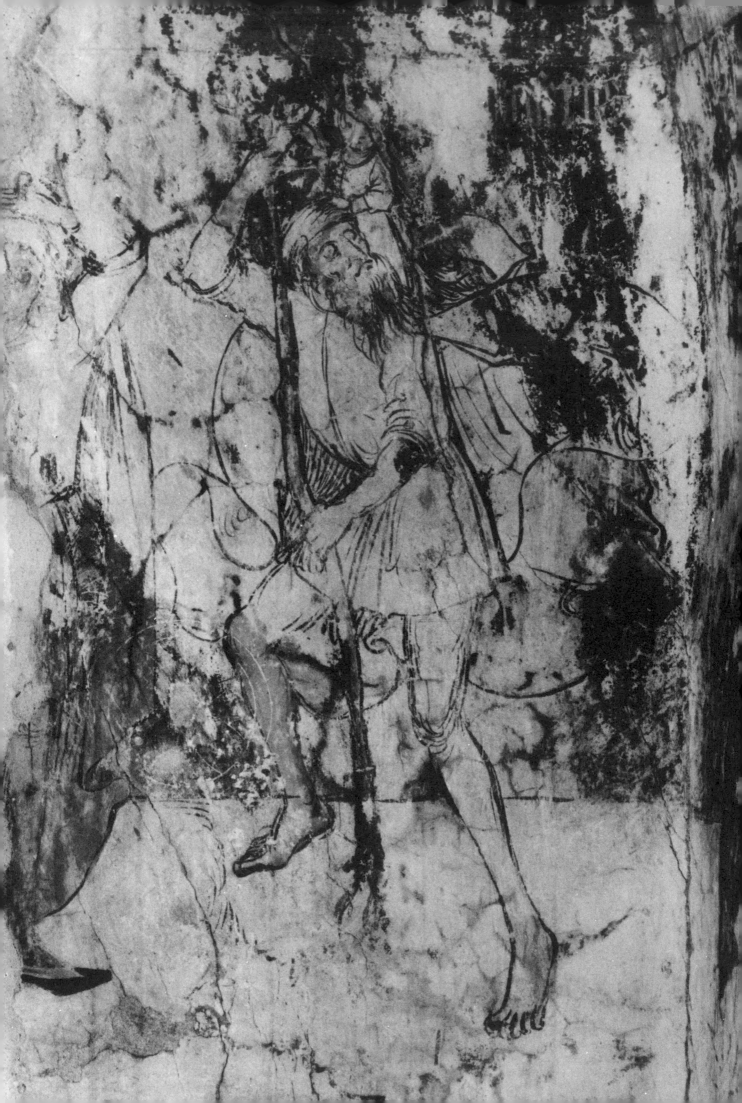

Supports

Secco is executed on a plastered wall, but, unlike buon fresco, it can also be executed on plastered wood, or wire netting and plasterboard. The basic condition is that the support is perfectly dry. If this condition cannot be observed (if a wall of an old building is unsuitable, and cannot be treated) the painting should be executed on reinforced board and the work hung on the wall.

104
Detail of medieval fresco secco
Žirovnice, a chapel of the castle (after 1490)
The flaked off colour layer reveals the preparatory drawing on smoothed plaster

Grounds

The ground for secco can be pure lime and gypsum plaster or limewash. Lime plaster must not be too lean so that the surface is not smudged, but it must not be too fat (rich in lime), because this leads to low and uneven absorption as well as to the formation of multiple thread-like cracks which permeate excessive paint. The ground may and sometimes has to be adjusted before painting by applying a coat to regulate absorption and improve the adhesion of the paint layer. Such a coat can be made with heavily diluted egg tempera, a weak solution of methyl cellulose, a 5-per cent casein solution, diluted milk, or a heavily diluted binder of the type that will be used in the painting. This coat can also be done with heavily diluted polyvinyl acetate, acrylic, or polyvinyl alcohol at a concentration of between 1 and 3 per cent. It is applied by spraying a fine mist onto the surface, or by brushing on in a criss-cross direction so that the coat spreads evenly.

In principle, the painting can be executed on any high-quality, 'mature' plaster which has been adjusted with a preliminary coat.

Coarse plaster surfaces call for a special painting technique and greater sophistication of brushstroke than semicoarse or smooth plaster surfaces. Gypsum plaster is prepared either from gypsum only, to be later ground and polished, or from plaster of Paris — gypsum-lime plaster. Such plaster is prepared by mixing:

24 parts (by volume) well slaked lime
72 parts (by volume) sand
24 parts (by volume) gypsum
20 parts (by volume) water
0.5 part (by volume) size

For the plaster to create firmer bonds and in order to prevent the development of cracks, 2—3 parts of chopped jute or hemp fibre or animal hair are added. First, the size and fibres are added to the water and then the gypsum is added. The resultant paste is mixed with mortar prepared from sand and lime. The mixture must be used without delay because it remains workable for only two hours. If the mixture is 'short' more size must be added. This gypsum-lime plaster can also

be applied to the netting fastened to a metal frame to make a portable panel.

Secco can also be executed on lime plaster extended with cement. It is recommended to use a purely cement support because the alkalinity is relatively high and persists long after the cement has hardened. The reason is that the chemical ageing of cement (unlike its quick hardening) lasts several years, during which the cement remains reactive. The alkalis that are yielded can, therefore, destroy the painting or cause the colours to change their tone. This risk can be reduced by sealing, but it can never be totally eliminated.

The oldest agent for binding pigments in secco painting is limewater, with a content of cow milk which stimulated the creation of lime caseate — this binds the pigments in the colour layer, making it sufficiently durable. In eastern and central Europe, artists used the broths of wheat or barley corn as binders, often with an admixture of plant glues which were combined with lime milk. Analysis of surviving murals has given no clear answer to the question of to what extent lime milk and limewater were used.

Cennini describes the technique of the Italian trecento, which can be safely assumed to be characteristic of Giotto, in which egg tempera, or its variants, were used, often combined with the milk of figs.

The casein binder for secco painting is prepared from 1 part of fresh curd and 2 parts of limewash, kneaded to a thick paste. This is then thinned with water according to requirement.

A starch binder is prepared by exposing potato starch to the action of alkalis: 100 g of potato starch are mixed with 2000 ml of water and heated in a water bath. Then, 2000 ml of a 1-per cent solution of potassium hydroxide are slowly added to the mixture. When clear, this is mixed with the previously

105
Composition of a fresco (medieval secco):
1 masonry, **2** rough coat, **3** *arricciato*, **4** *intonaco*,
5 colour layer (including a preparatory drawing on the *intonaco*)

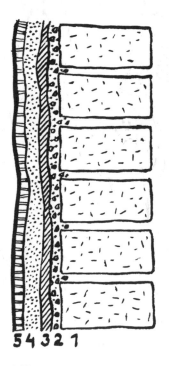

5 4 3 2 1

106
Preparatory drawing in charcoal and chalk on plaster
Karlštejn, the Chapel of the St Cross
(mid-14th century)

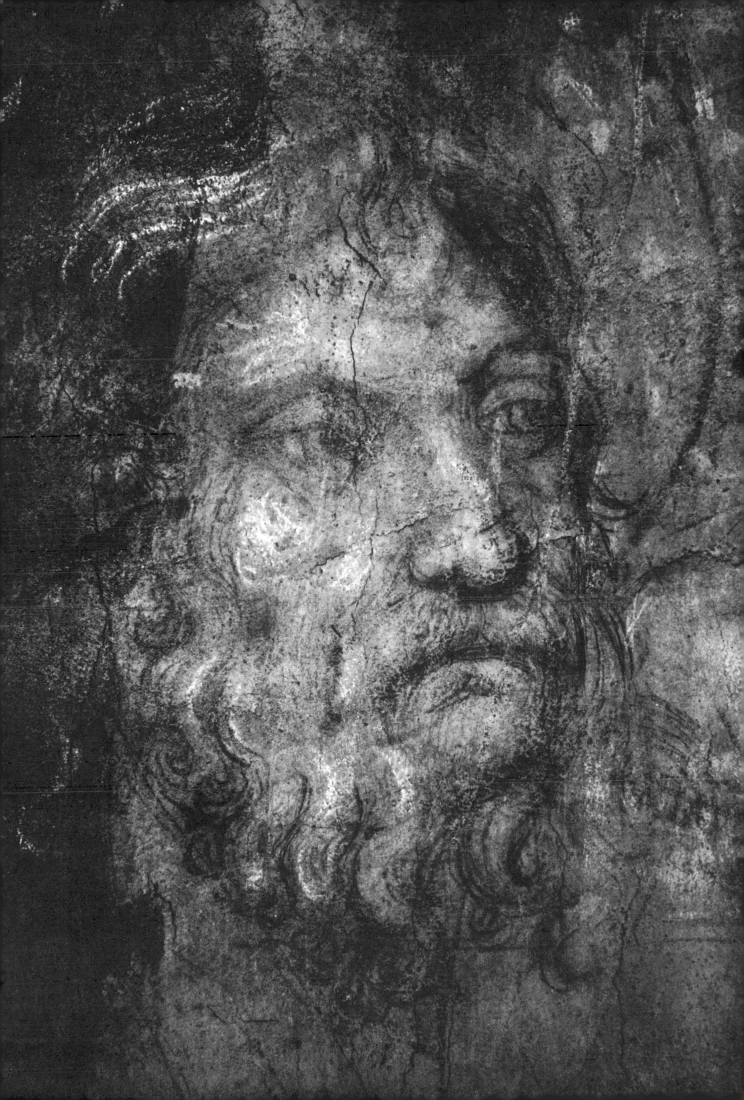

prepared compound of 50 g of Venice balsam and 50 g of linseed oil. The mixture can be further thinned with water according to need. This tempera binder was widely used in the decorative painting of interiors in the 19th century. Today, secco murals can be executed with acrylic paints, with a thinned, 1 : 2 solution of an emulsion binder applied as the first coat.

In the past, the drawing was outlined with a crayon or charcoal as well as with a brush. For true fresco secco, the former two were mainly used, while for 'mezzofresco' (painting on a wet lime layer), the brush was used. In medieval linear painting the drawing was overworked in robust colours. With the basic tones applied, artists modelled lights and shadows and, finally, laid down the brightest whites. They usually used thick hog-bristle brushes which were sufficiently elastic and endured abrasion when the painting was done on coarse plaster.

The simple secco technique transformed into the tempera technique in the late Middle Ages and came closer to the method of panel painting. As a result, as far back as the 14th century, plastered supports were already provided with sealant coats of glue, aimed at ensuring increased action of the 'stronger' tempera binder. This is clear evidence of the desire to find a mural painting technique which would allow a dense, compact, and bright surface of the paint layer, entirely different from the pale and subtle tones of the lime coats of the earlier styles.

In the 19th century the lime binder was abandoned with the arrival of mixed tempera mediums such as tempera with gum arabic and casein-wax tempera, but the painting technique was virtually identical to that of panel painting.

Sgraffito

Principles

Sgraffito is a technique of monumental painting in which the painting is created by scratching through the surface layer of plaster. This is a technique for exterior wall painting which was very popular in the Renaissance. The sgraffito technique can be subdivided into two main types:

1/ **Single-layer sgraffito,** in which the effect is achieved by roughening and scratching through a single layer of smoothly finished plaster. The coarser surfaces thus contrast with the smooth ones, and this contrast deepens in time as the former darken due to the action of the elements.

107
Single-layer coloured sgraffito
Detail of interior decoration
of Telč Castle (16th century)

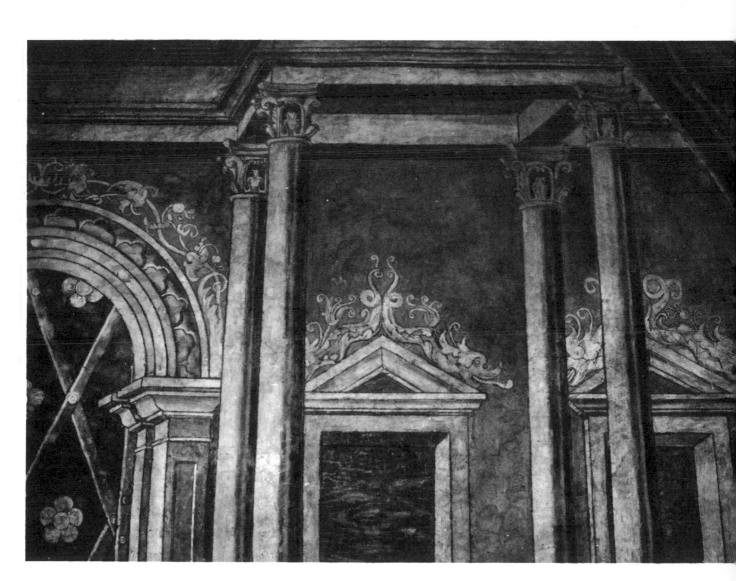

2/ **Double-layer sgraffito,** a method in which a rough plaster undercoat, usually of coarsely broken-up bricks or wood charcoal, is followed by fine-grain plaster. Before setting, the plastered surface is scratched through with spatulas to reveal a coloured ground. If the colours are arranged in reverse order, we talk of 'contrasgraffito'.

Sgraffito designs were transferred to the plastered wall with the help of preparatory perforated cartoons which were dabbed with a muslin bag full of charcoal. Sometimes the design was outlined on the wet surface of plaster, or chalk was used.

In the 19th century, artists frequently used gypsum sgraffito. In this method a rough plaster undercoat was overlaid with a thin gypsum coat which was polished to an intense gloss. The design was engraved with varying incisions in the plaster to reveal the coat beneath.

There are many ways of executing a painting in sgraffito. The artist can vary the depth of incisions, using gouges with blades of different shapes, and by varying the distance of the incisions from one another. Some figurative Renaissance sgraffiti are reminiscent of reliefs.

The sgraffito technique, being essentially drawing by engraving or scratching through plaster, appeared in the 14th century in North Italy and rapidly spread to Transalpine Europe. Undoubtedly it drew on the popular technique of decorating plaster surfaces by cutting and scratching.

Sgraffito is not an art of painting in the proper sense of the word, but it is a technique of monumental drawing, sometimes coloured drawing. In the 16th century sgraffito paintings, which often decorated whole façades, reproduced preparatory graphic patterns that were widely used. Their subject-matter ranged from moralizing scenes and legends to portraits of sacred and secular figures.

The oldest and commonest type of sgraffito is so-called single-layer sgraffito in which the drawing is created by the pattern of deep incisions and etchings in smooth plaster. In order to increase the contrast, artists started to use double-layer sgraffito in which a coloured plaster undercoat was followed by a smooth plaster layer on which the subject was engraved to reveal a coloured (or more often black) layer underneath. In the 16th century this double-layer technique already had derivatives such as multicolour sgraffito with additonal coloured surfaces, or sgraffito with a reversed order of colour arrangement (with the white layers followed by the coloured ones).

In the 19th century, the period of eclecticism, sgraffito was rediscovered as a decorative technique for interiors and the façades of houses.

108
An example of double-layer sgraffito
The house 'U minuty' in Prague

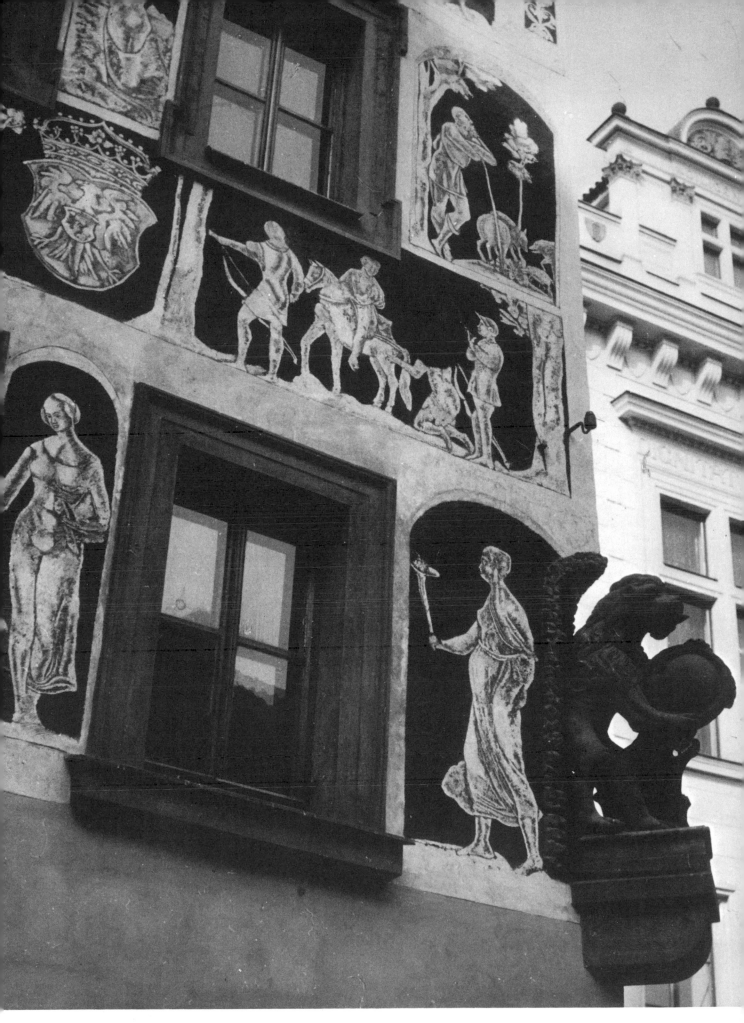

Supports and Grounds

The traditional support for sgraffito is stone or brick. Modern sgraffito is also executed on concrete or other types of building material, but always using a rough plaster undercoat. Modern gypsum sgraffito methods also use fibreboard or other light boards for supports. Thus, a sgraffito painting, originally considered as an inseparable part of a structure, has become a portable work of art, similar in character to a large panel painting.

A rough plaster undercoat on an ordinary brick wall can be of pure lime or lime slightly extended with a hydraulic additive (usually cement). This mortar is prepared from 1 part of lime and 3 parts of sand, plus a hydraulic additive (such as a high-grade cement) in a quantity amounting to 0.2—0.7 of a part.

The sand must be 'sharp' (its grains sharp-edged), without any major content of clay impurities. Washed sand with smooth siliceous grains is inappropriate in this case because of its low binding ability. The plaster undercoat must be coarse, with the prevailing grain size of the sand in the mortar between 2—6 mm, lending the mixture a good structure.

The plaster must be mature, at least 14 days old. In the summer it should be protected against direct sunlight which deprives it of the water necessary for the controlled process of solidification, causing cracks and powdering. Therefore, in the summer a plaster layer that has to be exposed to direct sunshine must be covered with a tarpaulin of rush mats and occasionally sprayed with a fine mist of water. The thickness of the plaster coat should not be more than 18 mm (three time the largest grain size). This plaster layer should be evened out with a wooden float, then followed by a layer of fine plaster.

Plaster Layers

In classical sgraffito the quality of the main underlay of colour determines the painting's longevity. It must be prepared from lime that has matured in a lime pit, or from a mixture at least one month old powdered lime hydrate with water. The lime is mixed with water to form a thick solution which needs to be sieved though a fine mesh in order to separate underburnt lumps and to obtain a fine limewash. This is mixed with sand in the proportion of 1 : 2, making the mixture relatively rich. A portion of the limewash is mixed with pigment (either finely divided wood charcoal or black or red ferric oxide) to prepare a tinted paste which is then added to the mixture. Different types of charcoal will produce a variety of tones. The charcoal will not readily mix with the mortar unless it is first prepared as a paste, because it repels water and remains on the surface of the mixture because of charcoal's low specific weight. For tinting plaster mixtures coarsely ground lime-fast pigments are used. Sometimes, sand rich in ferric compounds was tinted by being burnt on a metal sheet, or by the addition of a green vitriol solution, whereby an ochre tint of the underlying layer was achieved.

The simplest form of sgraffito, based on high-quality single-layer plaster, is that on a coat of lime. Soon after it has set, the tinted plaster undercoat, while it is still soft, is overlaid with a lime-milk coat. When set, it is scratched through to the plaster coat beneath.

Gouges are not suitable for this method. It is better to use broad knives or wire brushes. The character of the line will differ from the method where deeper cuts can be made.

The method of cutting into the uppermost smooth plaster layer is more important in sgraffito than its colour, because it is the contrast between the rough and the smooth surfaces which plays the dominant role when the work is viewed at an angle.

The fine plaster surface is the most important element in double-layer and multi-layer sgraffito. For greater contrast, marble powder and pure siliceous sand can be added to

the plaster mixture, making up to a third of its volume. To encourage a binding action, the mortar (sand and lime in the proportion 1 : 2) is enhanced by the addition of milk which smooths the plaster layer, with the smoothing carried out with a rounded brass scraper right after the application of the layer. The lime milk yielded by the plaster, being slightly pressed with the scraper, forms a lustrous crust on the surface. The surface should not be scraped too hard or it will separate the still soft plaster from the support.

109
Tools for sgraffito:
a wire loops, **b-d** knife blades, **e** watchmaker's spring, **f** gouge for fine hatching

a b c d e f

In single-layer or multi-layer sgraffito, the design is scratched or cut only when the plaster is set. Because its working time is limited (usually not more than 36 hours), work must be carefully planned to proceed smoothly and swiftly. This means that the artist has to plaster an area that can be managed during a day session. Large-scale work is usually carried out in horizontal bands, determined by the height of the 'storeys' of scaffolding.

The preparatory cartoon with the drawing on it is transferred to the plaster either by pricking through a pattern, or, with the cartoon laid against the wall, by dabbing the perforations with a muslin bag of pigment (usually charcoal, or chalk powder if the plaster is dark). Immediately after it has been transferred, the drawing is scratched through. The general contours are transferred with a pattern, while the fine hatching of shadows and modelling are performed directly, without a pattern.

It is important to take into account the joins of plaster which relate to the day's work on the preparatory drawing so as to incorporate them in the composition and to disguise them as much as possible.

The scratching is done with a variety of steel instruments such as loop gouges made from steel wire or watchmaker's springs, or steel spatulas with shaped edges. It is important that the instruments leave behind grooves with edges at 30° – 45°C to the surface as this prevents the accumulation of rain water in the grooves (the most frequent cause of the destruction of the plaster layer). Scratches, or incisions, must not be too regular which would detract from the unique quality of line and form that is so characteristic of the technique.

It is possible that hatching may lead to the separation of the plaster from the support and to its breaking off; it is advisable to cut shallow grooves with irregular edges.

The structure of plaster for sgraffito on interior walls should be as coarse as that used for exterior walls; it gives a more pleasing irregularity to the marks, and so contributes to the informality of the work.

In multicolour sgraffito the individual col-

oured plaster layers should not be too thick, so that the deepest cuts do not exceed 1.2—1.5 cm. The maximum thickness of each coloured layer is not usually more than 3 mm.

Multicolour sgraffito is very demanding and laborious, especially when executed on a large area. Characteristically, Renaissance sgraffito works used very simple means and a modest palette, but that did not prevent them from achieving a powerful impact. Success depends to a great extent on the absolute clarity of the artist's intent.

110
Jiří Sozanský (1939)
Expiration. Picture-Object
Assemblage and collage with painting, 2000 × 1500 mm

MODERN
TECHNIQUES

Modern
Painting Media

Synthetic media, developed by industrial research in the mid-20th century, have substantially enriched the conventional painting techniques. Certain properties of polymers (commonly used artificial, synthetic resins), invited themselves to be employed in painting. At first they were applied as substitutes for the classical mediums, especially natural resins, while later their new forms paved the way for independent painting techniques. As well as resins used for exterior wall painting, other highly stable materials were tried, such as those based on organic silicates, which have now found wide application in stone conservation. The first painter to use these materials (ethyl silicate in particular as pigment binders in monumental exterior painting) was the Mexican artist David Alfaro Siqueiros. His method was a sort of modified stereochromy technique (painting in colour bound by water glass, a viscous solution of sodium silicate), which at the beginning of this century was widespread in Germany, owing to a novel application of monumental painting in architecture, prompted by the use of hard, high-grade plaster coats and concrete.

The use of new media stimulated the development of artistic concepts, which sought new and unconventional means of expression. Futurism, Dada, and Surrealism experimented with expressiveness, using non-traditional techniques; Abstractionism added urgency to this quest. Despite the existence of assemblage, typical of Dada, abstractionists strived for a still more expressive colour mass that would create not only an optical, but also a tactile sensation. The interest in the structure of the layer became very important, but only few classical techniques, in particular oil painting, could meet the demand. Research focused on rapidly drying materials whose miscibility would be good, and the capacity to be built up unlimited. This demand was best met by commercially produced synthetic lacquers on the basis of alkyd and nitrocellulose resins. They allowed for a wide range of methods for building up the colour layer and could be combined with other mediums, including traditional ones.

However, modern developments show a return to classical techniques and only reliable modern methods have a chance of survival; those which ensure easy application and improve the durability of paintings — the polymer paints.

111
Michael Rittstein (1949)
A Study
Pen, watercolour, pastel on paper, 870 × 630 mm

Silicate Binders

Principles of the Technique

Ethyl silicate is a colourless liquid which is hydrolyzed to form an amorphous gel of silicic acid, which binds the pigments. Results have shown, however, that although ethyl silicate develops a hard film, it is brittle and deteriorated in time, and is susceptible to temperature changes. Therefore, ethyl silicate is now combined with organo-siliceous esters, such as methyl triethoxyl or methyl polyethoxy siloxane, or other compounds such as naturalized silicate, to obtain more durable films which do not crack and will resist weathering. Organo-siliceous binders create a colour layer with a wide spectrum of optical properties, ranging from glaze effects to a structure that can be used in relief.

Supports and Grounds

Painting with organo-silicates is mainly executed on concrete, plaster or ceramic materials. Stone is rarely used.

The ground must be hard and sufficiently porous to ensure fixation of the siliceous gel and so give firm adhesion to the paint layer. The ground normally consists of one, or at most two coats, according to requirement; the upper layer may form either a fine *intonaco* or a primer. The choice depends on the method of painting — in impasto, in successive layers, or in transparent glazes.

To achieve the porosity of the substrate, diatomite or tripoli are used as additives, Portland cement as a binder, and marble or another stone trit as fillers. M. Schätz suggests the following composition for the mortar:

1 part (by weight) Portland, white, or ordinary cement
2 parts (by weight) stone grit
0.3 to 0.5 part (by weight) diatomite (Celite 110, Hyflo)

The ingredients are first mixed when dry and then water is added while being constantly stirred until the mixture forms a medium-thick mortar. The mortar is spread evenly over the support and smoothed, as required, with a wooden or felt-covered float. When hard, the coat can be overlaid with the *intonaco* which has to be thoroughly smoothed with a metal float if a semi-lustrous, partially light-reflecting surface is required. The *intonaco* may incorporate titanium white or some other pigment, according to the needs of the artist; this low-consistency plaster is applied to form a primer. The *intonaco* can have the same composition as the undercoat, but the grains of the filler must be smaller. The amount of pigment in the *intonaco* can vary from 0.1 — 0.5 of one part by weight.

112
Giovanni Battista Tiepolo (1696—1770)
Apollo and Daphne
Fragment of fresco, almost monochrome

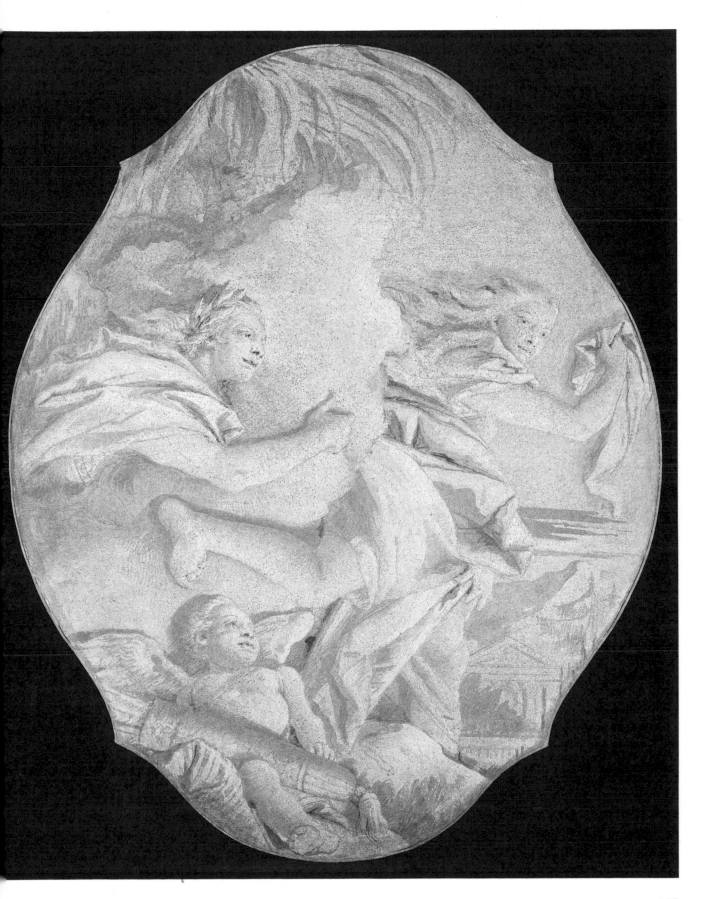

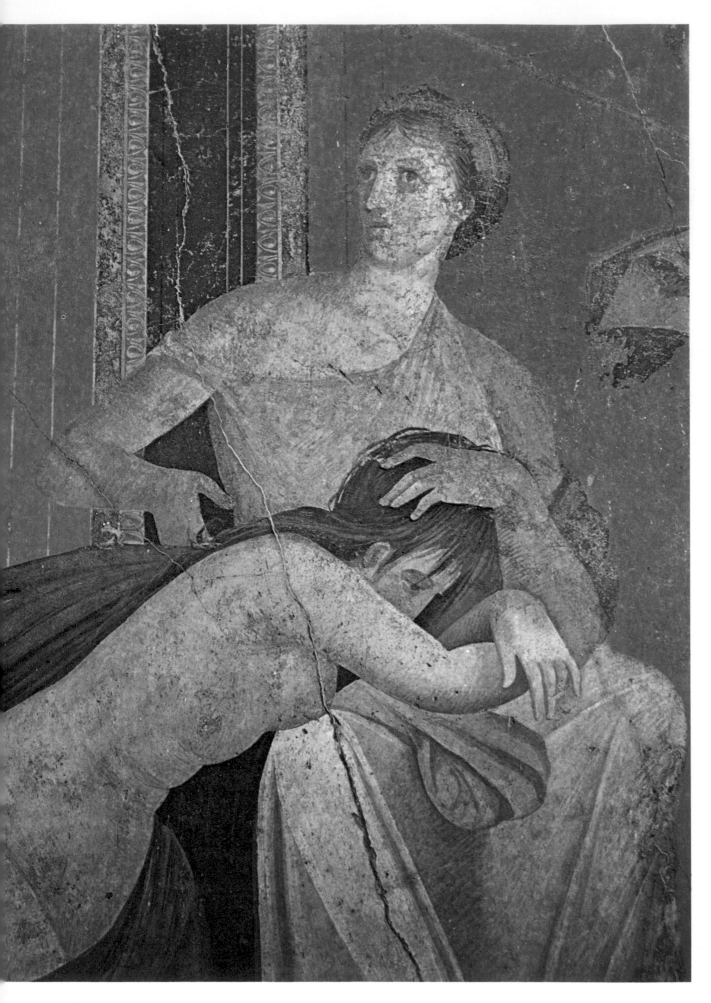

113
Detail of fresco decoration
Villa of Mysteries, Pompeii

114
Václav Vavřinec Reiner (1689—1743)
Mural in the former hospital in Duchcov,
Czechoslovakia
Mezzofresco (condition after transferring and
restoration)

115
František Ženíšek (1849—1916)
Detail of the decoration of the National Theatre in
Prague
Secco-tempera with gum arabic on smoothed plaster
An example of the monumentalism typical of the 19th
century

158

Pigments

Because organo-siliceous binders hydrolyze both in acid and in basic mediums, the pigments must be fast to both. Such pigments are:

whites	titanium white
	barites
	zinc white
yellows	ochres
	cadmium yellow
	chrome yellow
reds	iron oxide red
	pozzuoli
	minium
greens	chrome green
	phthalocyanine green
	green earth
blues	cobalt blue
	cerulean blue
	phthalocyanine blue
browns	sienna
	umber
	Cassel earth
blacks	bone black
	vine black

Preparing a Binder

The preparation of a binder involves mixing the ingredients to trigger the hydrolysis of the organo-siliceous compounds, after which the hydrolyzed binder is directly mixed with a pigment paste. Binder prepared in an acid medium requires:

50 parts (by weight) ethyl silicate 40
50 parts (by weight) methyl triethoxy silane
20 parts (by weight) ethyl alcohol
5 parts (by weight) water
1.5 parts (by weight) concentrated phospohoric acid

The mixture is blended with pigments ground in ethyl alcohol as soon as it is ready. Remember that the life of the binder is very short (just a few hours); when it expires, the preparation begins to gelatinize and cannot be brushed.

The composition of a binder to be prepared by alkaline hydrolysis is as follows:

50 parts (by weight) ethyl silicate 40
50 parts (by weight) methyl polyethoxy siloxane
5 parts (by weight) tetramethyl ethoxy silane
3 parts (by weight) magnesium oxide
80 parts (by weight) ethyl alcohol
20 parts (by weight) water
15 parts (by weight) siloxide

The hydrolysis lasts 30 minutes, resulting in a slight increase of the mixture's temperature which indicates its readiness for application. The life of the binder is limited to no more than six hours, so it should be used without delay. It is mixed with approximately 70 per cent pigment prepared with alcohol as a paste.

The first coat is prepared by the thinning of ethyl alcohol with water in the proportion 1:1. The pigments can be combined with siliceous sand to make the material's structure more textured, especially if it is to be applied to a large area.

A wide range of silicate paints are now commercially available.

Painting Techniques

The painting must be executed only on an absolutely hard ground that has no alkalinity and can no longer cause efflorescence; hard bristle brushes should be used. The paints can be thick and laid down side by side, or they can be thinned, possibly with ethyl alcohol, and piled up to form glazes.

An exterior wall painting is usually sprayed with a waterproof fixative, most commonly a silicon lacquer in a solvent such as toluene or white spirit.

116
Antonín Tomalík (1939—1968)
Object I
Wood, burlap, wire, nails, acrylic emulsion, oil,
860 × 1400 mm

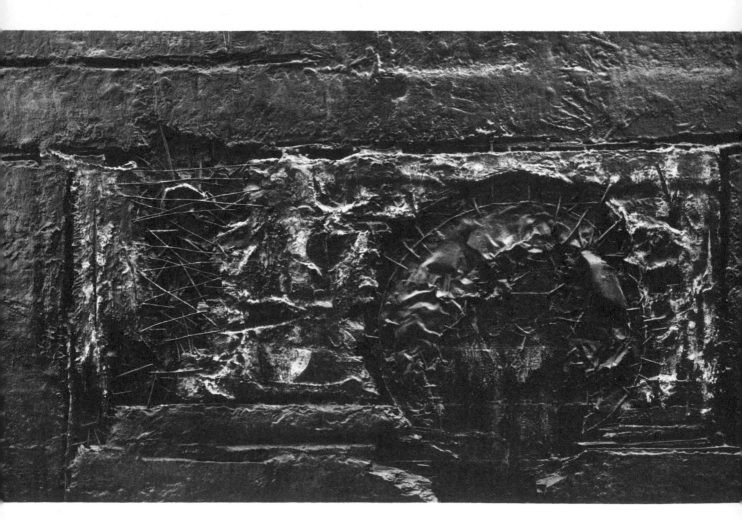

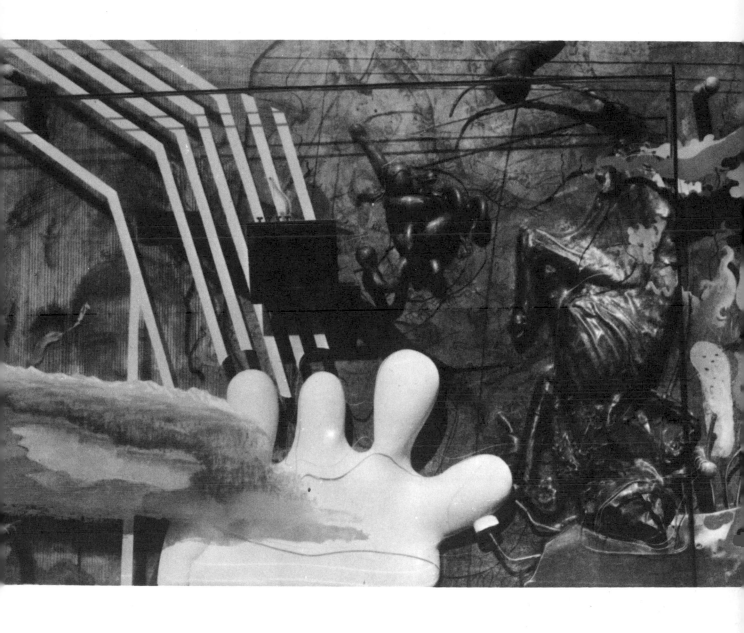

117
Bedřich Dlouhý (1932)
Portrait of a Friend
Drawing, painting, assemblage, masonite and plexiglass,
570 × 820 mm

Enamel

Supports and Grounds

Enamels dry to a compact, elastic, relatively durable, and optically stable film. Commercially produced enamels, used with their appropriate solvents, are available in various shades and so make their homemade preparation unnecessary. Synthetic enamels, based on alkyd resins, are diluted with organic solvents and dry by oxidation of the varnish film.

Car paints are a special group of high-grade enamels with considerable resistance; they are very elastic and resistant to weathering. This group includes polyurethanes, adapted for different applications, such as on wood or mineral surfaces; they can be mixed with special tinting pastes.

Enamels can be applied to wood, fibreboard, fabric, cardboard, metal sheet and plaster. The support must be degreased, cleaned and primed with an appropriate material. Aluminium and Duralumin sheets must be primed with a coat of zinc chromate paint. When dry, this can be overlaid with a ground or with another layer to serve as an undercoat. Before painting on plaster, its surface must first be cleaned, ground, covered with a coat to penetrate the surface (oil thinned with turpentine), and adjusted with lute (a mixture of cement and clay). The lute is then smoothed, after which the ground material can be applied.

Wood, fibreboard, canvas and possibly hardboard, can be coated with a white paint and ground when wet to a very smooth finish. Wood and plaster can be coated with oil thinned with turpentine or white spirit.

118
Zdeněk Beran (1937)
An Attempt at Stability
Oil and acrylic emulsion on masonite, 2300 × 1740 mm

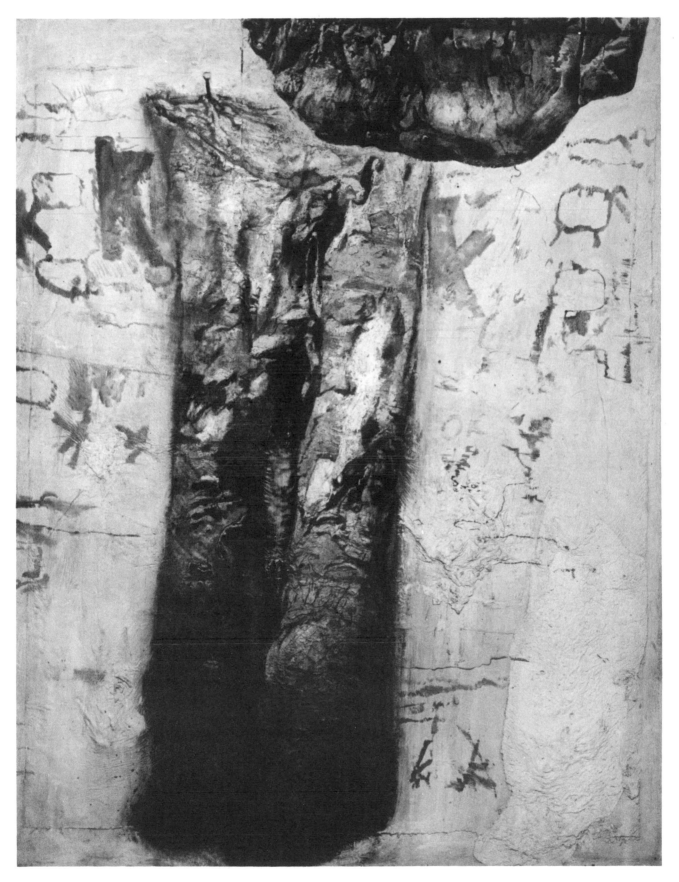

Painting Techniques

Enamels can be applied with hard bristle brushes, flexible spatulas of stainless steel and spray guns. Each layer applied by spraying must be allowed to dry before applying a next one.

When nitrocellulose lacquer is used in thin coats, each subsequent layer can be applied after a few minutes, but if applied in thick impasto, intervals should be extended to two hours. When spraying, the spray gun must be held at a 25—30 cm distance from the surface. The paint should be thinned.

Nitrocellulose lacquers are mainly thinned with acetone, but mixed acetate diluents can be used as well. Aerosol sprays can also be used. Paints can also be applied by pouring them over the surface to obtain a perfectly smooth and lustrous film, provided, of course, that the support is positioned horizontally.

119
Milan Langer (1944)
From the series *How to Make Delicate Tea*
Acrylic, car paint, silk screen, painting on canvas,
1000 × 1000 mm

120
Rudolf Němec (1936)
An example of splatter technique on paper,
500 × 700 mm

Polymer Paints

Supports

The basic composition of a macromolecular substance, e.g. synthetic resin, is a solution and an emulsion. Emulsions represent particles of a macromolecular substance dispersed in water and are prepared by emulsion polymerization. The stability of dispersed particles is ensured by the addition of an appropriate emulsifier. When the medium, water, evaporates, the particles form a coherent waterproof polymer film. The quality of a polymer film depends above all on the temperature under which the films is formed as well as on the properties of the polymer. The first natural aqueous emulsion, latex, was prepared from the milky juice of rubber trees. A rubber polymer was obtained from latex by heating and precipitating the smoke onto a screen. The name 'latex' was later used to describe all artificially prepared aqueous polymer dispersions.

Of the synthetic resins polymerized in this way, polyvinyl acetates and acrylates have proved to be best suited for the artist's purposes. The polyvinyl acetates (PVA) belong to the first generation of synthetic emulsions and have several disadvantages — the quality of the films must be adjusted with softening admixtures and stabilizers, their durability leaves much to be desired, they develop brittleness and also yellow in time. However, owing to their low price, they are widely used in the preparation of poster paints. Acrylic emulsions possess much better properties which make them very good artist's paints. They produce elastic films with high adhesive power, resistant to weathering and aggressive chemicals. Their stability accounts for their popularity in being used to paint exterior façades.

Different types of acrylic resins are often combined to obtain films with improved properties. Such combinations are called 'co-polymers' and require no softening or stabilizing additives. Their application in painting is extensive, as they can substitute a number of mediums, from gouache to tempera. Paint manufacturers produce a wide range of acrylic paints of differing consistency.

Acrylic paints can be applied to wood, paper, cardboard, fibreboard, canvas and plaster. Metal, stone and concrete are unsuitable for supports. Highly porous substrates must first be adjusted by priming. Primers are manufactured and sold ready made. The first coat (if two are used) should be diluted with water. Special attention should be paid to the treatment of a plaster support. Due to the considerable absorbency of plaster, it should be sealed in several stages with a thinned suspension until the support stops absorbing it completely. Only then can the support be coated with a ground. Supports with low porosity reach the required condition after one or two coatings (one coat is enough for a sheet of fibre-board) and if the surface is non-porous priming is unnecessary.

A canvas can be used tightened on a stretcher or glued to a thin board with size. The canvas is usually covered with one thin coat of primer.

Plywood is the most suitable of the wooden supports; most wooden boards or panels are liable to warp due to the action of the water. Five-ply plywood, 6—10 mm thick, is suitable for small works.

121
Jan Smetana (1918)
Forgotten Memory II
Decalcomania combined with painting, 700 × 500 mm

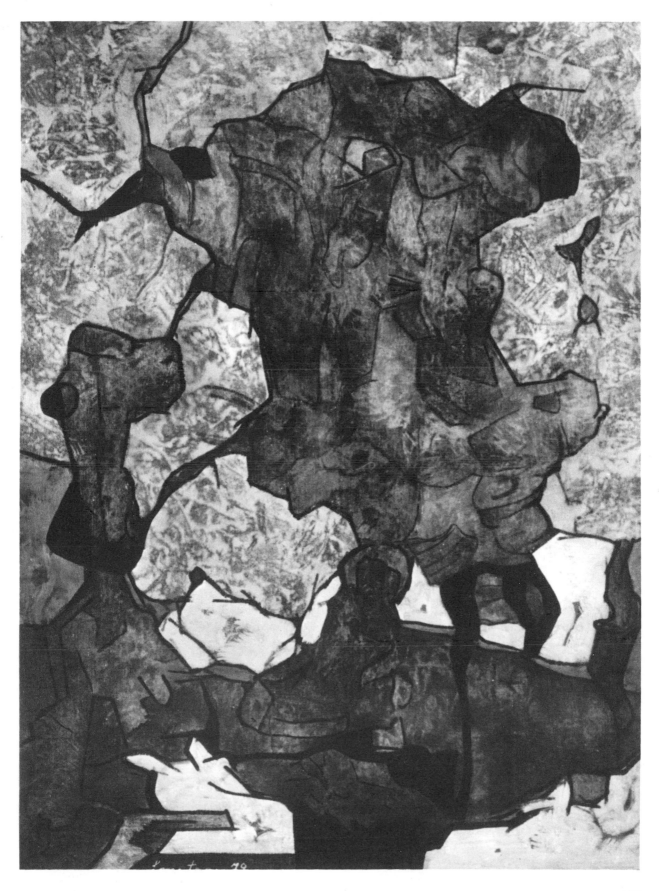

Grounds

An emulsion paint adheres well to supports with moderate absorbency. A ground can improve the properties of a support (lend it absorbency, for instance), but much depends on the support's composition. Generally, the ground is made with a combination of a colourless emulsion binder and an appropriate white pigment, such as titanium white, barite, or lithopone. An elastic ground, gypsum gesso, can be prepared from gypsum mixed with an emulsion thinned with water in the proportion of 1 : 3. For other pigments or inorganic fillers (such as chalk or diatomite), the emulsion is thinned so that the particles are firmly bonded and the film that forms as it dries is rigid and at the same time absorbent.

Because each filler demands its own degree of dispersion, the optimum consistency should be found by experimenting.

The number of coats on a canvas depends on the surface required. If the artist wants the canvas to retain its coarse structure, one coat is enough. An excessively thick coat on a loosely tightened canvas is inappropriate because the weight of the canvas and ground can cause thin cracks to appear. A ground applied with a spatula is only good on a canvas glued to a support. An emulsion ground brushed on to the support should be allowed to dry for several hours. Paper and cardboard as supports for acrylic paints do not usually require a ground.

122
Kateřina Černá (1937)
Two Figures
Mixed media with acrylic emulsion, 700 × 590 mm

123
Jan Vančura (1940)
The Tyl Theatre
Photomechanical process combined with glaze and
acrylic coating technique, 990 × 990 mm

Preparing Paints

Paints are commercially available, but they can also be prepared by mixing a basic emulsion with a pigment. The pigments must first be prepared with water and made into a thick paste, which is then mixed with the emulsion. This can be done with the help of an electric blender. The quantity of pigment used must be adjusted to obtain the correct consistency or it will have a harmful effect on the quality of the paint layer. As a rule, the total amount of pigment and additives should be within a range of 60—70 per cent of the volume of the emulsion used. The exact consistency can, however, be established through experimentation. This is especially advisable if other admixtures are used, such as sand, fibre or grit. The artist can use all common neutral dyes — titanium white, barites, and lithopone; ochres, cadmium yellow, Hansa yellow; iron oxide red, vermilion, minium, cadmium red, madder lake; cobalt blue, cerulean blue; phthalocyanine and naphthol greens; raw sienna, burnt sienna, umber, Mars brown, Cassel brown; ferric black, vine black, bone black.

In order to regulate the paint's consistency, especially when thickening it for building up impastos, the artist can use thickening additives such as siloxide (finely divided silicon oxide), although this also produces a strong matt effect.

In order to achieve the desired colour shade, especially a less saturated one, the artist can use titanium white. Emulsion paints can usually be applied 'wet on wet', a property which can be enhanced by coating the ground with a binder that will reduce absorption.

Painting Techniques

The preparatory drawing on a dry, prepared ground can be done in charcoal, crayon, or soft pencil. Coloured pencils should not be used, because many are soluble in emulsions. If the primer is dark, chalk can be used, or a brush with thinned paint.

Painting is largely executed in the 'alla prima' technique. However, a combined technique can also be used to achieve partial glaze effects by thinning the paints differently. Since they dry quickly to a matt film, they must be kept damp.

In order to retard drying and achieve lustrous, moderately thick colour layers resembling oil, emulsions are mixed with glycerine or ethylene glycol. These are added to paints in small quantities as the work progresses so that the applied paint is not allowed to dry out if there is a break in the painting session. Temperature is an important working condition. The higher the temperature, the better the quality of the paint film. They are not ideal for use in the open air in cold weather.

When applying and blending colours, the artist must bear in mind the optical properties of the paint. It is light in liquid state but dries darker on application. The colour layer is resiliant to the atmosphere to some extent, but if a painting is executed on a permanently damp support, the colour layer will very soon start to separate from the support, just as it does due to the action of moisture if the painting has been stored in a humid room.

Use soft hair brushes to imitate gouache or tempera technique and bristle brushes and a painting knife for impasto. The tools must be thoroughly cleansed with water immediately after use, otherwise the dried emulsion will have to be scraped away or removed with a solvent such as acetone or xylene — a laborious process.

The surface of a painting can be protected with a coat of an appropriate varnish, which can be gloss or matt, or a mixture of the two. If two coats are used allow the first to dry for several hours before applying the second.

124
Jiří Sopko (1942)
Nosy
Painting, using a relief layer of plaster, 750 × 950 mm

125
Pavel Nešleha (1937)
Iranian Landscape
Acrylic, 1000 × 1350 mm

Epoxy-oleous Paints

There is a medium that unites the properties of synthetic resins and oil paints. It is prepared by adding oil paints of required shades to a basic epoxy resin. This is a simplified version of the traditional oil resins: it helps achieve similar optical effects and glaze effects. As well as using tube oil paints, the artist can use all the organic pigments which mix well with epoxy resins. Because the hardeners for epoxy resins are based on alkaline amines, some pigments might be adversely affected, particularly if a stable paint of organic origin is involved. So, again, this must be ascertained by way of trial. Colours are blended on the palette with a metal spatula.

Schätz recommends mixing 1 part (by weight) of oil paint with 5 parts (by weight) of epoxy resin. It should be noted that, since a hardener shortens the life of the resin to which it is added, the blended paint must be applied quickly. However, the workability of the resin can be extended by varying the quantity of hardener used; the manufacturer's instructions must be observed. Due to the generally honey-like consistency of epoxy-oleous paints, the work should preferably be done with a knife rather than a brush.

Appropriate fillers can lend the paint interesting textures which can also be achieved by utilizing the material's powerful adhesive properties to assemble collages.

126
Václav Hejna (1914)
An Imaginary Portrait of Master Alfons Mucha
Assemblage and painting on wood, 2420 × 1000 mm

127
Jiří Anderle (1936)
Drawing combined with relief structure, 640 × 900 mm

128
Bedřich Fišárek (1906—1978) — Karel Mezera (1911)
Decorative panel in a shop
Stucco painting, Mezera's own technique

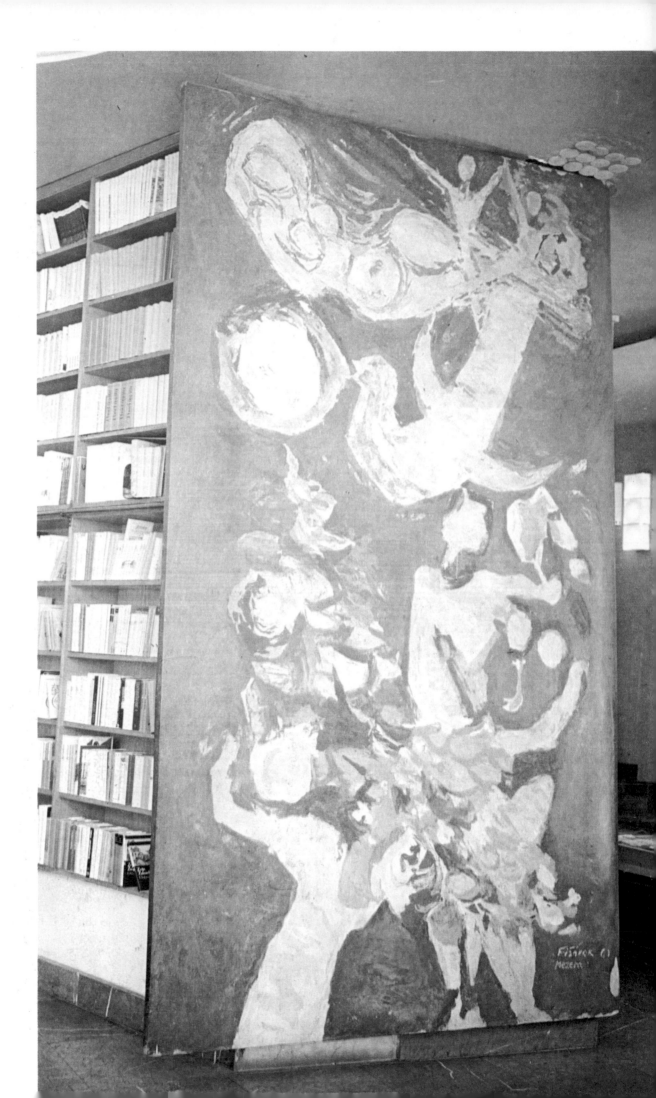

129
Folk-art glass painting (19th century)
St Wenceslas
Egg tempera, 240 × 300 mm

130
Václav Mergl (1935)
Salamander
Relief collage combined with painting, 1770 × 1440 mm

131
Adriena Šimotová (1926)
A Swimmer
Mixed media, 1500 × 1220 mm

132
Dana Zámečníková (1945)
Genuine Tiger Balm
Oil painting on stratified, matted and engraved glass,
165 × 165 mm

Stucco Painting

This chapter describes techniques which have either derived from folk art, or which were at one time commonly used in monumental painting and have now been forgotten. Some of their aspects could be of interest and benefit to today's artists.

The techniques of painting on stucco vary from a craft using artificial marble and stucco intarsia to a fine art of painting on the material.

The craft of imitating marble is a strictly decorative technique; it was popular for the adornment of temples and palaces of the 17th to 19th centuries. Originated in Italy, it was introduced to the Transalpine region by Italian craftsmen. It became known as 'scagliola' and was used particularly for decorating architectural features, and later furniture. It was also developed as a substitute for *pietra dura,* which was popular in the Renaissance.

Painting on stucco has retained its significance in interior decoration. Suitable surfaces for it are dry masonry, concrete panels, and gypsum walls, provided with the usual rough plaster coat.

The usual ground is a thin, double-layer stucco coat, either of pure lime or of lime with gypsum, with the coarser first layer prepared from 1 part (by volume) of slaked lime and 3 parts (by volume) of marble powder. Before this is applied, the rough undercoat is sprinkled with water. The rough coat should be approximately 5 mm thick and, on application, allowed to dry for 10—24 hours. If large areas are to be worked, the drying time should be reduced in order to prevent the plaster from drying out completely. This is followed by a 2 mm thick *intonaco* which can be thinned with an admixture of an earth pigment or with a coloured admixture that matches the hue of the marble powder used. The *intonaco* is prepared from finely divided strained limewash and marble powder, mixed together in the proportion of 2:1. The coat is allowed to partially set for 15—20 minutes, after which it is roughly applied and later smoothed out with a coat of pure lime, spread with a metal trowel using a circular motion and worked into the layer underneath. Repeat the smoothing until a slight glaze is obtained on the surface. Then, allow the *intonaco* to 'rest' for several hours.

The painting can be done on the stucco with a casein technique or a wax technique. The binder for casein is prepared from:

1 part (by volume) casein
1 part (by volume) slaked lime
1 part (by volume) ox gall
1 part (by volume) water

The lime-fast pigments, previously ground in water to a paste, are mixed with the binder immediately before the work is to be commenced. The amount of pigment should not exceed 70 per cent of the quantity of binder used. To achieve a glaze effect, thin the paint with water.

The binder for the wax technique (which is more frequently used) is prepared from:

3.5 parts (by weight) lime milk
0.5 part (by weight) thick soap solution
0.1 part (by weight) colophony
0.1 part (by weight) wax

The 'fat' ingredients are first melted in the soap solution and, when dry, are mixed with the lime milk. The pigments added to the mixture must not be affected by the alkaline medium.

The painting must be executed only with soft brushes, while delicate transitions, the weakening of local tones or those of large areas can be done with a natural sponge. After the colours have dried out, the finished painting (done in the casein technique), is washed with soap water, made from 1 part (by volume) of Venetian soap and 5 parts (by volume) of distilled water. The surface is then treated with a warm iron or heated metal trowel. The temperature is critical — it should not cause blisters or let the surface stick to it. The bottom of the iron, as the work progresses, should occasionally be cleaned with charcoal or a soft tissue. When ironing, use a criss-crossing motion. After a few days coat the painting with linseed oil or liquid wax.

If the wax technique is used, the surface of the painting is ironed immediately after the work is finished, then followed by a coat of liquid wax spread over the painting with a wad of cotton to give the surface a silky lustre.

Miniature Painting under Water

This very special technique was used in the 18th century for the painting of miniatures on quality canvas, apparently designed to imitate the smoothness and delicacy of painting on ivory. A textile support, such as linen, was glued with starch to a sheet of glass and coated with a ground of barite white and poppy oil. Three coats were applied, each one polished to a matt gloss before the next was applied. The sketch, outlined with lead, silverpoint, or a brush was strengthened by an underpainting in extremely fine pigment bound in poppy oil. Then a metal frame was placed tightly over the ground and flooded with water and the painting was completed in oil. As soon as stains of grease appeared on the surface of the water it was removed and the painting, protected with glass, was taken to a dry place to dry out. The painter then continued working. This method ensured the uniform smoothness of the layer of paint, made brush marks invisible and prevented the formation of areas that were too matt or shiny.

Glass Painting

Underpainting on glass implies painting on the reverse side of a glass sheet in tempera or oil and the use of various coats for backgrounds. It is a very old technique, rooted in antiquity, possibly developed from the craft of decorating gold bowls (there is an example of a 4th-century bowl with a portrait of a woman with two children on it, exhibited in the Municipal Museum of Natural History, Brescia). The oldest medieval 'underpaintings' are found as far back as the 14th century (*The Crucifixion,* from 1330, in Schwerin); the 15th and 16th centuries saw their popularity in Germany, the Netherlands and Italy, when the technique was employed for painting commemorative and dedicatory pictures and portrait miniatures. Later on, it was mainly applied for the embellishment of decorative works of art, particularly bowls. In the 18th and 19th centuries this technique and its variations was used for painting pictures, particularly in France, and it also became a widespread folk art.

Folk-Art Glass Painting

This term distinguishes the works with usually religious or wordly themes, which were intended for mass consumption and produced in great quantities by many painters' workshops. By the 18th century the technique had been significantly simplified by those who practised it. They used low-grade sheets of glass, cleaned and degreased with ox gall, and painted in egg or egg-casein tempera (poorer workshops used casein tempera). Oils came into use in the 19th century. The order of painting began with the contours, then the lights, complexion, shadows, drapery, and finally the background. After the painting had dried, the finished painting received a protective coat of minium mixed with drying oil, then paper or cardboard was glued to the painted surface with flour paste; the glass sheet was then given a simple wood frame. The more expensive works were protected with tin or silver foil. This later led to 'mirror' painting which at the beginning of the 18th century was widely practised by amateurs.

133
Artist unknown (18th century)
Solomon's Judgment
Glass painting

'Chinese' Painting Technique

Verre Eglomisé

This was a technique of painting pictures in gouache or tempera on smooth, thoroughly degreased tin foil. The foil was coated with mercury, spread out on the surface with a hare's leg, and covered with a sheet of glass which was pressed on tight to expel the superflous mercury. Another method was to use a press consisting of two smooth planks and a weight. The amalgam that formed on the unpainted areas firmly bonded the foil to the glass sheet.

J. B. Glomy, an 18th-century Parisian frame maker and art dealer, used a special method of manufacturing glass picture mounts for framing prints and drawings and gave his name to the technique which had, in fact, been known since ancient Roman times. It is a variant of glass painting, characterized by the use of engraving, or scratching into the glass and then colouring the drawing with paint, usually black. The background is then gilded. The process can also be reversed and the drawing is then picked out in gold. The engraving was then overworked in black, red, or polychrome colours. The technique was used to decorate glass boxes, so popular in the 16th and 17th centuries in Italy and particularly in Venice.

Bismuth Painting

This old, now forgotten technique was originally used to imitate fine metal decoration on furniture, and later for silhouette portraits to make them look as if they were cut from metal. It was also used in glass painting.

The ground was generally of sized gesso, which had to be smooth enough to accept finely divided bismuth powder bound in gum arabic. The finished painting, which appeared like old silver with a reddish metallic touch, was protected with tinted shellac-based drying oils or glazes of lake colours.

SELECTED BIBLIOGRAPHY

Berger, E., *Beiträge zur Entwicklungsgeschichte der Maltechnik,* Callwey, Munich 1901

Doerner, M., *The Materials of the* Artist, Hart-Davis, London 1953

Eastlake, Sir C., *Methods and Materials of Painting of the Great Schools and Masters,* 1847, reprinted Dover, New York 1960

Gettens, R. J. and Stout, G. L., *Painting Materials,* 1942, reprinted Dover, New York 1966

Laurie, A. P., *Materials of the Painter's Craft in Europe,* Foulis, Edinburgh 1910; *The Pigments and Mediums of the Old Masters,* Macmillan, London 1922; *Greek and Roman Methods of Painting,* CUP, Cambridge 1910; *The Painter's Methods and Materials,* 1926, reprinted Dover, New York 1967

Mayer, R., *The Artist's Handbook,* reprinted Faber, London 1973

Merrifield, M. G., *Original Treatises on the Arts of Painting,* 1849, reprinted Dover, New York 1967

Thompson, D. V., *Cennino Cennini: The Craftsman's Handbook* (translation), 1932, reprinted Dover, New York 1954; *The Materials and Techniques of Medieval Painting,* 1936, reprinted Dover, New York 1956

Winsor and Newton, *Notes on the Composition and Permanence of Artists' Colours,* n. d.

134
Artist unknown (late 18th century)
Connaissance des Arts
Verre églomisé, 85 × 125 mm
Engraved and gilded drawing on glass

List of Illustrations

135
Zdeněk Rybka (1947)
Electrography
Photographic paper, 940 × 600 mm

(**Bold** numbers refer to colour reproductions, normal numbers denote black-and-white reproductions, numbers in *italics* indicate pen-and-ink drawings)

113 Detail of fresco decoration in Villa of Mysteries, Pompeii
114 Václav Vavřinec Reiner (1689—1743): Mural from the former hospital in Duchcov. Mezzofresco. Castle garden. Duchcov, Czechoslovakia
115 František Ženíšek (1849—1916): Detail of the decoration of the National Theatre. Secco-tempera with gum arabic on smoothed plaster. National Theatre, Prague
116 Antonín Tomalík (1939—1968): *Object I.* Wood, burlap, wire, nails, acrylic emulsion, oil, 860 × 1400 mm. Private collection
117 Bedřich Dlouhý (1932): *Portrait of a Friend.* Drawing, painting, assemblage, masonite and plexiglass, 570 × 820 mm. Private collection
118 Zdeněk Beran (1937): *An Attempt at Stability.* Oil and acrylic emulsion on masonite, 2300 × 1740 mm. Private collection
119 Milan Langer (1944): From the series *How to Make Delicate Tea.* Acrylic, car paint, silk screen, painting on canvas, 1000 × 1000 mm. Private collection
120 Rudolf Němec (1936): An example of splatter technique on paper, 500 × 700 mm. Private collection
121 Jan Smetana (1918): *Forgotten Memory II.* Decalcomania combined with painting, 700 × 500 mm. Private collection
122 Kateřina Černá (1937): *Two Figures.* Mixed media with acrylic emulsion, 700 × 590 mm. Private collection
123 Jan Vančura (1940): *The Tyl Theatre.* Photomechanical process combined with glaze and acrylic coating technique, 990 × 990 mm. Private collection
124 Jiří Sopko (1942): *Nosy.* Painting using a relief layer of plaster, 750 × 950 mm. Private collection
125 Pavel Nešleha (1937): *Iranian Landscape.* Acrylic, 1000 × 1350 mm. Private collection
126 Václav Hejna (1914): *An Imaginary Portrait of Master Alfons Mucha.* Assemblage and painting on wood, 2420 × 1000 mm. Private collection
127 Jiří Anderle (1936): Drawing combined with relief structure, 640 × 900 mm. Private collection
128 Bedřich Fišárek (1906—1978)— Karel Mezera (1911): Decorative panel, stucco painting Czechoslovak Writers' saleroom, Prague
129 Folk-art glass painting (19th century): *St Wenceslas.* Egg tempera, 240 × 300 mm. Private collection
130 Václav Mergl (1935): *Salamander.* Relief collage combined with painting, 1770 × 1440 mm. Private collection
131 Adriena Šimotová (1926): *A Swimmer.* Mixed media, 1500 × 1220 mm. Private collection
132 Dana Zámečníková (1945): *Genuine Tiger Balm.* Oil painting on stratified, matted and engraved glass, 165 × 165 mm. Private collection
133 Artist unknown (late 18th century): *Solomon's Judgment.* Glass painting technique. Červená Lhota Castle, Czechoslovakia
134 Artist unknown (late 18th century): *Connaissance des Arts.* Verre églomisé, 85 × 125 mm. Private collection
135 Zdeněk Rybka (1947): *Electrography.* Photographic paper, 940 × 600 mm. Private collection

ACKNOWLEDGEMENTS

The publishers would like to express their gratitude to the following photographers:
Vlastimil Berger (97, 98), Soňa Divišová (11, 57, 99, 101, 102), Bedřich Forman (36), Werner Forman (55, 100), Vladimír Fyman (4, 28, 30, 41, 44, 45, 47, 50, 59, 63, 64, 70, 77, 79), Jaroslav Jeřábek (79), Jan Kříž (2, 3, 31, 60, 61, 80—82, 85—87, 89, 95, 96, 110, 111, 116—127, 130—132, 135), Gerhard Reinhold, Leipzig-Mölkau (23), Čestmír Šíla (104), Zdeněk Sýkora (88), Jan Vančura (93), Milan Zemina (1, 5—10, 14—20, 24, 27, 29, 32, 34, 35, 37, 40, 46, 53, 54, 56—58, 62, 66, 67, 71—75, 92—94, 103, 114, 115, 128).

The photographs of the pictures are reproduced by the kind permission of the following official bodies, institutions and individuals:
Antwerp: Koninklijk Museum voor Schone Kunsten (90); *Basle:* Kupferstichkabinett der Öffentlichen Kunstsammlung, Kunstmuseum (22); *Berlin:* Staatliche Museen Preussischer Kulturbesitz (112); *Brno:* Moravská galerie (32, 34); *Červená Lhota:* Státní zámek (133); *Dresden:* Staatliche Kunstsammlungen, Gemäldegalerie Alter Meister (23); *Duchcov:* Státní zámek (114); *Ghent:* Museum voor Schone Kunsten (21); *Liberec:* Oblastní galerie (27, 35); *London:* National Gallery (69), Spinks and Sons (55); *Madrid:* Museo del Prado (43); *Malibu:* Getty Museum (100); *Mariánské Lázně:* Městské muzeum (40, 73); *Paris:* Musée National du Louvre (68, 91); *Prague:* Československá akademie věd (57, 58), Československý spisovatel (128), Marie Hollerová (29, 37), Kancelář prezidenta ČSSR (62, 66, 67, 93), Emila Medková (2), Náprstkovo muzeum (54), Národní divadlo (115), Národní galerie (4, 11, 28, 30, 36, 41, 44, 45, 47, 50, 57, 59, 63, 64, 70, 77, 79, 99, 101, 102), Národní muzeum (53, 75), Státní ústav památkové péče a ochrany přírody (133), Útvar hlavního architekta hl. města Prahy (74); *Vienna:* Graphische Sammlung Albertina (25); all the contemporary artists mentioned in the book.

GLOSSARY

Alla prima Painting directly on a canvas or board with no preliminary underpainting, sometimes on an unprimed surface. Generally applies to oil painting.

Asphaltum Medium, a solution used as a brown glaze particularly in the 19th century.

Assemblage Work of art that may combine every-day three-dimensional objects and painting, giving the effect of a collage in relief.

Bozzetto A scaled-down sketch for a painting, or a model for a sculpture.

Cartapesta Moulding material of sized paper (see also **Papier-mâché**).

Cartoon Full-size preparatory drawing for a fresco, or an easel or panel painting. It is used as a pattern — the image is transferred to the painting surface by tracing, or by pouncing it through.

Casein A powder that is precipitated from milk curd and used for its adhesive properties as a binder for pigments.

Chiaroscuro (Italian for light/shade) A dramatic technique of contrasting lights and darks; usually a predominantly dark background with startling highlights.

Chrysography The art of writing in letters of gold practised especially by book artists.

Détrempe Painting wet on wet, a technique for gouache and watercolour.

Gesso A chalk or gypsum ground. The gesso grounds of Gothic panel paintings were sometimes carved to give a decorative surface.

Giornata (Italian for day's work) In fresco, the area covered by the artist(s) in one day. The colours must be applied to the intonaco while it is still damp.

Glaze Transparent or translucent paint layer.

Gouttes d'eau Drops of water, a technique of tiny drop-like dots.

Grisaille Painting made in black, white, grey and neutral tones only. Can give the effect of bas-relief.

Ground The surface on which the painting is made. In particular, it means the prepared surface (i.e. gesso, a paint layer, or, in fresco, the intonaco).

Guazzo Gouache.

Halftones Transitions from light areas to dark areas achieved through broken colour tones.

Hiding power The strength of a paint in terms of opacity (i.e. how well it will obscure previous layers).

Hue The chromatic value of a colour (not its tone).

Impasto Thick oil paint layer in which brushstrokes or palette knife marks stand out in relief.

Imprimitura Sealant, a thin paint layer, designed to adjust the optical properties of the ground.

Incrustation Decoration as with coloured materials (stone, stucco, metals); a technique used in Pompeiian paintings to imitate real incrustation.

Intonaco In fresco, the final fine plaster and lime layer that is laid in areas small enough to be worked in one day (giornata) while still damp.

Medium The binder, or vehicle in which the pigment is suspended, or by which it is diluted, and which gives the paint its characteristic (i.e. oil, acrylic etc.). Also, more generally, the means of artistic expression used (e.g. painting, sculpture etc.).

Mordant Wax-resin solution originally used to fix metal plates.

Musive gold Zinc-bronze alloy in powder form used to imitate gold.

Papier-mâché A light strong moulding material of wastepaper.

Pastiglia Relief ground for patterned or freely modelled backgrounds which was popular in trecento and quatrocento.

Pentimento The reappearance in an oil painting of original elements of drawing or painting that the artist has subsequently overpainted. It is caused by the ageing of the binders.

Pietra dura A mosaic of irregularly shaped stone plates (e.g. marble plates of different colours), polished to a high gloss (sometimes also called Florentine mosaic).

Pigment A colouring agent.

Plein air A painting done outside in the landscape, rather than built up from drawings in the studio.

Pointillé Dots, a painting technique of the Neo-Impressionists.

Poncif (spolvero) Transfer of a design from a perforated cartoon onto the wall by dabbing the perforations with a muslin bag of a powdered material.

Primer The first coat, applied to a sized or unsized support, which prepares the surface for the ground or paint layer.

Reservage A technique of painting; the way of 'negative' drawing, or leaving areas of local tones unpainted; the unpainted area is covered with a readily soluble and removable sealant.

Resinates Chemical compounds of heavy metals and natural resin the commonest of which are copper resinates which give blue-green glazes.

Scagliola An imitation of ornamental marble consisting of finely ground gypsum mixed with glue.

Sfumato The definition of form by the delicate blending of one tone into another, without any sharp outlines.

Sinopia A reddish-brown earth pigment used to make preliminary drawings for frescoes. Often used to mean the drawing itself.

Size Glue sealant used to prepare the surface of the support before priming or painting.

Stil de grain A natural, organic dyestuff obtained from the berries of the buckthorn.

Support The material on which a painting is made (e.g. canvas, board, or wall).

Tone The quality of a colour as it is adjusted by the addition of black or white to describe dark or light.

Underpainting The first paint layers, which are then built up with overpainting.

Verdaccio Underpainting in ochre or olive tones, used particularly in the trecento.

NAME INDEX

*Page numbers in italics refer to
illustration captions*